BARE BONES

CAMERA
COURSE FOR
FILM AND
VIDEO

BARE BONES

CAMERA

COURSE FOR

FILM AND

VIDEO

Third Edition

TOM SCHROEPPEL

Copyright © 1982-2015 by Tom Schroeppel

All rights reserved. Copyright under Berne Copyright Convention, Universal Copyright Convention, and Pan American Copyright Convention. No part of this book may be reproduced, stored in a retrieval system, or transmitted in any form, or by any means, electronic, mechanical, photocopying, recording or otherwise, without the express written consent of the publisher, except in the case of brief excerpts in critical reviews or articles. All inquiries should be addressed to Allworth Press, 307 West 36th Street, 11th Floor, New York, NY 10018.

Allworth Press books may be purchased in bulk at special discounts for sales promotion, corporate gifts, fund-raising, or educational purposes. Special editions can also be created to specifications. For details, contact the Special Sales Department, Allworth Press, 307 West 36th Street, 11th Floor, New York, NY 10018 or info@skyhorsepublishing.com.

23 22 21 20 19

109876

Published by Allworth Press, an imprint of Skyhorse Publishing, Inc. 307 West 36th Street, 11th Floor, New York, NY 10018.

Allworth Press® is a registered trademark of Skyhorse Publishing, Inc.®, a Delaware corporation.

www.allworth.com

Cover and design by Mary Belibasakis

Library of Congress Cataloging-in-Publication Data is available on file.

Print ISBN: 978-1-62153-526-3 Ebook ISBN: 978-1-62153-527-0

Printed in the United States of America

Table Of Contents

Author's Note: How We Got to Here	ix
Preface	xi
1. BASICS	1
The Camera—How it Works	1
Exposure	4
Color Temperature	6
Setting Exposure on a Video Camera	8
Setting Exposure on a Film Camera	9
Lenses	13
Depth of Field	19
2. COMPOSITION	25
The Camera—A Tool for Selective Vision	25
Use a Tripod	26
Rule of Thirds	27
Balance—Leading Looks	30
Balance—Masses	32
Balance—Colors	33
Angles	36
Frames within the Frame	38
Leading Lines	40
Backgrounds	41
In Search of a Good Composition	44

THE BARE BONES CAMERA COURSE

3. BASIC SEQUENCE	47
How a Basic Sequence Works	47
Shooting a Basic Sequence	52
Cutting on the Action	55
Clean Entrance/Clean Exit	56
Some Final Words on Basic Sequences	60
4. SCREEN DIRECTION	61
Screen Direction and Crossing the Line	61
Using Screen Direction to Solve Shooting Problems	69
5. CAMERA MOVES	73
Making Camera Moves	75
6. MONTAGES	79
7. LIGHTING	81
Exterior Lighting	81
Interior Lighting	84
Basic Lighting Setup	87
8. SOUND	91
Vibrating Bodies Create Spherical Sound Waves	91
Microphones	94
Sound Waves Bounce	103
Record Clean Sound	104
Wild Effects	105
Recording Voices and Presence	106
Voice-Slate and Keep a Sound Log	108
Remember Your Viewers	109
The Best Sound Recording Advice I Can Give You	110

TABLE OF CONTENTS

9. DOING IT	111
Planning and Shooting a Sequence	111
Shooting Scripts and Storyboards	113
Shooting Out of Sequence	114
Communicating	116
Working in Uncontrolled Situations	116
10. AFTER THE SHOOT—EDITING	119
The Human Eye as Editor	119
Read the Script. Divorce the Director	123
Good Log = Good Edit	124
Paper Edits	125
Establish Your Program's World, Then Re-Establish It	126
Look for Basic Sequences, Then Use Them	128
The Great Underlying Rule of Editing:	
Make Sure Each New Shot Is Different	129
Pacing—How Fast Things Change	130
Use an Appropriate Editing Style	131
Sound in Editing	133
Background Music	135
Selecting and Cutting Library Music	136
Sound Mixing—Separate Your Tracks	138
Your Last Step: Divorce the Editor	138
Some Final Words	141
Exercises	143
About the Author	160
Indov	161

AUTHOR'S NOTE How We Got to Here

In the late 1970s, I was shooting TV commercials and industrial sales films in Miami. I was also traveling to Ecuador a couple times a year to train camera crews at a TV network there. One day as I was drawing on a Little Havana restaurant napkin to explain a setup to a client, I realized that this was the same thing I had explained in Spanish the previous week in Quito. I decided to translate my training notes back into English and print them in a book version I could give to clients. I hoped to also sell a few copies to cover my costs. I decided to call the book *The Bare Bones Camera Course for Film and Video*.

I based the content of The Bare Bones Camera Course on what I was teaching in Ecuador. This is turn was based on what I had learned at the Army Motion Picture Photography School at Fort Monmouth, New Jersey. (I was an Army cameraman and later a Signal Corps officer.) Both combat photography and TV news coverage require quick but thorough knowledge of basic camerawork.

I hoped to sell enough copies of the book to break even; to my surprise, it did better than that. Students found it easy to understand, teachers found it helpful, and over the years more than 700 colleges chose it as a basic text. Major publishers made me offers, but I continued to self-publish because I enjoyed the personal contact with my customers and I wanted to keep the book available to them at a reasonable cost.

Now, when the time has come to pass the torch, I am pleased to have an organization of the stature of Allworth Press publish this latest edition of *The Bare Bones Camera Course for Film and Video*, guaranteeing that it will be around and affordable for many years to come. I hope it continues to serve you, my readers, well.

PREFACE

This book explains, as simply as possible, how to shoot usable images on film, tape, and other media.

If you are, or plan to be, a cameraperson, I suggest you read your camera's operator's manual in addition to this book. When you understand both, you should be able to go out and shoot footage that works.

If you're not interested in becoming a cameraperson, but simply want to better understand how the camera is used, no additional reading is required. Just relax and enjoy the book.

This edition of *The Bare Bones Camera Course* includes information on sound and editing which was originally published in my book *Video Goals: Getting Results with Pictures and Sound.*

1 BASICS

THE CAMERA-HOW IT WORKS

The camera is an imperfect imitation of the human eye. Like the eye, it sees by means of a lens which gathers light reflected off objects. The lens directs this light onto a surface which senses the pattern formed by the differences in brightness and color of the different parts of the scene. In the case of the eye, this surface at the back of the eye sends the pattern of light to the brain where it is translated into an image which we "see."

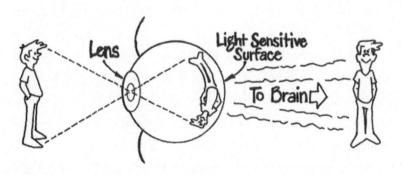

THE EYE GATHERS PATTERNS OF REFLECTED LIGHT WHICH THE BRAIN TRANSLATES INTO IMAGES WE SEE.

In the case of the camera, the lens directs the patterns of light onto a variety of sensitive surfaces. Still film cameras record light patterns on film coated with light-sensitive chemicals. The chemicals react differently to different amounts and colors of light, forming a record, or image, of the light pattern. After the film is processed in other chemicals, the image becomes visible.

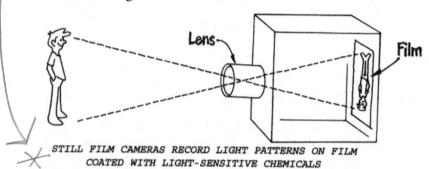

You'll notice that both the lens of the eye and the lens of the camera turn the light pattern upside down as it passes through. This is because they're both convex lenses, or lenses which curve outward. Because of their physical properties, convex lenses always invert images. In the brain, and in the camera viewfinder, the images are turned right side up again.

Movie cameras record images in the same way as still film cameras, except they do it more often. Eight mm movie cameras normally take eighteen different pictures, or frames, every second. Sixteen mm and 35mm movie cameras take twenty-four frames per second. When these pictures are projected on a screen at the same fast rate, they

8mm = 18 pics/second 2 lemm \$35m = 25 pics/sec

convex lenses; curve authord

give the illusion of continuous movement. The viewer's mind fills in the gaps between the individual frames, due to a physiological phenomenon known as persistence of vision.

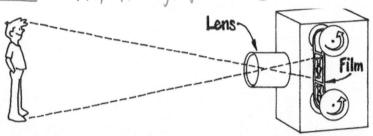

MOVIE CAMERAS TAKE MANY DIFFERENT PICTURES EVERY SECOND.

In digital cameras—both still and video—the lens focuses light patterns onto an image sensor, either a CCD (charge coupled device) or a CMOS (complementary metal oxide semiconductor). The surface of the sensor contains from thousands to millions of tiny light-sensitive areas called picture elements, or pixels, which change according to the color and intensity of the light hitting them. In video cameras, the image formed by all the pixels taken together is electronically collected off the sensor at a rate of either twenty-five or thirty complete images per second. These images can then be recorded or broadcast. (See illustration on following page.)

At the viewfinder or TV set the process is reversed to recreate the original image. Persistence of vision causes the viewer to perceive the separate pictures, or frames, as continuous movement.

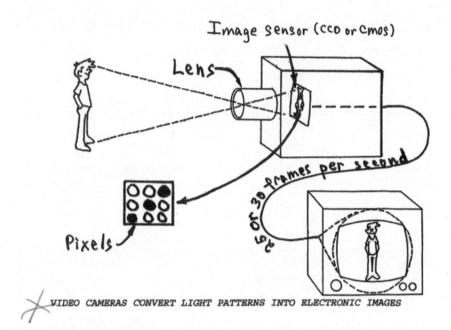

EXPOSURE

Exposure is the amount of light that comes through the lens and hits the film or CCD chip. The hole in the center of the lens that the light travels through is called the aperture. If the aperture is big, it lets in lots of light. If it's small, it lets in very little light. The size of the aperture is adjusted by the f/stop ring on the outside of the lens. An f/stop is simply a measure of how big or how little the aperture is.

I find that the easiest way to understand f/stops is to think of them in terms of fractions, because that's what they really are. F/2 means that the aperture is 1/2 as big across as the lens is long. F/16 means that the aperture is 1/16th as big across as the lens is long.

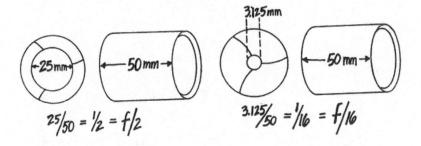

When you look at it this way, it's easy to understand why in a dark room, you'll probably be shooting at f/2 to let in all the light you can. Conversely, outside in bright sunlight, where you've got a lot of light, you'll probably stop down to f/11 or f/16, to let less light in.

Now that you understand that, let me point out that in most modern lenses, especially zoom lenses, what I've just told you isn't absolutely true. An f/2 aperture won't physically be exactly 1/2 the length of the lens. But optically it will be. It will let through as much light as if it were indeed 1/2 the length of the lens. And that's the important thing.

F/stops are constructed so that as you go from f/1 to f/22 and beyond, each stop admits 1/2 as much light as the one before. The progression is: f/1, f/1.4, f/2, f/2,8, f/4, f/5.6, f/8, f/11, f/16, f/22, f/32, f/45, f/64, and so on. F/1.4 admits half as much light as f/1. F/4 admits half as much light as f/2.8.

Many of the newer lenses are marked in both f/stops and T/stops, or T/stops alone. T/stops are more accurately measured f/stops. F/4 on one lens may not let in

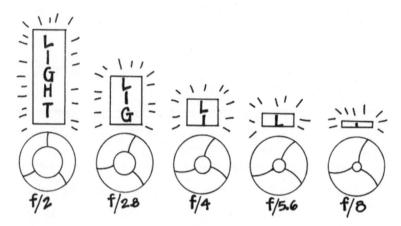

EACH F/STOP ADMITS HALF AS MUCH LIGHT AS THE ONE BEFORE.

exactly the same amount of light as f/4 on another lens; but T/4 is the same on every lens. It always lets in the same amount of light.

COLOR TEMPERATURE

Have you ever been out walking on a cold, dingy day and remarked to yourself how warm and cozy all the lighted windows looked? Well, that was because the light in the windows was of a warmer color than the light outside.

Yes, light comes in different colors. If you think about it, you'll see it's true. There's the red glow from an open fire or a sunset; the bluish cast of a sky dark with rainclouds; and that blue-green ghoulish look you get from the fluorescents in all-night pizzerias. As a general rule, our eyes adjust so well to these different colored light sources that we hardly notice them. Not so the camera.

Color films and CCD/CMOS chips can handle only one color of light source at a time and reproduce colors accurately. They do this by means of color temperature and color filters.

Color temperature is a way to identify different colors of light sources. It's measured in degrees Kelvin, after Britain's Lord Kelvin, who devised the system. It's written like this: 2500K.

The idea is, you take a perfectly black body, like a piece of coal, at absolute zero (-273°C), and start heating it up. As it gets hotter, it puts out different colors of light: first red, then blue, then bluish-white. The different colors of light are identified by the temperatures at which they occur. 2000K is the reddish light produced at 2000 degrees Kelvin. 8000K is the bluish light produced at 8000 degrees Kelvin.

As I mentioned above, color films and CCD/CMOS sensors can handle only one color of light source at a time. To take pictures under a different colored light source, color filters are used to convert the existing light to the color temperature required.

Professional video cameras have built-in filters, which you set according to the light you'll be shooting under. A typical filter selection might include: tungsten-incandescent (3200K); mixed tungsten and daylight/fluorescent (4300K); daylight (5400K); and shade (6600K). (Fluorescent light, strictly speaking, has a discontinuous spectrum and doesn't fit into the Kelvin system; still, a 4300K filter setting will give you adequate color reproduction.)

Once you select the correct filter on a video camera, fine tune the color by adjusting your white balance. This procedure varies from camera to camera and can be as simple as pushing a single button. It ensures that the whites in your scene reproduce as whites; the other colors then fall into place.

Color movie films are manufactured for two kinds of light: 3200K-tungsten (interior); and 5400K-daylight. If you shoot tungsten film in tungsten light, you don't need a filter. Likewise if you shoot daylight film in daylight.

To shoot tungsten film in daylight, put a #85 filter on the front of the lens or in a filter slot on the camera. This orange filter converts 5400K bluish daylight to reddish 3200K tungsten.

To shoot daylight film inside with tungsten light, use a #80A filter. This blue filter converts reddish tungsten light to bluish daylight. For photoflood lights (3400K) use a #80B filter.

SETTING EXPOSURE ON A VIDEO CAMERA

First, select the correct filter and adjust your white balance, as discussed above.

If your camera has automatic exposure and you can't turn it off, all you can do is avoid large light areas and large dark areas within the frame. These will throw your exposure off.

Professional video cameras have both auto and manual exposure. To manually change your exposure, look in the viewfinder and move the f/stop ring until the picture looks good. Ideally, you'll be able to record detail in both the

bright (highlight) areas and the dark (shadowed) areas. Most camera viewfinders can highlight overexposed areas with non-recording zebra stripes.

With a new or strange camera, it's a good idea to make a test recording under various lighting conditions and play it back on a good monitor to check the calibration of your camera's viewfinder. Sometimes you'll have to go a little darker or a little lighter in the viewfinder to get the best color on playback.

The main problem with video cameras is large areas of white, particularly those caused by strong backlight-light shining toward the camera from behind the subject. If you include too much pure, bright white in your frame, all the other colors go dark. Sometimes the white will "bleed" over into the other colors. White problems are seen clearly in your viewfinder, so they're easily avoidable by moving the camera or subject or both, or by changing your lighting or scenery.

SETTING EXPOSURE ON A FILM CAMERA ISO

Check the film label to see what ISO your film is. ISO stands for International Standards Organization. The ISO number indicates the speed or sensitivity of the film. The lower the number, the less sensitive, the "slower" the film is, and the more light you need to get a usable picture. The higher the number, the more sensitive, the "faster" the film is, and the less light you need to get a usable picture.

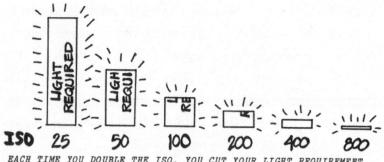

EACH TIME YOU DOUBLE THE ISO, YOU CUT YOUR LIGHT REQUIREMENT IN HALF.

Film speed may also be indicated as ASA, for American Standards Association, or EI, for Exposure Index. For all practical purposes, ASA and EI numbers are equivalent to ISO numbers.

ISO numbers progress geometrically in terms of sensitivity. Each time you double the ISO number, you halve the amount of light needed to get a usable image.

Slower, low ISO films generally produce a higher quality picture. Faster, higher ISO films, while requiring much less light, generally produce grainier, lower quality images.

Color Temperature

Make sure the color temperature of your film is the same as the color temperature of the light you're filming under. If not, put on a #85 filter to use tungsten film in daylight; or put on a #80A filter to use daylight film in tungsten light.

Remember, any time you use a filter on the camera, you're reducing the amount of light reaching the film. This means you have to have that much more light entering the lens to compensate for the light soaked up

by the filter. Since your light requirements have gone up, you've effectively lowered your ISO. Look once more at the chart above and you'll see what I mean: higher light requirement equals lower ISO number. To determine the correct ISO for the film-filter combination you're using, check the manufacturer's information sheet for that particular film.

Light Meters

Light meters measure the amount of light hitting them. Then, based on the ISO of your film and the number of frames per second you're shooting, they tell you what f/ stop to set for the best exposure of your scene.

For all intents and purposes, light meters see everything in black and white, in terms of lightness and darkness. They don't react to the color of a subject, only to its lightness or darkness.

On most cameras with built-in meters and on hand-held light meters you must manually set the ISO. The method varies, but be sure you do it. Otherwise, the meter won't know how much light your film requires and will give you incorrect exposures.

Overexposure means you let too much light in—the picture is too light, washed out. Underexposure means you didn't let enough light in—the picture is too dark.

Using a Light Meter

If you have an automatic exposure camera and you can't manually override it, all you can do is try to avoid large light and dark areas in your frame, which will throw off your exposure.

On-camera exposure meters are called *reflective* meters. They measure the light *reflected* at the camera by whatever it is you're pointing the camera at. Handheld reflective meters work the same way.

ON-CAMERA AND HANDHELD REFLECTIVE LIGHT METERS MEASURE LIGHT REFLECTED OFF THE SUBJECT.

Reflective meters work on the basis of a theoretical average subject which is gray and reflects 18 percent of the light hitting it. (You can buy an 18 percent Gray Card from Kodak.) No matter where you point it, the meter will tell you the f/stop needed to reproduce that subject as if it were 18 percent gray. This usually gives you a satisfactory exposure. However, for lighter-than-average gray subjects, you have to open up your aperture to reproduce the subject as lighter than 18 percent gray. For darker-than-average subjects, close down to let less light in and reproduce the subject correctly as darker than 18 percent gray. How much, you have to learn by experience.

For most film work, the best way to measure light is with a hand-held *incident* light meter. The incident meter has a white half-sphere which you hold in front of your subject, pointing

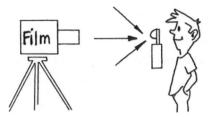

INCIDENT LIGHT METERS MEASURE LIGHT FALLING ON THE SUBJECT.

toward the camera. The meter measures the light falling on that particular spot and calculates an f/stop for an average 18 percent gray subject. (It's essentially the same as taking a reflective reading off a gray card held in front of your subject.) This gives you the correct exposure for almost any subject, since once you set your exposure correctly for 18 percent gray, all the other reflectance values fall into place. A white subject with 90 percent reflectance reproduces as 90 percent white. Zero percent black reproduces as 0 percent black. Fifty percent gray reproduces as 50 percent gray. And so on.

Normally, the only time you have to adjust an incident reading is when you want to reproduce something darker or lighter than it really is. For example, you might want to open up your aperture to lighten and show more detail in a very black face, or close down and darken a very white face to see more detail in it.

LENSES

The human eye is a wonder. With a single lens, it can concentrate on a tiny detail of a scene, excluding all else, and in the next instant take in a whole panorama. Unfortunately, the camera is not so versatile. It requires

many different lenses to even approximate the performance of the eye.

Every camera has one lens which is considered the "normal" lens. This is the lens which comes closest to reproducing objects with the same perspective as the human eye; that is, objects appear to be the same size, proportion, and distance as if we weren't looking through the camera at all, but seeing them with the naked eye. The normal lens usually includes a horizontal area of about 25 degrees.

On a 16mm camera, the normal lens has a focal length (its optical measurement) of 25 millimeters. On a 35mm camera, it's 50 millimeters long. On a video camera with a 2/3" CCD/CMOS chip, the normal lens is 25 millimeters long.

The other lenses on the camera are classified "wide angle" if they include a larger area than the normal lens, and "telephoto" if they include a smaller area.

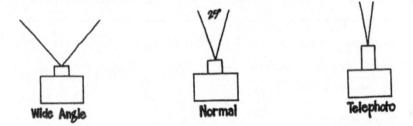

Wide angle lenses are shorter than normal lenses; telephoto lenses are longer. If your normal lens is 25mm, your wide angle might be 12mm and your telephoto 100mm.

Wide angle and telephoto lenses have special characteristics which can be summarized as follows:

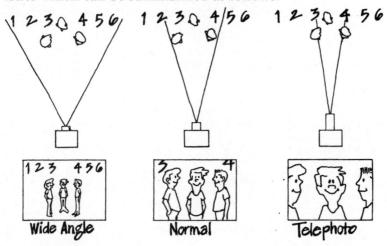

- * Includes a larger area than the normal lens at the same distance--good for cramped quarters where you can't move the camera back any farther.
- * Subject is smaller in the frame than with the normal lens at the same distance.
- * Exaggerates depthmakes elements appear farther apart than normal.
- * Because of exaggerated distances, movements toward and away from the camera seem faster than normal. Move 6 inches toward the camera and it looks like you're moving 18 inches.
- * Because of smaller image size, camera jiggles are less noticeable. Good for handholding the camera.

- * Includes a smaller area than the normal lens at the same distance--good for distant subjects where you can't move the camera closer.
- * Subject is larger in the frame than with the normal lens at the same distance.
- * Compresses depth--makes elements appear closer together than normal.
- * Because of compressed distances, movements toward and away from the camera seem slower than normal. Move 18 inches toward the camera and it looks like you're moving 6 inches.
- * Because of larger image size, camera jiggles are more noticeable. Bad for handholding the camera.

Wide angle and telephoto lenses reproduce faces in different ways:

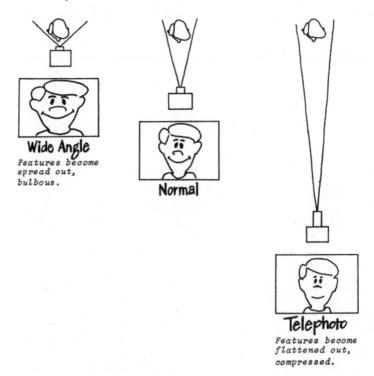

The more extreme wide angle lenses suffer from geometric distortion. Vertical and horizontal lines become curved near the edges of the frame. This is referred to as "barrel distortion."

Focus

The healthy human eye normally sees images in focus—that is, sharp and clear, not blurry. This is because the lens of the eye automatically brings each light ray to a sharp point on the light-sensitive surface at the back of the eye. The pattern formed by all these sharp points of light taken together forms a clear, sharp image.

Automatic focus cameras, which emulate the eye, don't always work the way you want them to. When you have the time, it's usually best to do the focusing yourself.

To focus a camera which doesn't have through-the-lens viewing, you measure or estimate the distance of the subject from the camera, then move the focus ring on the lens to that setting.

Focusing is easier, quicker, and surer on cameras with through-the-lens viewing systems. This is because there's no guesswork involved—what you see is what you get. All you do is look in the viewfinder and turn the focus ring on the lens till your subject looks sharp and clear. (If possible on a film camera, you should open the lens to its widest aperture for focusing—I'll explain why in the following section on depth of field.)

Some cameras have focusing eyepieces, which use little diopter rings to adjust the focus of the image in the viewfinder to the individual eye of the cameraperson. Adjustable eyepieces are especially useful for people who wear glasses but who prefer or need to shoot without them. (It's not a good idea to wear glasses when shooting with a through-the-lens film camera—light entering the viewing system from around the edges of your glasses can fog the film.)

If your camera has a focusing eyepiece, do adjust it to your eye—otherwise you'll never see a perfectly sharp image through the lens and you'll never be 100 percent sure of your focus.

To adjust a focusing eyepiece, first point the camera at a bright area—the sky, or a white wall, for example. Open the lens to its widest aperture. Throw the lens out of focus—turn the focus ring until everything is as blurry as possible. Then, on a film camera, turn the diopter ring on the eyepiece until the ground glass of the view-finder screen is in focus—until the textured surface of the screen is as sharp and clear as possible. On a video camera, adjust the diopter ring until the messages on the viewfinder screen are as sharp as possible. That's all there is to it. Now you're ready to focus the lens with complete confidence.

Zoom Lenses

Most cameras use a zoom lens, which combines a wide range of focal lengths in a single lens. By moving a single control, you can switch from wide angle to normal to telephoto, or anywhere in between, without changing lenses. This makes it a lot easier and quicker to compose your shots. If you want a little wider frame, zoom back to wide angle; for a closer shot, zoom in to telephoto.

There's a special way to focus a zoom lens. First, zoom all the way in on your subject, with the lens in maximum telephoto position. Focus the lens, even if all you see is an eyeball. Then zoom out wide and find your final framing. Your subject will remain sharp and in focus at any zoom setting, as long as neither the camera or the subject changes position. (When possible on a film camera, you should also open the lens to its widest aperture for focusing—we'll learn why in the following section on depth of field.)

"Zooming" with smart phone and tablet cameras: When you use the "digital zoom" feature on your average smart phone or tablet camera screen, you are not zooming, you are simply cropping the image produced by the device's fixed wide angle lens. You will not see any of the effects of a telephoto lens as discussed earlier. You will achieve a lower quality image, as you are filling the screen with fewer pixels.

DEPTH OF FIELD

Depth of field is simply the area in front of your camera where everything looks sharp and in focus. For example, if you're focused on somebody standing ten feet in front of the camera, your depth of field might be from eight feet to fourteen feet. That means objects falling within that area will be acceptably sharp and in focus; objects falling outside the area will be soft and out of focus.

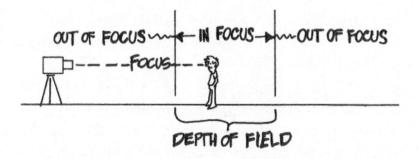

There are several important things to know about depth of field. First is this: Your depth of field decreases as you increase your focal length.* In other words, with a telephoto lens, you have a much shallower area in focus than with a normal lens. That's why with a zoom lens, you zoom in to telephoto for focusing—it makes it easier to see the exact point where your subject is sharpest.

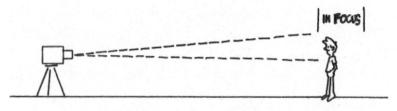

TELEPHOTO = LESS DEPTH OF FIELD

The next thing to know is: Your depth of field increases as you decrease your focal length.* With a wide angle lens, you have a much deeper area in focus than with a normal lens. This is why, when you're shooting in uncontrolled situa-

^{*} Focal length = the length of the lens measured optically, not physically.

tions with a zoom lens and don't have time to zoom in and check focus, you're better off setting an approximate focus and staying at wide angle. This will give you your best chance of keeping everything in acceptable focus.

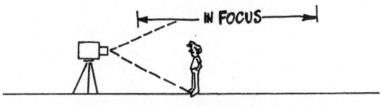

WIDE ANGLE = GREATER DEPTH OF FIELD

Another thing about depth of field: Your depth of field increases as you close down your aperture. At f/16 you have more depth of field than at f/2. When you make your aperture smaller, it's essentially the same as squinting your eyes to see something sharper in the distance. This is why on film cameras we open the lens to its widest aperture to focus: it makes it easier to see the exact focus point.

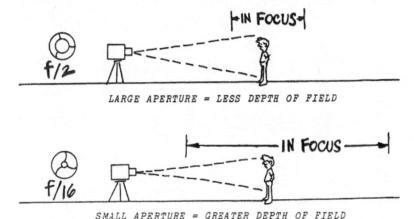

21

Next: Your depth of field increases as your subject gets farther from the camera. The farther away the subject, the more depth of field; the closer the subject, the less depth of field.

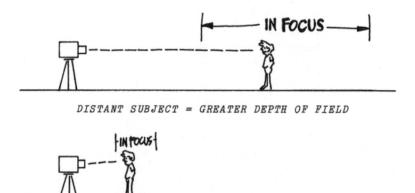

CLOSE SUBJECT = LESS DEPTH OF FIELD

Finally: You always have less depth of field in front of your point of focus than behind it. This is especially noticeable at distances of twenty-five feet or less. At these near distances, you can usually figure on your depth of field extending approximately 1/3 in front and 2/3 behind your point of focus. So, if you're working with a shallow depth of field and you want to take maximum advantage of it, focus on a point 1/3 of the way into the area you want in focus.

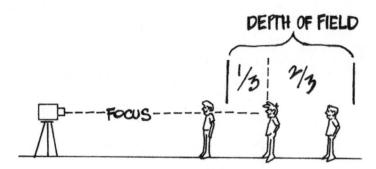

FOCUSING IN THE MIDDLE LEAVES THE FRONT MAN OUT OF FOCUS.

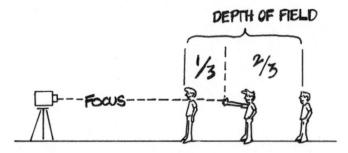

FOCUSING ON A POINT 1/3 OF THE WAY IN PUTS EVERYBODY IN FOCUS.

2 COMPOSITION

THE CAMERA-A TOOL FOR SELECTIVE VISION

The camera is a tool for looking at things in a special way. It's a window on the world which you control. Your viewers—the persons who will look at the pictures you take—will see only what *you* decide to show them. This selectivity is the basis of all camerawork.

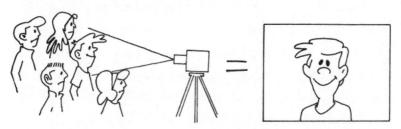

THE CAMERA IS SELECTIVE. YOU DECIDE WHAT THE VIEWERS WILL SEE

Say you're shooting a program about a high school. The decisions you as a cameraperson make will shape the reality of the school as perceived by your viewers. Leave Student A out of your frame and for your viewers she will never

exist. Include B, C, and D in a number of shots and they become important persons. Show E studying by himself and he becomes a loner. By choosing what to shoot and how to shoot it, you create your own selective version of the high school. How close your version comes to reality depends on your camera skills and how you use them. The opposite is also true; your camera skills can be used to distort reality if that's your goal.

USE A TRIPOD

To appreciate a good composition, your viewers must first see it without distractions. One of the most common distractions is camera jiggle caused by shaky handholding of the camera.

Shaky pictures are okay if you're shooting an earthquake, or if you're in the middle of a prison riot or some other precarious situation. Most of the time, though, shaky pictures are just plain annoying to your viewers. They make it harder for them to see what's happening and they remind them of the camera; they destroy the illusion that they're seeing the real thing.

In editing scenes together, the only thing more distracting than a shaky shot of a building inserted between two nice steady shots is two different shaky shots one after the other, with one shaking up and down and the other shaking side to side. Where they come together, it looks like the cut was made with a chain saw.

So use a tripod whenever possible. A good tripod, preferably with a fluid head, will give you a steady frame, make

your camera moves smoother, and keep your arms and the rest of your body from getting tired so quickly.

It's not that much trouble to use a tripod. With practice, most people can set up and level a tripod in less than 30 seconds. But, if you don't have a tripod, or you're someplace where a tripod would get in the way, or you're just moving too fast to bother with it, you can still try for tripod-like support. Use a monopod or a shoulder brace. Lean against a wall, a chair, or your assistant.

Try for at least three points of support for the camera. With a well-balanced news camera, these would be your shoulder, your hand on the grip, and the side of your head. If you can brace the elbow of your camera-supporting arm against your side, so much the better.

RULE OF THIRDS

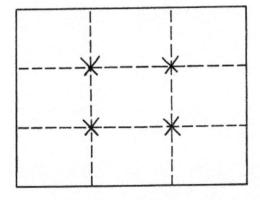

The rule of thirds is an old, old theory about composition that still works pretty well. It won't compose the picture for you, but it'll at least give you someplace to start. The idea is to mentally divide the frame into thirds horizontally and vertically. Then you place your elements along the lines, preferably with the center of interest at one of the four points where the lines cross.

Here are some examples of compositions improved by using the rule of thirds:

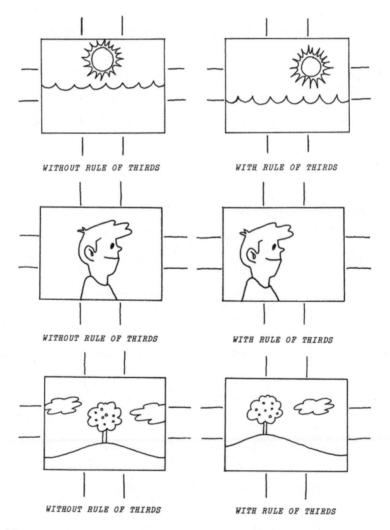

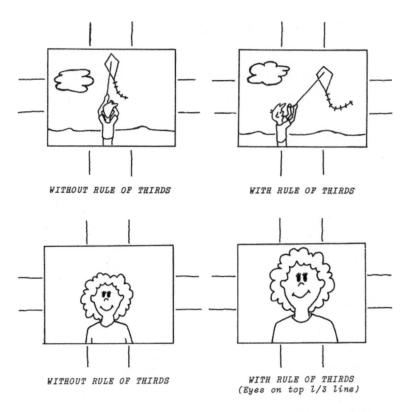

In paintings, still photos, and feature films, you'll see many interesting and good compositions that don't comply with the rule of thirds. But remember, such compositions, being more complicated, require more time from the viewers to comprehend. Their eyes will roam around more before they see what you want them to see. If you can afford to leave an unusual composition on the screen fifteen or twenty seconds or more, it can work—often quite nicely. But be sure you know what you're doing and why. For most documentary film and TV work, the rule of thirds is a good safe bet.

BALANCE-LEADING LOOKS

One of the most common errors among camerapersons everywhere is the failure to leave enough space in front of people's faces when they're looking to one side or the other.

A shot like this

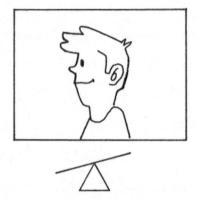

is annoying to look at. Psychologically, your viewers perceive the man as boxed in, with no place to go. By moving the frame just a little, like this,

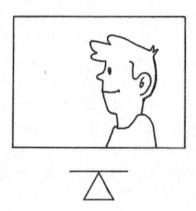

you get a more comfortable composition. You've allowed for the compositional weight of the look. This is also known as *bead room* or *lead room*.

People aren't the only things that have looks. Almost everything has a look. Some examples follow:

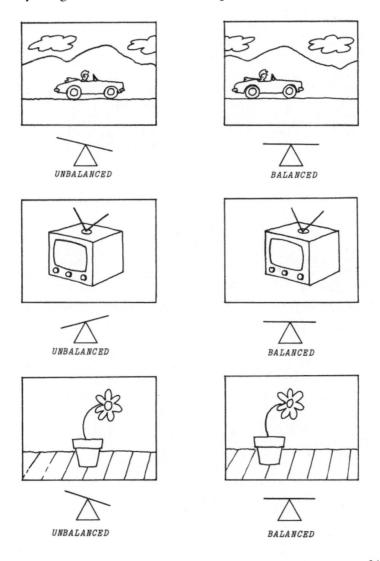

BALANCE-MASSES

Sometimes you see a scene with a large object on one side and nothing significant on the other side. Even though it doesn't look all that bad, you still feel a little uneasy about it. That's because it's off balance in terms of mass. This is most pleasantly corrected by placing a smaller object at some distance away within the frame. Visual leverage then balances the two nicely, like this:

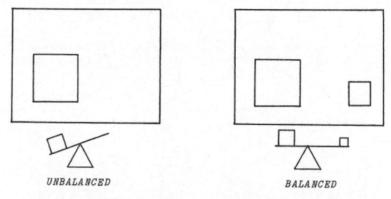

Of course you *can* balance out with another object the same size in the frame, but it usually ends up kind of static and unexciting:

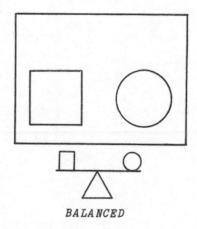

Remember, when we're balancing masses we're not concerned with the true size of things. All that matters is how big they look through the camera. Objects closer to the camera will always appear larger; those farther away will appear smaller. Depending on the camera angle, a house in the distance can balance out a man in the foreground:

Some other examples:

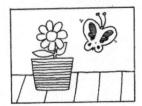

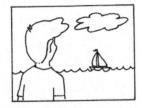

BALANCE-COLORS

The most important thing to know about colors is that bright ones attract your viewers' eyes. How often have you seen a TV interview on location somewhere and found yourself watching, not the interview, but some guy in a red shirt in the background? Your eye just naturally goes to white or brightly colored areas in the frame. Once you know this fact, you can use it to help your pictures.

First off, try to arrange your frame so that the brightest area is also the area you want the viewers to look at first. Consider the following example, where we want the viewers to look at the man:

EYE GOES TO THE WALL INSTEAD OF THE MAN

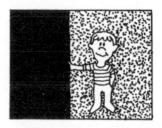

EYE GOES TO THE MAN

When you do include a bright object or area in your frame, remember that its brightness gives it extra weight in the composition—weight you have to balance out, either with another bright area, or with a larger mass.

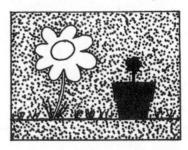

Although the masses of the flower and the pot balance out, the brightness of the flower pulls the composition to the left.

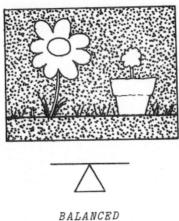

BALANCED

The brightness of the pot now balances out the brightness of the flower.

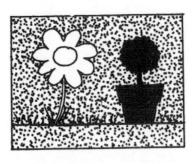

BALANCED

Here the brightness of the flower is balanced out by placing larger mass on the other side of the frame.

ANGLES

Reality has three physical dimensions: height, width, and depth. In pictures we have only two dimensions: height and width. To give the illusion of depth, we show things at an angle, so we can at least see two sides.

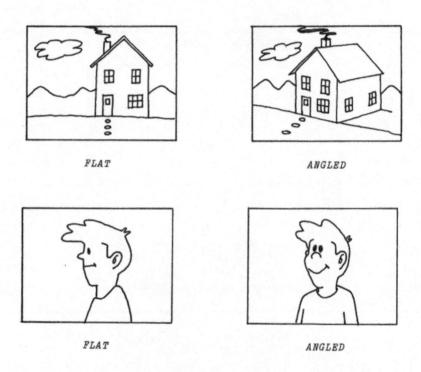

The angle created by the difference in height between the camera and the subject makes a definite impression on your viewers:

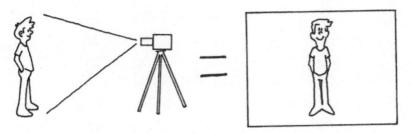

When the camera and the subject are at the same height, it gives the feeling that the viewers and the subject are of equal value.

When the camera is higher than the subject, it gives the feeling that the subject is inferior, smaller, less important.

When the camera is lower than the subject, it gives the feeling that the subject is superior, larger, more important.

By raising or lowering your camera, you can subtly influence how your viewers will perceive your subject.

This is used to great effect in horror films and political TV commercials.

FRAMES WITHIN THE FRAME

Often you can make a picture more interesting by using elements of your location to create full or partial frames within the camera frame.

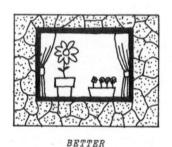

BETTER

This type of framing can also be used to hide or obstruct unwanted elements. For example, a cut tree branch held near the camera can cover up an ugly sky or a billboard in the background.

NO GOOD

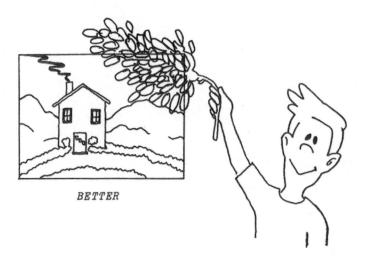

LEADING LINES

A nice way to direct your viewers' eyes to your subject is through the use of leading lines. Here are some examples:

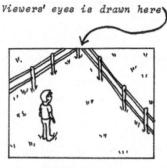

NOT VERY GOOD

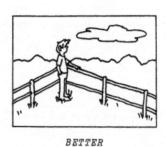

Lines of fence now lead to man.

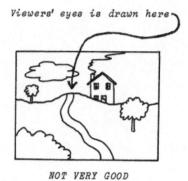

From this angle, the path leads away from the house.

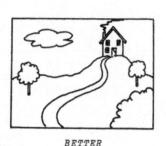

From this angle, the path leads toward the house.

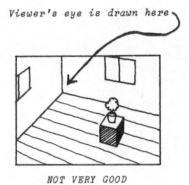

The lines lead away from the flower on the table.

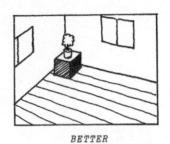

All lines now lead to the flower on the table

BACKGROUNDS

The best background is the one that stays where it belongsin the background. Unfortunately, some types of backgrounds push forward and call attention away from your foreground subjects. Let's look at some of the more common distracting backgrounds and ways to avoid them:

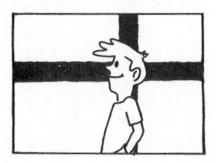

PROBLEM: Door frames, window frames, trees, poles, etc., that grow out of people's heads.

SOLUTION: Move the camera, the subject, or both.

PROBLEM: Backgrounds that are too visually busy, so full of details and colors similar to those of the subject that the subject becomes buried in the background.

SOLUTION #1: Move the camera, the subject, or both. SOLUTION #2: Move the camera far enough back from the subject so you can use a telephoto focal length. This will give you a more shallow depth of field, throwing the background out of focus while leaving the subject sharp.

PROBLEM: Unusual or persistent movements in the background.

SOLUTION: Move the camera, the subject, or both. One quick way to remove a distracting background element from your frame is to move closer to your subject, drop the camera to a lower level, and shoot up:

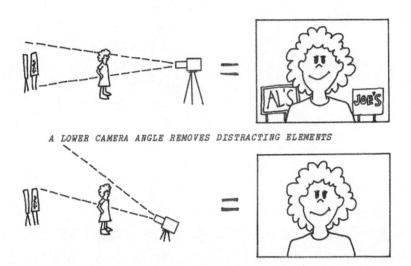

Another way to eliminate a distracting element in the background is to place either the subject or another object in the foreground to block the camera's view of the distracting element.

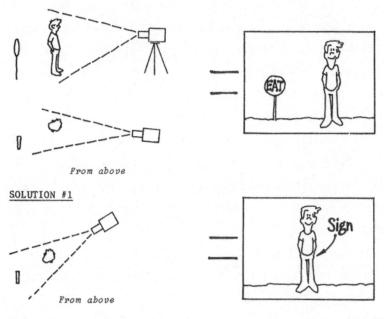

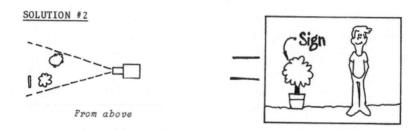

A plant placed between the camera and the sign hides the sign.

IN SEARCH OF A GOOD COMPOSITION

A common mistake made by camerapersons everywhere is to arrive at a location, set up the camera in the first clear space that looks pretty good, and go from there. If you do this, you're short-changing yourself.

Sure, go ahead and set the camera down. But then take a quick walk around. As you walk, go up on your toes, squat down, lean from side to side. Find your best angle for framing, background, color, and balance. The whole operation could take less than a minute, and it's well worth your time. If you have trouble visualizing shots, carry the camera around with you and look through it to find your angle.

Remember, you don't have to accept the location exactly as you see it. If you've got a couple minutes, you can rearrange furniture, remove distracting elements, add interesting ones—do all kinds of things to improve your composition.

Look, then look again, as critically as you can. The human eye has a tendency to cancel out unimportant details, but the camera sees and records everything equally. Think back to that "perfect" shot of a wilderness sunset you took on vacation, only to discover when you looked at it later that you had telephone wires running across the frame. When you learn to see the wires *before* you take the picture, *then* you can call yourself a cameraperson.

3 **BASIC SEQUENCE**

HOW A BASIC SEQUENCE WORKS

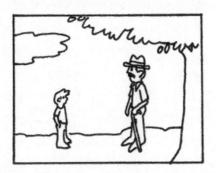

Look at this shot. Imagine that the man is talking to the boy. Let's say he talks for thirty seconds. Try looking at the picture while you count one-thousand-one, one-thousand-two, and so on, up to thirty seconds.

If you're normal, you won't get much past onethousand-ten before your eyes start wandering. Now look at the sequence of shots on the next page. Count to onethousand-five at each one before moving to the next.

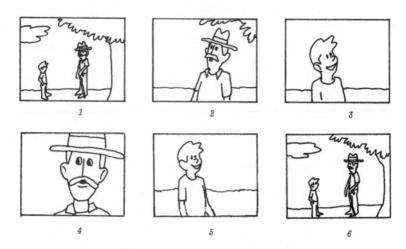

That was a lot easier, wasn't it? So what have we proved? We've proved that it's easier to look at six different images in thirty seconds than to look at one single image for the same time. That's the idea behind the basic sequence—to break up one long scene into several shorter scenes. This makes the story more interesting for your viewers. It also gives us the opportunity, in editing, to vary the length and emphasis of the story as we desire. Let's review the basic sequence we've just seen, shot by shot, and see how it works.

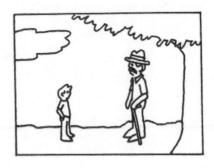

WIDE SHOT

A WIDE SHOT or ESTABLISHING SHOT is simply that—a shot that's wide enough to establish your subject in the mind of your viewers. In this particular case, we see the man, the boy, and enough of their surroundings to establish that they're in the great outdoors.

Remember, a WIDE SHOT doesn't have to show everything—just everything that's important. A WIDE SHOT of a mountain would be a landscape. AWIDE SHOT of a man writing might show only the man and his computer, eliminating from the shot the rest of his desk and the surrounding office. A WIDE SHOT of an ant would be a fraction of an inch across.

MEDIUM SHOT

CLOSE-UP

The MEDIUM SHOT and the CLOSE-UP are, like the WIDE SHOT, endlessly variable, depending on your subject and your own point of view.

Essentially, the CLOSE-UP is the tightest, the closest you choose to be to your subject. In a person, it's usually a full head shot, as shown here. The MEDIUM SHOT falls somewhere in between the WIDE SHOT and the CLOSE-UP.

CUTAWAY

The CUTAWAY is the one shot that lets you easily change the length and/or order of your sequence. It's the shot most often forgotten by camerapersons and most often needed by editors.

In our sequence of the man and the boy, let's say that instead of talking for thirty seconds, the man talked for two minutes, the middle minute-and-a-half of which was boring. So, in editing, you let the man talk for the first fifteen seconds, *cut away* to the boy listening, throw out the boring middle of the talk, then cut back to the man for the final fifteen seconds. So instead of this:

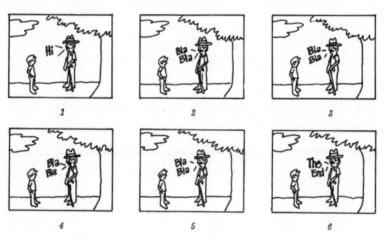

we have this:

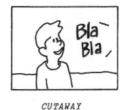

COINWA

The splice in the sound track between Scenes 1 and 6 is covered by the cutaway of the boy listening.

The most common cutaway is the shot of the reporter listening in TV interviews. However, anything can serve as a cutaway, as long as it's related to the main action, but not visually connected to it. That's the great value of a cutaway: when you cut to it, you don't have to match anything in the main shot you're cutting away from.

For example, a sequence of a man making toys can be shortened or rearranged by cutting away to shots of already completed toys on the shelves. Or the toymaker's face can serve as a cutaway from close-up actions of his hands working on the toy.

If you look hard enough, you can find a cutaway for just about any sequence you shoot. In an interview with an athlete, his photos and trophies are cutaways. If a woman is just sitting and talking to the camera, a close-up of her hands in her lap is a cutaway. An extreme wide shot, or a shot from behind, can also be a cutaway.

Cutaways can serve to enhance the story. If a man is talking about how he won an auto race, you can cut away

to footage of the race, while continuing his voice on the sound track. If an interviewee mentions a person who helped her in her career, you can cut away to a shot of that person.

SHOOTING A BASIC SEQUENCE

The most important thing to remember in shooting a basic sequence is that each new shot should, if at all possible, involve a change in both image size and camera angle. This not only makes the sequence more interesting but, as we'll see, it makes it much easier to cut back and forth between shots. Below is a diagram, from above, showing where I placed the camera for the sequence of the man talking to the boy.

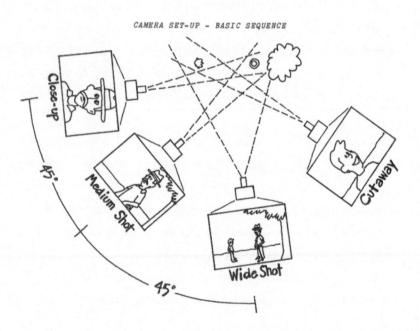

Notice that between WIDE SHOT, MEDIUM SHOT, and CLOSE-UP, I changed my camera angle by at least 45 degrees. You should always try to move your camera at least that much.

It's pretty obvious that a change in image size and angle between shots makes for a more interesting sequence. What's not quite so obvious is that it makes the transition from shot to shot smoother and easier to accomplish. With rare exceptions, most non-studio work is shot with a single camera. This means your subject has to repeat himself for the medium shots and close-ups. He's not always going to be able to remember and duplicate his actions exactly for every take. So you might end up having to cut from a wide shot where he's looking straight ahead

to a medium shot where his head is inclined slightly downward:

If you change image size and not camera angle, you'll see the man's head jerk down on the cut. This is called a jump cut.

But, if you change not only the image size but also the camera angle, you'll be home free. The combination of

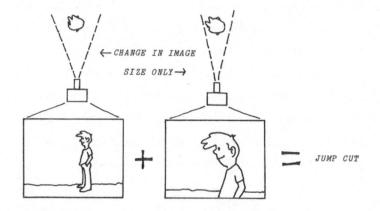

image change and angle change will alter your viewers' perspective just enough for them not to notice the slight mismatch in head position.

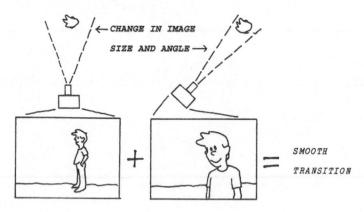

Often, you'll find that a change in image size and camera angle will cover even greater mismatches.

One special situation: When your subject is talking directly to the camera and you change camera angles, be sure to show the subject physically pivoting his body from one camera position to the other. Otherwise, the abrupt change in background will confuse your viewers. If you prefer, in the editing, you can cut on the action of the turn. They do this every night on your local news show when the anchor turns to a new camera and says, "On the local scene . . ."

CUTTING ON THE ACTION

A good way to get smooth transitions between shots is to cut on the action. Your viewers' eyes naturally follow movement on the screen. If a movement begins in one shot and ends in the next, your viewers' eyes will follow the action right across the cut, without paying much attention to anything else.

Let's say that the man in our original basic sequence takes off his hat. We shoot the wide shot down to the point where he completes the action of removing his hat. Then we set the camera up for the medium shot, and have him begin the medium shot by repeating the action of removing his hat.

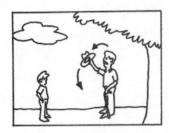

WIDE SHOT

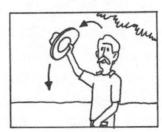

MEDIUM SHOT

Then, in the editing, we CUT ON THE ACTION, so that he starts removing his hat in the wide shot and completes the removal in the medium shot. Without even realizing it, your viewers are carried smoothly from one shot to the next.

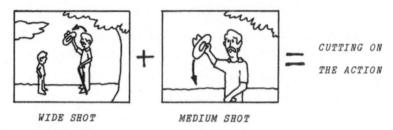

There are lots of obvious situations where it's convenient to cut on the action. For example: opening doors, getting out of cars, sitting down, standing up, reaching for objects, walking, running, jumping—almost any kind of movement. The important thing to remember is that the last action of the first shot has to be repeated at the beginning of the second shot. So you have to shoot the same movement twice. This is called overlapping action.

CLEAN ENTRANCE / CLEAN EXIT

Having a clean entrance and a clean exit is almost as good as having a million different cutaways. Clean entrances and exits give you terrific flexibility in your editing. Let's say for example that you are shooting an explanation of the controls on a complicated piece of equipment. Your master shot—the one where you keep the camera running for the whole explanation—looks like this:

As the man explains the different buttons, he touches them and turns them. When you've finished the master shot, move in for close-ups of the different knobs. Start each shot showing only the knob on the machine. Then have the man's hand come in (CLEAN ENTRANCE), fiddle with the knob, and go out again (CLEAN EXIT), leaving once more just the knob in the frame.

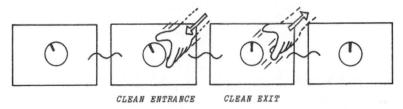

So what does this do for us? Well, first off, if you cut to the knob, wait a beat, then have the hand enter, you don't have to worry about matching the position of the man's hand from the wide shot to the close-up, because when you cut to the close-up the hand isn't yet in the frame.

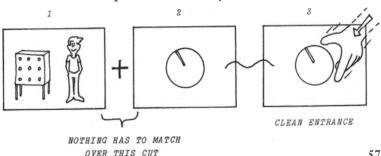

Secondly, let's say you decide after the shoot that you only have time to explain the most important controls and you're going to have to eliminate some of the middle explanations. Easy as pie. Just go to a close-up of the last knob before the section you want to eliminate, let the hand exit cleanly, wait a beat, then cut to the wide shot, picking it up after the dropped section. Since you're cutting from a close-up of the knob without the hand, nothing has to match when you go back to the wide shot at a much later point in the explanation.

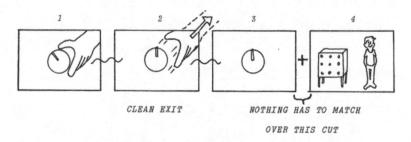

If you think about it, you can see there are many ways this sequence could be rearranged by taking advantage of the clean entrances and exits of the hand.

Let's look at another example. Say you've got a wide shot of a car driving by and you have to cut to a different shot of the same car, but the background is different. If you just cut from one shot to the other, the change in backgrounds will be very noticeable. But, if you let the car exit the frame in the first shot, hold a beat, then cut to the new shot with a different background, it'll work. By not seeing the car for a second or two, the audience will accept that it had time to get to a different place for the following shot.

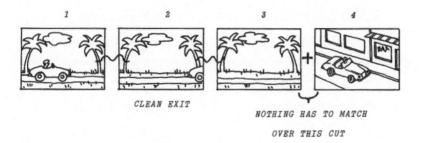

Or you could accomplish the same thing by cutting to the new shot without the car there, waiting a beat, and then letting the car make a clean entrance.

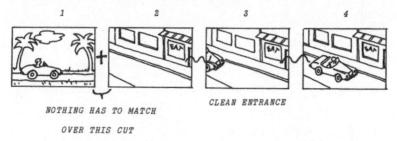

Clean entrances and clean exits are very helpful in getting people quickly from one place to another. Say you have a sequence of a boy walking into his house and upstairs to his room. Rather than follow him all the way up with the camera, just show him walking in the front door (CLEAN EXIT), wait a beat, then cut to his room as he enters it (CLEAN ENTRANCE).

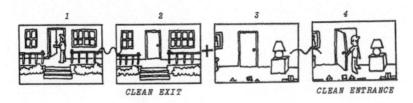

Clean entrances and exits are good for almost any kind of shot where somebody or something is moving from one place to another, picking something up, putting something down, hitting, pulling, selecting, etc. Whenever you have anything moving through your frame, particularly in a close-up, you'll be doing yourself a big favor by giving it either a clean entrance or a clean exit, or both. This will always allow you greater freedom in your editing.

SOME FINAL WORDS ON BASIC SEQUENCES

Only amateurs and some geniuses plan on making every cut a match cut. The more you cover yourself with changes in image size, changes in camera angle, cutaways, overlapping actions, and clean entrances and clean exits, the better your final product will be.

Remember, any still photographer can shoot a bunch of pretty shots, but only a real cameraperson can shoot a *sequence*.

4 SCREEN DIRECTION

SCREEN DIRECTION AND CROSSING THE LINE

Screen direction is the direction people and things face when viewed through the camera.

Have you ever been watching a conversation on TV between two people when suddenly the scene changes and it looks like one of them is talking to the back of the other's head? That's called reversed screen direction. The cameraperson causes it by CROSSING THE LINE.

The line is also known as the axis of action, or simply the axis. By whatever name, it's an imaginary line which determines the direction people and things face when viewed through the camera. When you cross the line, you reverse the screen direction of everything you see through the camera, even though nothing has moved but the camera. In our sequence of the man talking to the boy, the line would intersect the man and the boy:

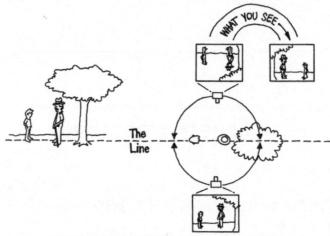

CROSSING THE LINE REVERSES YOUR SCREEN DIRECTION

As long as the camera stays on the front side of the line, the man will be looking screen left and the boy will be looking screen right. If you cross the line, they'll be looking in just the opposite directions, although they haven't moved at all. Now, this is really no problem, as long as you stay on one side of the line or the other. But you can't go jumping back and forth.

Say you make your wide shot from one side of the line, like this:

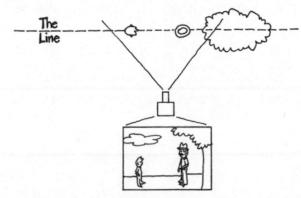

Then, for some reason, you shoot your cutaway of the boy from the other side, like this:

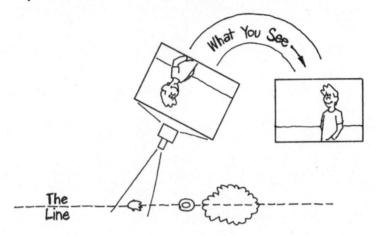

When you cut them together, you get this:

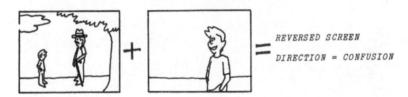

It looks like the boy has turned completely around, with his back to the man!

Let's take another example, a person working at a computer. See what happens when you cross the line.

It looks like she's got her head twisted on backwards!

There are circumstances in which you have to cross the line, whether you want to or not. Maybe your subject's body is blocking a new detail you need to show.

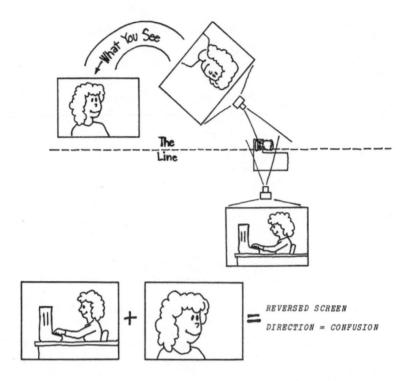

Maybe part of your sequence just looks better from the other side of the line. Maybe you have no control over your subject's movements. Whatever, don't fear. There are ways to cross the line without confusing your viewers.

The easiest way is when your subject changes direction on camera, within the frame. You stand still, and the line actually crosses under you. For example, a car turning around. Or a person turning from a friend on his right to a friend on his left. As long as the change in screen direction is made on camera, there's no confusion.

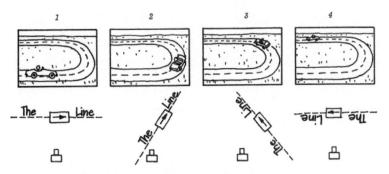

CROSSING THE LINE - SUBJECT CHANGES DIRECTION ON CAMERA

Another way is to cross the line in one continuous move with the camera. In uncontrolled situations, this is sometimes your only recourse. Say a race car mechanic is working on a car and he moves so you can't see what he's doing. All you can do, if you want the shot, is to keep the camera running and walk around to where you can see what's going on:

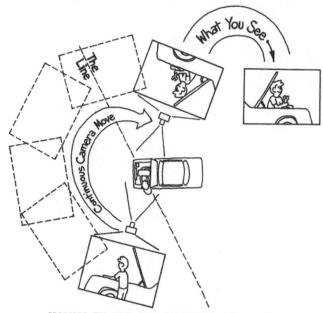

CROSSING THE LINE IN A CONTINUOUS CAMERA MOVE

You see this type of shot frequently in TV commercials and feature films. It's usually done with a dolly—a camera platform on wheels. Low budget productions can make this kind of move using a wheelchair or even a skateboard to simulate a dolly.

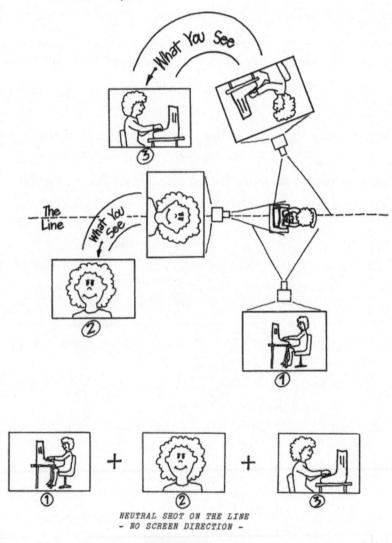

Sooner or later we all get in a situation where we're finishing up shooting a sequence and we *know* we've jumped back and forth across the line. No matter what the reason, we've got to figure some way to save the day. This is where my favorite line-crossing method comes in handy. It's based on a simple truth: *you can cross the line if you stop on it*. You can go from one screen direction to another if you put a neutral shot with no screen direction in the middle. As long as you have at least one neutral shot as a bridge, you can cross the line. (See diagram on opposite page.)

You'd be amazed at the mileage you can get out of one or two good neutral shots.

One neutral shot which doesn't always occur to everybody is the POV, the point-of-view shot. In the sequence of the woman typing, the point-of-view would be a shot of the computer screen from the point of view of the typist.

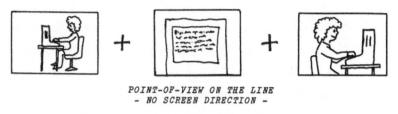

CROSSING THE LINE WITH A POINT-OF-VIEW SHOT

Often you can fake a point-of-view shot after your subject has left. For the closeup of the computer screen, who says you have to use the same person, if you don't see her hands in the shot? Or, if you need to show hands, you can still use another woman with similar hands.

There are two other ways to cross the line which, though not perfect, are certainly better than nothing.

First is the situation where you have a clean point of reference to help the viewers orient themselves a little. In a lot of old movies, you'll see a wide shot of people going up a gangplank to a ship, followed by a medium shot from across the line. The argument here is that the gangplank serves as a reference for the audience to hold onto.

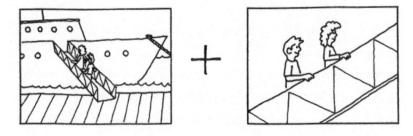

CROSSING THE LINE WITH A REFERENCE

Other common references which can ease a reversal in screen direction are sidewalks, roads, hallways, tables, cars, boats—anything that's in both shots and has a clearly defined direction of its own. Please note: this does not make a perfect cut, but it's better than nothing.

The other not-so-perfect way to reverse screen direction is to cross the line at the same time as you cut on the action. The idea is that the continuity of action over the cut will psychologically cover the reversal in screen direction.

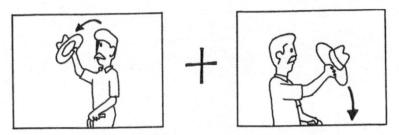

CROSSING THE LINE BY CUTTING ON THE ACTION

Again, it's not perfect. But in a pinch, it's better than nothing.

USING SCREEN DIRECTION TO SOLVE SHOOTING PROBLEMS

As we learned earlier, screen direction is the direction people and things face when viewed through the camera. It's determined by the axis of action, the line. When you cross the line, you reverse your screen direction, even though nothing has moved but the camera. The corollary to this is: As long as you don't cross the line, as long as you keep the same screen direction, you can move people, things, and camera anywhere you want. This can help you solve many shooting problems.

Let's say you're shooting an interview with a well-known naturalist. Since he'll be talking about the wonders of the great outdoors, it would look best if he were in an outdoorsy setting. But for reasons of time and money, you have to shoot in his suburban backyard. After a quick reconnoiter of the backyard, you find your best location and select two camera positions:

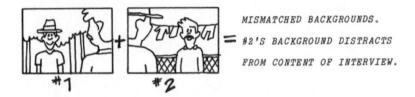

From Position #1, you can do your wide shot over the shoulder of the reporter, as well as medium shots and close-ups of the naturalist—all with lush trees in the background. So far, so good. But, when you move around to Position #2 for your shots of the reporter, you see an ugly fence and the neighbor's clothesline in the background. Not exactly the lush natural setting you'd like.

The solution? After you've finished with all of your shots of the naturalist from Position #1, pivot the

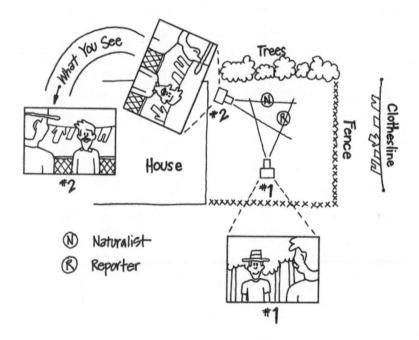

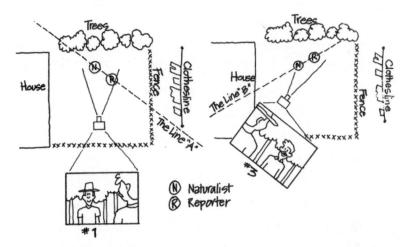

naturalist and the reporter counter-clockwise so that the trees are now behind the reporter, who is still facing screen left.

You see, you haven't crossed the line. You've merely pivoted it—and your subjects—from Position A to Position B. As long as you stay on the same side of the line and keep the same screen direction, you can move the line anywhere you want. In fact, in a pinch, you could even shoot the reporter's close-ups—without the naturalist—at another place and time!

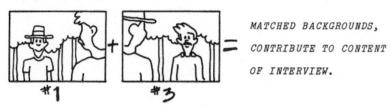

Aha, you might say. It still won't work because we *know* there's a fence behind the reporter and not trees. Well,

maybe we know it, but the viewers sure don't. All they know is what they see on the screen. Screen geography has nothing to do with real geography. Nothing exists for your viewers except what you show them. Once you understand this, you can work wonders.

You won't always have to go the extremes illustrated by this example. Sometimes it's just a matter of moving or pivoting your subject a few feet one way or the other to get a better shot. Remember, as long as you keep the same screen direction and everything else matches, you've got nothing to worry about. I've moved people closer to windows to get better light on close-ups, put them in different rooms to get better backgrounds; once, in a very tight situation, I shot five different angles without moving the camera, but moving the subjects instead—and it worked!

5 CAMERA MOVES

The basic camera moves are ZOOMS, PANS, TILTS, and combinations thereof.

In general, a ZOOM-IN (from wide shot to close-up) directs our attention to whatever it is we're zooming in on. So if you zoom in, try to zoom in on something interesting or important.

A ZOOM-IN DIRECTS ATTENTION

A ZOOM-OUT (from close-up to wide shot) usually reveals new information. Often it tells us where we are.

For example, you can start on a close-up of a man's face talking about flowers, then zoom back to reveal that he's surrounded by flowers.

A ZOOM-OUT REVEALS NEW INFORMATION

PANS (horizontal moves) and TILTS (vertical moves) also reveal new information.

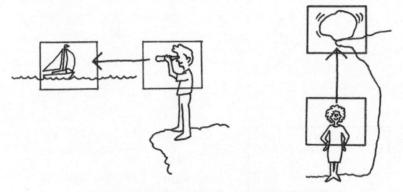

PANS AND TILTS REVEAL NEW INFORMATION

One caution about pans. If you pan too fast, vertical lines, like fenceposts, doorframes, etc., will strobe on you, trailing ghost images behind. When in doubt, pan a little slower.

An effective way to lead your viewers through a long pan is to follow a smaller object—a person walking, a car perhaps—as it passes by your subject. For example, a wide shot pan across the front of a building is much more interesting with a person walking by, leading the move.

MAKING CAMERA MOVES

The first rule of camera movement is this: begin and end every move with a well-composed static shot. It's very distracting to cut from a static composition to a move that's already in progress. Likewise, to cut from a move to a static. Oh, you can do it, and sometimes it works when you want to create a feeling of excitement and action. And you can dissolve between static shots and moves, visually blending one scene into another, with good results. But why limit your options? If you're going to make a move, hold it steady for a beat or two at the beginning, ease into your move, make the move, ease gradually out of the move, and hold for a beat or two at the end. You'll be glad you did when you start editing.

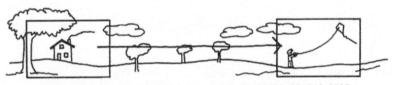

BEGIN AND END EVERY MOVE WITH A WELL-COMPOSED STATIC SHOT

The other rule of camera movement is this: always move from an uncomfortable position to a comfortable position. This is especially important in pans, when you're moving in a wide horizontal arc. Have you ever seen a cameraperson start to pan with a passing car and, as he follows the car by, slowly twist himself into a quivering pretzel? He's starting with

his muscles relaxed and then twisting them into a tense, unnatural position. For the smoothest possible move, you should be doing just the opposite. You should get comfortable in your end position, then twist around into the beginning position. That way, when you make the move, your muscles will be relaxing, untensing, returning smoothly to their natural position. You'll be moving from uncomfortable to comfortable, smoothly, naturally. This is true of any move, not just pans.

MOVE FROM UNCOMFORTABLE TO COMFORTABLE

There's a tendency among camerapersons, especially beginners, to be continually moving the camera—zooming in, zooming out, panning left, panning right, tilting up, tilting down. I guess they feel they're not earning their money if they just hold the camera still. They're wrong. A camera move should have a purpose. It should in some way contribute to your viewers' understanding of what they're seeing. If it doesn't, the move distracts and calls attention to itself.

Camera moves limit you in your editing. If the only shot you have of a certain subject is a zoom and the zoom lasts fifteen seconds, but you only have five seconds of narration to go over it, you're stuck. Either you leave the whole move in, and your viewers sit bored for ten seconds of silence, or you cut in and out of a five-second piece of the zoom, which is visually jarring. The safe thing to do is shoot your move, then cover yourself with a couple of static shots of the same thing. You'll be glad you did when you start editing.

One final tip. I've found that when combining a zoom with a tilt or a pan, it works smoother if I start the pan or tilt just a fraction of a second before the zoom. I don't know why it works better this way, but it does.

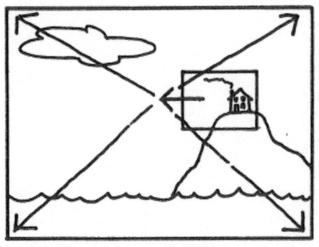

ON COMBINED MOVES, START THE PAN OR TILT A FRACTION OF A SECOND BEFORE THE ZOOM.

6 **MONTAGES**

A montage is a series of related shots used to condense time or distance, set a mood, or summarize information. For example, a montage of highway signs, a montage of pretty nature shots, or a montage of company products. Most TV commercials are montages.

For a montage to work, it's usually best if each shot is clearly different from the one before it; otherwise it looks like a bad cut between two similar shots of the same thing. If you shoot an employee montage with everybody framed the same, it will look like one face changing abruptly into another. But if you shoot a variety of angles and image sizes, the effect can be very nice.

AN INEFFECTIVE MONTAGE - THE SHOTS ARE TOO SIMILAR

AN EFFECTIVE MONTAGE - EACH SHOT IS DIFFERENT

An easy way to make a nice sign montage is to tilt each one a different way. For some reason, these are called Dutch tilts.

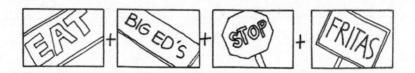

7 LIGHTING

EXTERIOR LIGHTING

The most powerful and common source of light is the sun, but for film and TV it has one big disadvantage: it's always moving. It traces an arc across the sky, east to west, horizon to horizon, every day. This means that the angle at which sunlight is falling on our subjects is also constantly changing. Most people look their best in sunlight when the sun is no higher than about 45 degrees above the horizon. When the sun is higher, around the noon hour, it casts ugly shadows on faces. Eye sockets go dark and little shadow "beards" show up on chins and under cheekbones and noses.

PEOPLE LOOK BEST IN SUNLIGHT FALLING AT ANGLES OF 45 DEGREES OR LESS. THE NOONTIME OVERHEAD SUN CASTS UGLY SHADOWS.

Most exterior shots are made with the subject facing the sun, so it illuminates him directly. Sometimes, though, this isn't possible or desirable. Perhaps the location doesn't permit it; or maybe the sun is bothering your subject's eyes; or maybe your subject looks really nice with the sun behind him. So you end up shooting with backlight or sidelight. Both conditions cast strong shadows on your subject's face.

SIDELIGHT AND BACKLIGHT CAST STRONG SHADOWS

The shadows cast by backlight and sidelight can be filled in—brightened up with light—in two ways: *reflectors* and *fill lights*.

A *reflector* is anything which reflects light. It's normally a board covered with silver paint or foil. But it can also be a white poster board, or a white wall, or a piece of canvas. You use the reflector to bounce sunlight into the shadow areas where it's needed.

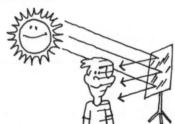

REFLECTORS FILL IN SHADOW AREAS WITH BOUNCED SUNLIGHT

Any light can be used as a *fill light* outside, as long as it puts out daylight-colored light, with a color temperature of 5400K. The lamp can be 5400K, or it can be 3200K-tungsten, with a dichroic filter or a blue gelatin sheet in front to convert it to 5400K.

One disadvantage to using a fill light instead of a reflector is that you need electricity to power it—from a battery, a portable generator, or an extension cord. Another disadvantage is that, in order to match the tremendous brightness of the sun, you either have to bring the fill light in very close to the subject, or else use a very powerful fill light, requiring a lot of electricity.

The advantage to a fill light is that, unlike a reflector, it's not directly dependent on the sun. You can place it anywhere you want, at any angle you want, for the best lighting effect and for maximum comfort of your subject. The fill light is especially useful in completely backlit situations where a reflector may shine a glare right into your subject's eyes.

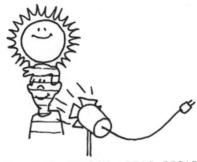

A FILL LIGHT BRIGHTENS UP SHADOW AREAS REGARDLESS OF WHERE THE SUN IS.

A fill light is the best way to brighten up the shadows cast by the noontime overhead sun. And on overcast days, a light shining directly on your subject can stand in for an absent sun and give your pictures needed brightness and contrast.

INTERIOR LIGHTING

Three basic types of lights, using tungsten quartz halogen bulbs, are traditionally used in interior lighting: *focusing quartz*, *broads*, and *softlights*.

(More modern versions of these same lights using LEDs, flourescent bulbs, or HMI bulbs are more energy-efficient and operate more coolly. In terms of lighting technique, however, they all work the same—except that LEDs and flourescents generally put out less light than quartz bulbs and HMIs put out more light.)

The *focusing quartz light* is the movie and TV version of the theatrical spot light. It's the most common, versatile light in use. By moving a lever, you control the intensity and pattern of light it puts out. The range is from "spot" to "flood." At "spot," you get a small, concentrated area of light. At "flood," you get a spread-out, less intense area.

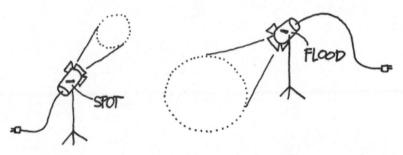

FOCUSING QUARTZ LIGHTS RANGE FROM SPOT TO FLOOD.

One caution on using focusing quartz lights: don't count on getting a smooth, even pattern of light at every setting. Even at full flood you may find a hot spot or two. Before doing any really critical lighting, your best bet is to shine each light on the wall or the floor and run it through the whole range from spot to flood, noticing the light pattern at each setting.

Quartz lights, even on flood, put out a hard, direct light. This produces sharp-edged dark shadows, which are not always desirable, especially in people shots. To diffuse the light—to spread it out and produce softer, more flattering shadows—we can do one of two things: either put diffusing material, like spun glass, in front of the light; or bounce the light off a reflector-type surface, like a white wall or ceiling, or a silver-coated space blanket taped to the ceiling. Both methods work well, but they also reduce the amount of light reaching the subject.

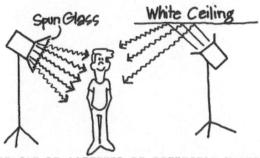

QUARTZ LIGHT CAN BE SOFTENED BY DIFFUSION MATERIAL IN FRONT OF THE LIGHT, OR BY BOUNCING THE LIGHT OFF A RE-FLECTOR-TYPE SURFACE.

Broads are non-focusing lights designed to put out a broad even light over a large area. They have no fine-tuning controls.

All you do is turn them on and point them. The hard, direct light from a broad, like that from a focusing quartz, can be softened with diffusion material or by bouncing.

A BROAD LIGHT PUTS OUT A FLAT EVEN PATTERN OF LIGHT

A *softlight* is a permanent, portable bounce light. It consists of a curved scoop, the inside of which is white or silver-colored. A broad-type lamp is mounted facing the scoop, so that its light bounces off the curved surface and out towards the subject.

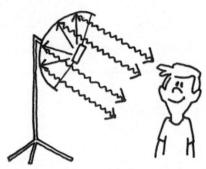

A SOFTLIGHT IS A PERMANENT, PORTABLE BOUNCE LIGHT

The advantages of a softlight over a bounced light are convenience—you can use it anywhere, with no need for a wall or ceiling to bounce off—and control—it's easier to

direct the light exactly where you want it. However, it does take up more space.

Most lights, be they focusing, broads, or softlights, come with barn doors. These are little black flaps which are used to block off light from areas where you don't want it, to shape the pattern of light you put out. They are very useful.

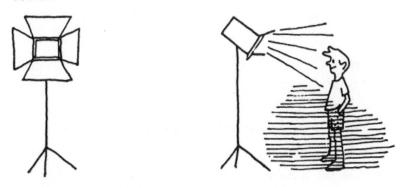

BARN DOORS SHAPE THE PATTERN OF LIGHT

BASIC LIGHTING SETUP

The classic basic lighting setup is as follows:

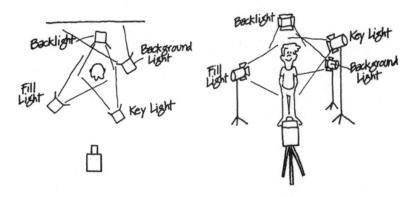

First you place your key light (some call it the "main" light) to one side of the camera and at about a 45 degree angle above your subject. This is your main light, the basis for the rest of your lighting setup.

Unless you have a good reason, no area in your frame should be brighter than the area lit by the key light. Your viewers' eyes are always attracted first to the brightest area of the frame. If that turns out to be the background, then your lighting isn't working the way it should; or it's working in a special way, which you should be aware of.

Set up your fill light on the opposite side of the subject from the key light. The fill should be bright enough to partially fill in the shadows from the key, leaving just enough shadows on the subject's face to give a feeling of depth. (Completely shadowless lighting is called flat lighting and gives less sense of depth.)

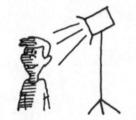

KEY LIGHT ALONE = HEAVY SHADOWS

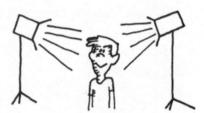

KEY + FILL = JUST ENOUGH SHADOWS FOR FEELING OF DEPTH

Next, place your backlight. This falls on your subject's head and shoulders from behind, creating a rim of light which visually separates him from the background. The backlight is especially useful when the subject's hair or clothes are similar in color to the background.

THE BACKLIGHT SEPARATES THE SUBJECT FROM THE BACKGROUND.

Last but not least, place your background light. This brings the background up into the same range of illumination as the rest of the scene and gives an added sense of depth. As a general rule, it's a good idea to have your background a little darker than your key area.

Well, you say, so now I know how to light one person. But how do I light two or three or more? And what happens if they start moving around? Well, you multiply the basic setup. You place a key light for every important area, then start building. It gets complicated, but if you just take it one step at a time you'll do all right.

Often you'll find you can cover more than one subject with the same key light. Or that the fall-off from one subject's key light can serve as fill light on another subject. A single broad can provide backlight for several people.

To avoid multiple, unnatural-looking shadows on walls, keep your lights high and your subjects away from the walls. Keep in mind that shadows are less noticeable on darkcolored walls than on light-colored ones; so, sometimes a change of scenery can solve a lighting problem. Also, film shows more shadow detail than video; so for TV, you'll have to throw more light into your shadow areas.

In the last few years, a lot of camerapersons—myself included—have begun lighting entire scenes with bounce light. It's not dramatic lighting; but it is quick and efficient, and it looks natural in a lot of situations.

Really good lighting for TV and film is an art in itself. Please don't take the basic lighting setup as gospel. Like the rule of thirds in composition, it's a place to start—no more, no less.

The best advice I can give you for your first few lighting jobs is to be methodical. Go slow. Put up one light at a time and watch what it does. If you do get confused at some point, turn off all your lights. Then turn them on again one at a time, so you can see what each is doing and regain control.

8 SOUND

VIBRATING BODIES CREATE SPHERICAL SOUND WAVES

The sounds we speak are created by air from our lungs, passing over and vibrating the vocal cords in our necks. Every sound, whether it be a human voice or a tree falling in the forest, is caused by something vibrating. When an object vibrates, it moves back and forth in the surrounding air, creating waves which move outward, very similar to

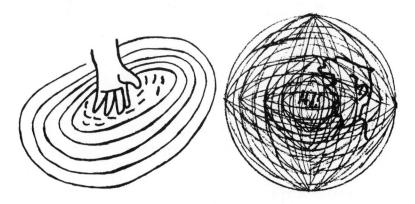

Water waves travel horizontally.
Sound waves travel spherically outward from the source.

waves rippling away from fingers wiggling in a pond. The main difference is that while water waves primarily travel outward horizontally on the pond surface, sound waves travel outward in all directions, spherically.

The human eardrum is a thin membrane which vibrates when sound waves reach it. These vibrations are converted to nerve impulses and sent to the brain, where they are translated into sounds we "hear."

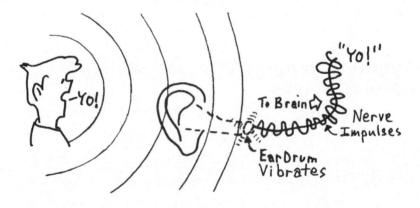

We "hear" the vibrations caused by sound waves.

Microphones are imitations of our ears. Every microphone has an "eardrum," called a diaphragm, which vibrates when hit by sound waves. The vibrations are then converted to an electrical signal which can be broadcast or recorded. Loudspeakers are microphones working in reverse: electric signals vibrate a diaphragm to create sound waves.

The ear, and the microphone, can tell one sound from another by how close together the sound waves occur, and

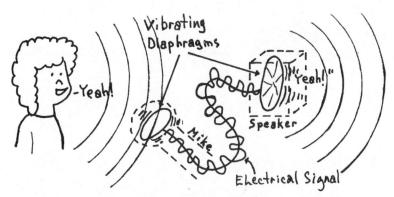

Microphones and loudspeakers imitate the human ear.

how big they are. The closeness of the waves is called the sound *frequency*; the size is called *amplitude*, which we perceive as loudness.

Sound frequency is measured in the number of complete waves, or cycles, that occur each second. Since the words "cycles per second" are not the same in all languages, it was decided to express frequency in Hertz, abbreviated Hz. (Hertz was a German physicist who discovered electromagnetic waves.) 60 Hz means 60 cycles or sound waves per second.

The higher the frequency—the number of waves or cycles per second—the shriller the sound. The lower the sound frequency, the lower or deeper the sound. Most human speech vibrates at frequencies between 80 Hz and 10,000 Hz, with most of the significant sounds occurring between 200 Hz and 2700 Hz. The average person can hear sounds from around 20 Hz to approximately 20,000 Hz.

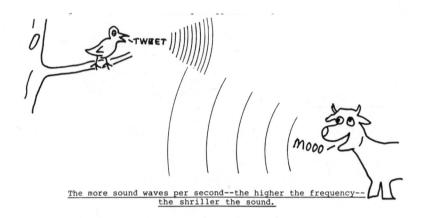

The size of a sound wave—its amplitude—is determined by the intensity of the energy which creates it. As with pond waves, if you hit the water hard, you make a bigger wave; so if you shout you make a bigger sound wave than if you whisper. Our ears perceive the amplitude of a sound wave as loudness.

Sound intensity or loudness is measured in decibels, abbreviated dB. Most audio equipment uses VU (Volume Unit) meters to indicate the strength of a sound signal, as measured in dB. Zero dB on a VU meter is set at a scientifically determined sound level—close to where the average human can just *not* hear a 1000 Hz tone. Each increase of 3 dB indicates a doubling of the sound intensity. So 6 dB is twice as loud as 3 dB and 9 dB is four times as loud as 3 dB.

MICROPHONES

Film and video productions commonly use two basic types of microphones: dynamic, and electret condenser. Both have diaphragms or membranes that vibrate when hit by sound waves. Both then convert the vibrations into electrical signals.

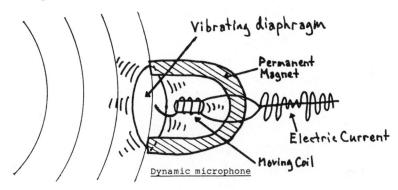

In a dynamic microphone, the vibrating diaphragm moves a coil of wire inside a permanent magnet, creating an electric current. The current varies according to the strength and frequency of the sound waves moving the diaphragm. Dynamic microphones are very rugged and can produce excellent sound. They're sometimes called moving coil microphones.

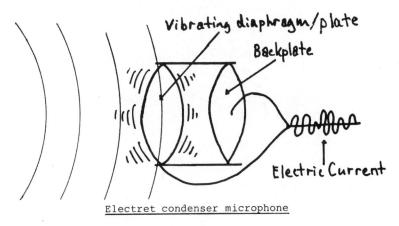

The diaphragm of an electret condenser microphone is actually one plate of a condenser, or capacitor. The diaphragm/plate and another plate hold an electric charge between them. As the diaphragm vibrates to sound waves, changing the distance between the two plates, a tiny electric current is created, varying according to the sound waves. A battery supplies power to amplify the signal to a usable level.

Because, unlike dynamic mikes, they don't contain heavy permanent magnets, condenser mikes can be made very small and lightweight. They can produce excellent sound. However, they do require batteries, which wear out and die. So carry backups.

Microphone Pickup Patterns

A microphone's pickup pattern is the area in which it is most sensitive to incoming sound waves. There are two basic types of pickup patterns, omnidirectional and directional.

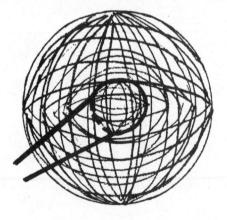

Omnidirectional pickup pattern

An omnidirectional mike picks up sound equally well from every direction. This is the most common pickup pattern; it looks like a sphere with the microphone at the center.

The two most common types of directional pickup patterns are the cardioid and the supercardioid, or shotgun.

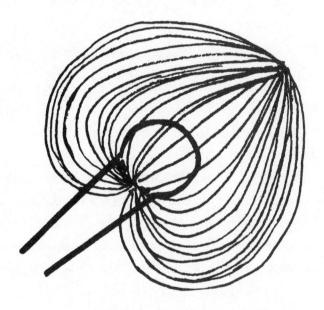

Cardioid pickup pattern

"Cardioid" comes from the Greek word meaning "heartshaped." A cardioid pickup pattern looks like a heart, with the pointed end indicating the area of greatest sensitivity, directly in front of the microphone.

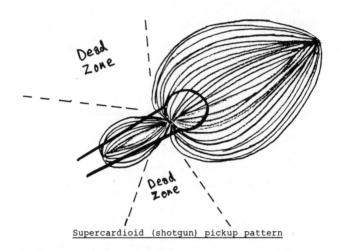

The supercardioid mike is also called a shotgun mike; this is because the area of sensitivity is so narrow that, to pick up the correct sound, you have to aim the microphone like a shotgun directly at the source.

To eliminate or reduce unwanted sound hitting a directional microphone, angle the mike so the dead zone—the area of no sensitivity—is pointing at the unwanted sound. For example, tilting a supercardioid slightly upward, as pictured above, points the dead zone toward the floor, eliminating reflected sound from that direction.

Types of Microphones

Film and video productions use three common types of microphones. From smallest to largest, they are the lavalier, the hand mike, and the shotgun.

The *lavalier* is a small, electret condenser mike, normally designed with an omnidirectional pickup pattern. (Some lavaliers have cardioid pickup patterns.) Lavalier

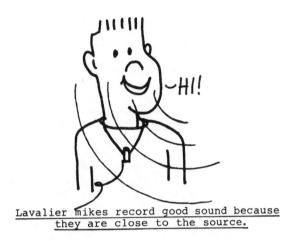

mikes are designed to be worn on the chest of the speaker, either hung by a cord, or attached with a clip. Placed so close to the sound source—the speaker's mouth—they provide a very strong signal.

Sometimes you'll want to hide a lavalier mike under a tie or shirt. This presents two problems. First, any movement of clothing across or near the mike will be picked up; so use tape to hold the mike firmly in place, and don't hide it behind noisy materials, like silk. Secondly, anything you cover the mike with is going to block some of the incoming sound waves; so use porous, loose-knit material, like wool or cotton, that lets most of the sound through.

If you use a lavalier loose, off the chest, be aware that it will boost the higher frequencies, making voices sound shriller than normal. When a lavalier is worn on the chest, as it is designed to be, the boost compensates for the lack of high frequency voice tones under the chin. The all-purpose *band mike* is the most versatile and widely used in the industry. It can be either dynamic or condenser, with either an omnidirectional or a cardioid pickup pattern.

With a stand, it can also be used as a desk or platform microphone.

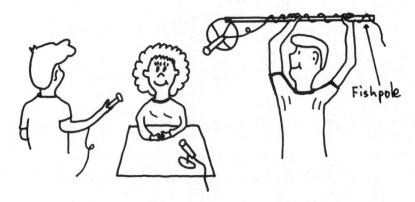

The all-purpose hand mike is the most versatile mike.

The *supercardioid* or *shotgun mike* takes its name from its pickup pattern, discussed above. It's a great mike to use for distant sounds or in uncontrolled situations, like television news coverage. It's also very useful on a boom or fishpole in controlled situations, such as dramatic productions.

The great advantage of the shotgun mike—its superdirectionality—is also its greatest disadvantage. While it accepts sounds only within its narrow cone pickup pattern, it accepts *all* the sounds within that cone, in front of and behind your subject. A shotgun mike will pick up the voice of a man standing on the sidewalk across the street; unfortunately, it will also pick up the sound of cars passing in the foreground and the voices of people walking behind him.

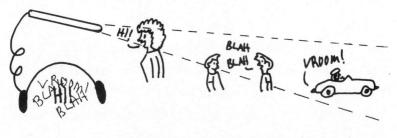

Shotgun mikes pick up everything in the direction they're pointed.

In responding to lower frequencies, below 250 or 300 Hz, the shotgun mike's pickup pattern is essentially cardioid. This means it picks up a lot of traffic noise, machine rumbles, and similar sounds. Most shotguns have a bass cutoff switch to filter out these frequencies.

Shotgun mikes are sensitive to sound echoes—reverberation. If you use one in a "live" room—one with lots of echoes—they'll only worsen the problem.

Microphone Selection

Remember your viewers. Use the microphone that, under the circumstances, will best capture the sound you want your viewers to hear.

The surest way to get good, clean sound from one person talking is to use a lavalier mike. Complications arise

when you want to hide the mike: rustling clothes, muted sound. Multiple miking—putting lavs on several people at the same time—also complicates the procedure. When using several microphones, try to have only one microphone "open" or on at a time.

For a spur-of-the-moment walking street interview with a politician, an omnidirectional hand mike is best—not because it gives the best sound, but because it gives the best sound under the circumstances. It's almost impossible to *not* record something usable with an omnidirectional hand mike.

For uncontrolled documentary shooting, a shotgun is the microphone of choice. With it, you can record understandable, usable sound at any distance, from an inch to infinity. The sound may not always be perfect, but you'll have something to work with.

The shotgun, used on a boom—an extendable armlike microphone holder—can provide excellent sound for rehearsed, dramatic programs, or any other circumstance where a number of people are talking from known positions. The shotgun's pickup pattern is so narrow that exact aiming is absolutely essential.

If I could have only one mike for all situations, I'd choose a dynamic hand mike with a cardioid pickup pattern. Dynamic for durability. Cardioid for the pickup pattern—selective but not too selective; you can be a little off in aiming and still cover the sound source. This mike works well as a hand mike, as a desk mike, and as a boom or fishpole mike.

Smart Phone and Tablet Microphones

The built-in mikes on smart phones and tablets are usually electret microphones with omnidirectional pickup patterns. They are designed primarily to record human voices at close distances, which they do very well. For better and more controlled sound recording, use an external mike.

SOUND WAVES BOUNCE

From the source, spherical sound waves travel straight out in all directions. When they hit a hard, non-porous surface, they bounce—like waves hitting the edge of a swimming pool.

Since sound waves bounce, you can bounce or reflect unwanted sounds away from your microphone. The most typical example is to position a subject's body between the unwanted sound and the microphone. Other objects, like sun reflectors, work just as well.

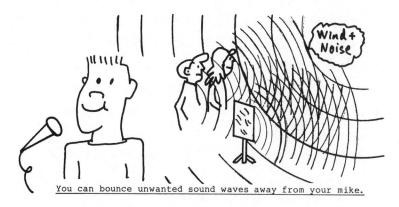

A surface composed of many smaller surfaces facing different directions is said to be porous. When sound waves hit a porous surface, they bounce back and forth, getting smaller and smaller, in the same way pond waves disperse when they flow into a patch of reeds. Foam rubber, like that used in microphone windscreens, and thick felt are good examples of porous surfaces. Extremely porous surfaces, which completely eliminate sound waves, are said to be sound absorbent.

Sounds in any enclosed space, like a room, are reflected back and forth many times, getting progressively smaller and quieter as they die away, or decay. The total effect of the reflected sound waves is called *reverberation*. If a room is dead, with no reverberation, sounds die quickly, with no decay; they seem muffled and dull. In a well-designed sound studio, with good reverberation, sounds decay smoothly and quickly. A room with too much reverberation produces echoes—repetitions of the original sound.

A dead room can be livened up by adding hard reflective surfaces—tables, plastic screens, pieces of glass—and removing porous items, like upholstered furniture. If you can't remove off-camera porous items, cover them with slick plastic sheets.

Excessive reverberation, or echo, can be muted by filling the room with many different surfaces—furniture, boxes, people—at different angles to each other. Cover hard surfaces with porous materials. Put carpet on the floor.

RECORD CLEAN SOUND

As a general rule, you'll record cleaner, richer sound if you use a separate sound recorder. Record your sound as closely and as cleanly as possible, with the broadest possible frequency range. Resist the temptation to filter or modify the frequency response of the sound as it is recorded. You can always cut frequencies later, but you can't add them when you never recorded them in the first place. One exception: bass cutoff filters on shotgun mikes to eliminate traffic noise and other low-frequency noise.

If at all possible, use the same microphone or the same type of microphone to record all of an individual's lines, no matter when or where you record them. The difference in sound quality from one type of mike to another can be noticeable and distracting.

Just as a good monitor is important for judging your images, so a good pair of sound-isolating headphones with a broad frequency response is important to judge your sound. Sound-isolating headphones completely surround the ears and let you hear only what you are recording.

When deciding how to frame a shot, consider not only the visual elements, but also sound. Sometimes a slight change of camera angle can greatly reduce a wind or noise problem. Moving a prop or piece of furniture can make it possible to get a mike closer to an actor. Modifying the route an actor walks through the set can make it easier to follow him with a boom mike.

WILD EFFECTS

Whenever there is a noticeable sound effect in a scene, such as a car starting, a door slamming, a machine running in the background, take a few extra seconds to record the same sound closeup, without picture. These effects are called *wild effects*, different from *sync effects*, which are recorded at the same time as the picture. Wild effects can substitute for sync effects that are low or muddled. They also add depth and continuity to your picture; unrelated shots of workers come alive and tie together when you add appropriate sound effects and background noise.

Closeup wild effects stand out; they add texture to your program. And, since they are clean and isolated, you can control them completely in the mix. As with pictures, you'll do yourself and your editor a big favor if you slate all your wild effects, either by voice or—on video—visually.

You can do lots of things outside the camera frame to improve the quality of your sound. Put carpet on the floor. Hang blankets to reduce reflected sound. Use extra people as human windbreaks. If background and screen direction match, you can move an actor to a different, quieter area for the closeups.

When recording sound around professional movie and television lights, don't let your mike cords run parallel and close to electrical cables—this will put a hum on your sound track. If you must lay a mike cord across an electrical cable, lay it at right angles; better still, raise it up on a bridge made from a box, a stool, or a chair.

RECORDING VOICES AND PRESENCE

Syncsound is sound recorded in synchronization with the camera, such as a person talking on camera. **Voice-over** is

a narrative *voice* heard *over* the picture but not seen. When the same person is heard in syncsound and voice-over, try to record all the lines with the same mike and in the same place, so the quality of the voice will be consistent in the final program. If the syncsound is recorded in a noisy location, record the voice-over at the same time but in a place nearby that's quieter.

If you record voice-over after the shoot, try to record the voice-over at the same time of day as you recorded the syncsound. People's voices change noticeably over the course of a day; the same voice recorded in morning and afternoon can sound like two different people.

Presence, or **ambience**, is the sound of a location without any single sound predominating. For example, factory presence would be the muddle of different sounds you'd hear while standing in the middle of an assembly line. Lonely beach presence would be wind, waves, and bird noises.

If you're recording dialogue, presence is the sound between the words. Whenever you finish recording your last dialogue scene at a particular location, leave the recorder set at the same level, tell everybody to hold still, and record thirty seconds of presence, preceded by an audio slate. This serves several purposes in the mix.

First, presence serves as an audio bridge to ease the transition when you cut from one location to another, or from syncsound to voice-over. Fade in extra presence before a cut, then fade it out afterward. This will smooth out sudden changes or cutoffs of background presence.

Presence can be used to fill the holes when you space out narration. You may think a studio recording is perfectly quiet, but if you lengthen a narrator's pause by a few seconds and leave the pause completely noiseless, you'll notice it. You need the recording booth's presence to fill the space. Location presence is even noisier and more needed to fill in these open spaces in the voice track.

A presence recording helps in the cleaning up of sound tracks. For example, voice tracks recorded with air conditioner hum in the background are a common problem. Playing a continuous loop of the A/C presence, you can equalize (raise or lower selected frequencies) the sound track until you find the air conditioner frequencies and lower or eliminate them. You can then process the voice track through the same equalizer settings, filtering out the air conditioner noise. (Sometimes the A/C and the voice share frequencies, so you have to put frequencies back in to make the voice sound natural.)

VOICE-SLATE AND KEEP A SOUND LOG

If you record double-system sound, with a separate audio recorder, voice-slate everything you record. A voice-slate is a recorded description; without it, you have to guess what's on the audio. For syncsound, the traditional clapstick slate provides both a voice-slate ("Scene one, Take one!") and a common audio-visual sync point when the clapstick closes (CLAAAK!).

Keep a sound log, listing everything you've recorded, in the order you recorded it. This will help you quickly locate recorded material later, for use in editing. When shooting single-system video, you can either combine your sound log with your camera log, or keep a separate sound log, depending on the needs of the production.

As with the camera log, the sound log includes as little or as much information as you want to put in it. I recommend noting at least the scene and take number, the mike and recorder used, the location, time code if applicable, and a description of the sound recorded. Circle or otherwise mark the numbers of the good takes.

REMEMBER YOUR VIEWERS

The purpose of your program should be to get your viewers to react in a certain way. Keep this in mind when deciding what sounds to record and how. If you want to communicate a positive feeling about an industry you're filming, record people talking in quiet areas; if you want to make your viewers uncomfortable, record workers shouting to be heard over a clamorous assembly line. If you need to present the assembly line in a positive way, show it with the sound mixed low under an off-camera narrator's voice; or consider dubbing the assembly line workers' voices. In the same way, you can make an office seem more chaotic by adding extra background telephones, file drawer sounds, and voices in the mix.

THE BEST SOUND RECORDING ADVICE I CAN GIVE YOU

Record your voices, sound effects, and presence separately and cleanly. This will give you maximum flexibility in your mix.

9 **DOING IT**

PLANNING AND SHOOTING A SEQUENCE

When planning a shoot, the first thing is to decide what you want to end up with. What sort of story do you want to tell? Who will be your audience? How do you want them to react? What things should you emphasize? What should you downplay? Keep all this in mind as you look over the location and talk with the people you'll be working with.

Next, make a shooting plan, even if it's only in your head. Decide where your camera and subjects will be for each shot. For relatively short sequences, your best bet is to shoot the whole thing all the way through in a wide shot, then repeat it in a medium shot, and again in a close-up. Then shoot your cutaways. This method takes up additional time on the set and can use up a lot of film, tape, or other media, but you can be sure you'll have material for editing. It's probably the best way to shoot your first few projects.

Later, after you have a better understanding of what you're doing, you can try shooting all the way through in a wide shot, and then just repeating certain sections for medium shots, close-ups and cutaways. At this stage of the game, you'll have to start thinking about *slates*.

A *slate* is simply a piece of identification, whether on a fancy clapboard or a scrap of paper. When you have many different shots to piece together in the editing, you need some way to quickly tell one from the other. That's what slates are for. You write a scene number or a description on the slate, hold it in front of the camera, and run off a second or two of it before you shoot the scene.

Slates are wonderful things. They never forget, even if you do. Any time you have the slightest doubt that the editor might not know what a scene is or where it goes, use a slate to provide the necessary information. You should do this even if you're going to edit everything yourself. In the first place, it's good discipline. It forces you to think about how the pieces are going to fit together. Secondly, who wants to spend half an editing session wondering where this scene goes or where that one goes, when a simple slate would tell you in a second? Also, if you number various takes of the same scene, you can go immediately to the one marked best on your location notes, and not waste time reviewing bad takes. For more complicated shoots, seriously consider keeping a camera log with detailed scene and take descriptions.

SHOOTING SCRIPTS AND STORYBOARDS

Often it helps to make up a *shooting script*. This is simply a list of what you're going to shoot and how you're going to shoot it. For example:

VIDEO	AUDIO
1. WIDE SHOT. Salesman by car.	SALESMAN: Hiya folks. Let me tell you about the new Zootmobile!
2. MEDIUM SHOT. Salesman. PAN as he moves to sticker on window.	This car is the greatest! And cheap? I'll tell you it's cheap! Look at this sticker!
3.CLOSE-UP. Sticker.	25,000 drachmas! And that's including tax, tag, and dealer prep!
4.WIDE SHOT. Salesman by car.	So come on down and buy one today. Okay? Okay!

Sometimes you can visualize better what you're going to shoot if you make up a storyboard. A storyboard is a series of simple drawings—you can do them with stick figures—representing the shots you plan to make. Drawing a storyboard is like a free practice shoot—and it doesn't use up any film or tape! For example:

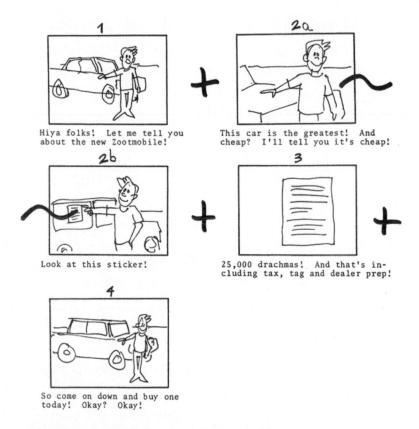

SHOOTING OUT OF SEQUENCE

For some sequences, especially those involving a lot of lighting changes, there are advantages to shooting the scenes out of sequence-out of order.

Say, for example, that only the first thirty seconds and the last fifteen seconds of your sequence need to be shown in a wide shot. What you do is, set up for your wide shot, shoot the first thirty seconds, cut, then jump ahead and shoot the last fifteen seconds right then, without moving the camera. This way you're finished once and

for all with that camera position. Now you can move your lights, microphones and everything else around for your other shots. And you don't have to worry about putting everything back again for the end wide shot—because you've already shot it!

Take another example. Say you have a sequence consisting of four scenes. You decide that Scenes 1 and 3 will be shot from Camera Position A. Scenes 2 and 4 will look best from Position B. If you have control of the situation, it makes a lot more sense to shoot Scene 1 from Position A, stay there and shoot Scene 3; and then move to Position B for Scenes 2 and 4. That way you move the camera one time. If you shoot the scenes in their natural order, you'll move the camera three times: From A for Scene 1 to B for Scene 2 to A for Scene 3 to B for Scene 4.

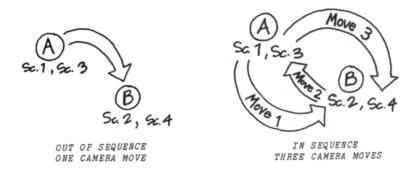

When circumstances allow, you can save a lot of time and energy by shooting out of sequence. Just remember to plan well, and don't forget your slates and camera log!

COMMUNICATING

Everybody has his or her own philosophy of working. I'd like to make a small pitch for mine.

I believe in communicating. I try to let everybody, from my assistants to the people who will appear on camera, know what we're going to do. Before we start, I discuss the shooting plan, ask for suggestions, and let everybody look through the camera. I try to get across the idea that we're all on the same team and we're going to have fun. Most of the time, we do.

Of course, I also make it understood that, for the shoot to go smoothly, somebody has to be in charge—and that somebody is me. But since by this point everybody knows what we're doing and why, mine can usually be a benevolent dictatorship.

WORKING IN UNCONTROLLED SITUATIONS

Sooner or later you'll find yourself working in a totally uncontrolled situation. If you're a television news cameraperson, you'll be doing it every day. But you can still use what you've learned in this book.

You can always try for a decent composition. You can construct basic sequences by regularly changing your camera angle and image size, and by grabbing cutaways wherever you can—even if it's the old standby of a closeup of another cameraperson. You can maintain your screen direction—and cover yourself with neutral shots when you cross the line. You can let your subject enter and exit the

frame cleanly. You can still shoot great sequences—you just have to hustle more to get them.

Shooting in uncontrolled situations can be exciting and fun, especially when it's all over and you know that in spite of everything you've got footage that works.

10 AFTER THE SHOOT—EDITING

THE HUMAN EYE AS EDITOR

The eye "edits" automatically by focusing on what interests it. Let's go for an imaginary drive in your car. First you see a medium wide shot ahead of the road. Then you "cut" to a close-up of the speedometer and gauges. A quick medium shot to the right as you glance at your passenger. A zoom-in to a warning sign coming up. Get the idea? We see in terms of basic sequences.

Our angle of view is about 25 degrees:

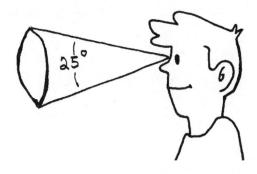

The basic shot our eyes give us has an angle of view approximately 25 degrees wide. This is equivalent to what you see through the standard 50mm lens on a traditional 35mm still camera or a full frame digital camera. Through sideways peripheral vision, we can sense movement outside the 25 degree area but not visualize clearly what's there.

Here's an experiment to demonstrate the principles of editing. Find a room that has lots of visual interest—lots of things in it. Ask a friend to stand as far from you as possible while reading the next section aloud. Face your friend and follow the instructions exactly.

BEGIN EXPERIMENT—YOUR FRIEND SHOULD READ THE FOLLOWING ALOUD

"Look straight ahead and try to see as much of me and the room as you can. This is your establishing shot. Notice that as you change your area of interest, without moving your head, you can shift first to a medium shot of me from the waist up, then to a close-up of my face.

"As I *slowly* walk to my right, zoom back to a wider shot. Now, without moving your head, shift your eyes right for a cutaway of something else in the room. You can do all this comfortably.

"When I say 'GO,' move your whole head quickly to the left and look at what's there. GO! When I say 'GO,' move your head quickly to the right and notice what's there. GO!

"Each time you move your head quickly, you should feel a moment of softness, of perceptive hesitation, as your brain rushes to drink in the new visual information and absorb it. The fast image change makes your brain play catch-up.

"Now, when I say 'GO,' move your head *slowly* to the left and look at what's there. GO!

"When I say 'GO,' move your head *slowly* to the right and look at what's there. GO!

"When you move your head slowly, the new visual information is introduced gradually. Your brain has time to absorb it as it is introduced. When you finally get turned sideways, the image is complete in your mind.

"When I say 'GO,' cover your ears with your hands, count to three slowly; then remove your hands. GO!

"Now close your eyes. Without opening your eyes, move your head to your right. Look down. Now, open and close your eyes as fast as you can. What did you see? Now open your eyes and leave them open. Do you see anything now that you missed before?

"One last experiment. Look at your watch on your wrist. Now, without moving your head, move your wrist up and down rapidly and try to read the watch label. Now hold the watch still and read the time."

END OF EXPERIMENT

This is the essence of editing. In the experiment your friend *controlled* what you saw and heard. She «edited» your reality. As a film or video editor, you edit the reality of your viewers—you control the window through which they see and hear the world of your program. Your choices of pictures and sounds determine how well your message gets across, and

how the viewers react to it. The principles demonstrated in our experiment are the basic principles of editing.

To communicate clearly and tension-free, don't surprise your viewers. Use an establishing shot to show them where everything is. Keep the camera still unless there's a reason to move it. Remember how easy it was to focus on wide shots, medium shots and closeups of your friend without moving your head?

Give your viewers new images and sounds slowly enough for their brains to absorb them. If possible, lead into camera moves by following a known object moving within the frame, such as your friend walking across the room in our experiment. Use camera moves that *ease* in and *ease* out—remember the difference between moving your head fast and moving it slow?

If you present totally new information, give your viewers a little extra time to absorb it and feel comfortable with it. Remember opening your eyes for just a fraction of a second, then holding them open longer? You needed that extra time to absorb the new information.

In some circumstances, particularly in dramatic programs, you *want* to send a muddled message or create tension. You want to make the editing style itself part of your message. To do this, you deliberately surprise your viewers. You push unfamiliar images and sounds on them faster than their brains can absorb them. You cut to new scenes without clear establishing shots. You cut quickly from one shot to another. You make fast, jerky camera moves. You

use unsteady camera frames, blurred images, indistinct or distorted sound. These are all valid techniques, as long as they are intentional, and not simply bad work on your part.

READ THE SCRIPT. DIVORCE THE DIRECTOR.

Beginning editors want to jump right into cutting. This is a mistake. First, read your script and make sure you understand perfectly how your viewers are supposed to react to the program. Base all your editing decisions on the question, "Is this the best way to make my viewers react the way I want them to?" As you work, visualize your viewers watching each cut.

Start the editing process by divorcing yourself from the person who directed the program, even if that person is you. Think of him or her as some stranger whose ideas and shots you will judge strictly on their own merit. Look at the script and the pictures and sounds as if for the first time. If you were the director or cameraperson, it helps if you can schedule the end of shooting and the beginning of editing a few weeks apart.

I've seen many programs weakened in the editing because a director was personally attached to a concept, a shot, or a sequence that simply didn't work on the screen. This usually happens when the director can't separate the idea or the shot from the attached memories.

Remember all those ideas you, as director, had about how certain scenes would be edited together? Remember how you stayed up late working out concepts in your head, then overslept and missed breakfast? Forget everything except the ideas. Consider them fresh, as if someone else had thought of them. Then, if they don't work, throw them out. So you lost some sleep and missed breakfast; what has that got to do with getting your viewers to react in a certain way? Nothing. It's excess baggage; throw it out.

Remember how much trouble you had getting that one incredibly beautiful shot? Look at it now as simply a shot that either works or doesn't work toward your program's goals. Your viewers don't care how much trouble you had getting the camera into position and waiting for just the right light; they don't care that it took you two months to get permission to film at that location. That's all off-screen; all that matters is what the viewers see on the screen, in the window that you control. If a shot doesn't work there—if it doesn't move your viewers the way it's supposed to—toss it.

GOOD LOG = GOOD EDIT

Log all material with as much detail as possible, either in the field with a logger program or later before you start editing. In your descriptions, use consistent key words, like identifying every scene as "Scene #_." Use the same abbreviations, like "MS," "LS," etc. Try to use the same descriptive terms, like "good" to describe usable takes and "NG" for no good takes. If you have a script, use key words from the script in your log descriptions.

I suggest you spend as much time as possible viewing and reviewing before you start cutting. The better you know your pictures and sounds, the more effectively you'll be able to edit them together.

When you start to edit, use your video editing program's search function to find only usable takes. For example, search for "Scene #23, Joe, MS, good," and you'll call up only clips whose log entries contain those words. Don't waste time on bad takes.

PAPER EDITS

Unscripted sequences and programs are the most fun to edit, because they're actually written in the editing. As you view the material, make a detailed log (or add your own notes to a copy of the camera/sound log). Look for your most powerful pictures and sounds—save them for the beginning and end of your program and to liven up the middle. Look for connections between scenes—similar colors, moves, sounds, dialogue. Then do a paper edit.

A paper edit is a script constructed from cut-up sections of an editing log. You arrange and rearrange your material on a big table or the floor until it works as a script. (You can use a computer word processor or spreadsheet to do a virtual paper edit on screen, but you won't have the same big work space as you would working with actual paper slips.)

Think of yourself as a scriptwriter who is reconstructing a wonderful script that somehow got cut into pieces

and mixed up. Use all the techniques of style and shape and texture that a scriptwriter would use. Design a program that makes your viewers react the way you want them to. Then tape together all the sections in their new order and proceed to edit, using the paper edit as you would a formal script.

A good paper edit makes it possible for a documentary to move your viewers as well or better than the most tightly scripted dramatic program.

Please, *please* don't make the mistake of editing a documentary or other unscripted program without a good log and a paper edit. You will waste a lot of time and probably find yourself at two o'clock in the morning with five minutes remaining in the program and no material left to fill it with. That's the beauty of a paper edit; it lets you make the most of what you've got.

ESTABLISH YOUR PROGRAM'S WORLD, THEN RE-ESTABLISH IT

As an editor, your first priority is to establish the world of the program for your viewers, to introduce them to this new reality and make them comfortable in it. If they are wondering where they are, they're not thinking about your message. Show them an establishing shot within the first few shots of a sequence.

Narration or dialogue can serve just as well as a visual to let your viewers know where they are: "As we look through a high-powered microscope, we can see the virus . . ."

The establishing shot shows where everything is.

Previous, related shots can help establish a new location: after several sequences about biological labs, your viewers will assume that a white-coated person shown in medium close-up is another lab person, even without another wide shot of a lab.

If your viewers are already familiar with the subject, they can figure out where they are based on less information from you. For example, a program for mechanics on engine rebuilding can begin with the engine already out of the car; you can assume your mechanic/viewers will know immediately what an engine is and where it came from.

After you establish, re-establish frequently. Editing is a sequential process, one scene after the other, always moving forward. Most people can't remember the visuals of more than two or three scenes back. A series of closeups,

with no visual reminders of screen geography, can disorient your viewers and suck them into a perceptual tunnel; they'll spend more time trying to figure out where they are than paying attention to what you're telling them. So cut back to a wider shot from time to time to remind your viewers where everything is. This will keep their feet on the ground and their attention on the contents of your program.

LOOK FOR BASIC SEQUENCES, THEN USE THEM

If the director shot basic sequences, use them. A basic sequence—cutting back and forth between related shots in the same location—mimics the way your viewers see life around them every day. It communicates information better than a series of unrelated scenes, each coming as a surprise to your viewers.

If no basic sequences were shot, look for pictures and sounds that can be edited together in the form of basic sequences. For example, a series of interviews with teachers at a school, all shot in similar locations with similar camera framings, and with no cutaways. Rather than cut from one head-and-shoulders shot to the next, find cutaways to put between them. Let's say Teacher #1 talks about science classes, while Teacher #2 talks about student discipline. Finish Teacher #1's comments off-camera over a shot of students working in a lab. Start Teacher #2's comments over the same shot, then continue with Teacher #2

on camera. The shot of the students is a natural cutaway for both interviews, as well as a natural link. The final effect is of one continuous interview with a cutaway, rather than two separate talking heads.

THE GREAT UNDERLYING RULE OF EDITING: MAKE SURE EACH NEW SHOT IS DIFFERENT

Imagine yourself at a wedding reception, moving down a receiving line that's so crowded you can just barely see the person in front of you. After being introduced to a man and shaking his hand, you move down one person—and meet the same man again! Well, actually it's his identical twin. When you meet the second twin, you do a double take. Why? Because you were expecting each person in line to look different. In your momentary confusion, you have to ask the second twin to repeat his name. The same phenomenon applies to editing.

Each time you cut to a new shot, your viewers expect to see something different. If the new shot is very similar to the old shot, they are momentarily confused and their attention is jarred away from your program's content. Therefore, as a general rule, each new shot should be clearly different—in content, framing, or both from the previous shot. The elements of a basic sequence—wide shot, medium shot, closeup, and cutaway—while similar in content, must be clearly different in framing and camera angle or they won't cut together smoothly.

PACING-HOW FAST THINGS CHANGE

Pacing is the rate at which you change your pictures and sounds. A good editor gently leads his or her viewers from shot to shot without distracting them from the program's content. If the content of your program is totally interesting to the viewers, do nothing; no one got bored looking at that single camera shot of the first men on the moon.

There are only two reasons to change your pictures and sounds: to better communicate your program's message, or to keep the viewers' interest. Never cut just to be cutting. The general rule is to stay with a shot as long as it's effective in getting your message across or keeping your viewers interested, then cut to something new. To know when to cut, you have to know your viewers and how you want them to react.

A good editor anticipates his or her viewers. Before the viewers can begin to drift away, the editor shows them a new reason for staying. The editor does a dance with the viewers' attention, giving a gentle tug from time to time to keep them in step with the program.

To give something importance, show it longer. This is the visual equivalent of drawing out a phrase in conversation. For example, "a hundred dollars" said quickly is peanuts; but "A HUHHHHHHNDRED DAWWWWWWWWWWWWWARS" is a lot of money. A sequence about dental hygiene will have more impact if you linger a beat or two on a closeup of a decayed tooth, rather than skip quickly past.

To give something importance, show it more often. Repetition works. How well would you know your multiplication tables if you hadn't repeated them umpteen times? Show a safety technique one time, and your viewers might remember it. Show it a second or third time, in slightly different ways, and they will remember it better.

If you're presenting new or complicated information, cut slower; give your viewers more time to absorb your message. If you cut to a new scene before your viewers totally understand what's on the screen at the moment, you'll frustrate them. For example, an introductory film on any subject should be more slowly paced than an intermediate film on the same subject; the intermediate information will already be somewhat familiar to your viewers.

USE AN APPROPRIATE EDITING STYLE

The goal of any video program should be to make your viewers react to the program's content or message the way you want them to. Style is the way you deliver that content or message to your viewers.

Your editing style is determined by the pictures and sounds you select, the order in which you present them to your viewers, and how fast you change from one picture or sound to the next—pacing.

Your editing style should complement the style already established by your script, the director, and the cameraperson. If your program is well-written, well-directed, and well-shot, follow the editing rules I've discussed: establish and

An appropriate style delivers the message without distracting.

re-establish, use basic sequences, make every new shot different, and match your pacing to your viewers' interest. If you do this, your editing style will be invisible and your viewers will get your program's message loud and clear.

If the material you're given to edit is less than perfect, you can make it work better by breaking the rules and increasing tension—giving your viewers a nudge from time to time to keep them alert and interested. This is a delicate operation.

To increase tension, cut faster than expected, use unusually framed shots, cut to unexpected shots, use jump cuts. A jump cut is when you cut, for example, from a wide shot of a man with his arm up to a closeup of the same man with his arm down; on the scene change, the arm "jumps" down. This is also called bad continuity.

Try to synchronize the amount of tension you inject with the rising and falling of your viewers' interest. You might precede a sequence of unavoidably dull instruction with a sequence cut progressively quicker, to subtly stimulate your viewers. Or you could raise the background music level at the beginning of the dull sequence to make

your viewers strain slightly to understand the narrator, thus involuntarily paying more attention.

Most viewers are accustomed to seeing a dissolve or a fullscreen visual effect used to indicate a change in time, place, or subject matter. However, if you use these visual effects for any other purpose, or if you use them excessively, they call attention away from your program's message. The exception is when these and other visual effects are used in montages, commercials, music videos, and television news and sports. In these instances visual effects are meant to call attention to themselves; they're part of the message. Used for that purpose, they're very effective.

There is a limit to what the editor can do to make a program work. If the writing, directing, and camerawork are bad, no amount of editing tricks can save it. You can't make a gourmet meal from garbage, nor can you edit a good program from poor material.

Summary: With the exception of montages, the best editing style is usually transparent and not noticed. If you want your editing style to be noticed—if it's supposed to intentionally form part of your message—then go ahead and break the rules. But be sure, first, that you know your viewers and, second, that they are going to react the way you want them to.

SOUND IN EDITING

Sound is an excellent connecting device across cuts. L-cuts are particularly useful in dialogue scenes and for linking documentary elements together. They are the basic technique for interweaving pictures and sounds to add texture.

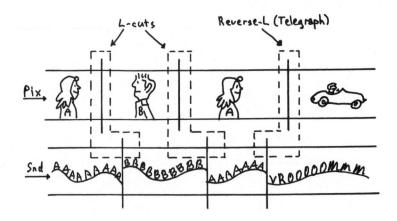

If Person A is talking to Person B, cut to the picture of B listening to the last of A's dialogue, then B begins to talk. Just before B finishes, cut to picture of A listening, then A begins to talk. These are L-Cuts.

L-Cuts give your program texture and forward movement. First, they tease your viewers with a picture that doesn't match the sound they're hearing; then they immediately satisfy their curiosity, drawing them into the next scene.

When B interrupts A, use a Reverse-L cut. Cut to B's sound while still seeing A's picture, then cut to B's picture.

The Reverse-L is also called a telegraph cut, because it gives your viewers an early hint of what's to come. It smooths an edit by cutting first to the incoming scene's sound, then later to the new picture. I use Reverse-L's to bring in the backgound sound or music of a new scene early. By first cutting in new sound, then new picture, the transition is less noticeable than cutting straight to both new sound and new picture at the same time.

I've already mentioned the use of narration or dialogue to help establish a sequence. Other types of sound—presence and sound effects—can also help establish. For example, if assembly line noise continues over several very different shots, your viewers can assume they're still in the same area. If the noise continues, but at a lower level, over a shot of a man working at a desk, your viewers can assume the man is somewhere nearby in the same factory.

BACKGROUND MUSIC

Most music used in editing is in the background. Like other aspects of editing, background music is most effective when it is neither noticed nor remembered by your viewers. Nonetheless, it plays a very important role.

Background music can help to convey a mood or to reinforce your program's message. Your viewers will associate their feelings about the music with what they're seeing on the screen. For example, when demonstrating safe work procedures, use upbeat and positive music. When demonstrating bad work habits, use strident, even discordant music, to reinforce your negative narrative and visual message.

Background music can give forward momentum to your program. Dull pictures and narration can come alive when coupled with an optimistic, peppy piece of music. Background music can give cohesion and order to your program. When the same piece of music covers a series of unrelated shots, your viewers know instinctively that they have something in common and adjust their frame of mind accordingly.

SELECTING AND CUTTING LIBRARY MUSIC

Background music is like plumbing: its function is more important than its beauty. To function properly, background music must be consistent in theme and volume, and it must stay in the background. Most commercial music has too many variations—too many noticeable peaks and valleys—to serve as background music. Your best bet is library music—music specially composed for use in film and television programs.

There are thousands of pieces of excellent library music available. Most editing houses have at least one collection on hand. The license fee you pay is usually less than the cost of commercial music rights, and much less than original music.

When searching library music, keep your mind open; often a selection you listen to for one purpose will actually work better somewhere else in the program. The most important thing is to find music that conveys the mood of your program and that doesn't clash with your voice track. Try to find pieces of music that all have similar instrumentation and style, especially when one selection is going to pick up immediately after another ends. If the selections will be separated in the final program, this isn't as important.

Many pieces of library music begin and end with musically neutral percussion sections; this makes transitions easier. Also, a strong sound effect or piece of dialogue can blanket a musical change and make it less noticeable. Or you can do a musical dissolve in the mix, fading the old music out while fading the new music in. This is called a *segue*, pronounced SEG-way.

There are three basic ways to edit a piece of library music into your program sound tracks. You can head-sync it, starting the music where the picture section starts, then fade the music out at the end of the section. You can tail-sync the music, lining it up so it ends when the picture section ends, then fade it in at the beginning of the section. Or—what I usually do—you can cut the music selection in the middle, head-sync the front half on one track, tail-sync the back half on another track, and do a segue or a cut where they cross and sound similar. If you do the segue or cut under a piece of dialogue or a sound effect, it won't even be noticed.

If you have the budget for original music, plan for it the same way you would plan to select library music; write out all your requirements as clearly as possible, and show the composer the edited program. Sometimes it helps the composer if you show him some library or commercial music that is similar to what you want. Most importantly, don't let the composer get carried away and create background music that pushes out and calls attention to itself when it shouldn't.

SOUND MIXING-SEPARATE YOUR TRACKS

A sound mix has two basic objectives: 1) to improve the quality and effectiveness of your original sound recordings; and 2) to mix all your sound elements—voice, music and sound effects—together in such a way that they help get your message across to the viewers. Both objectives are best served by separating your sound elements off onto as many separate audio tracks as possible.

By having a sound element on its own separate track, you have maximum control over it. If, in the recording of a conversation, Person A talks very loud and Person B talks very softly, you will be continually adjusting the volume up and down during the mix to maintain a consistent sound level. However, if Person A's voice is put on one track and Person B's on another, then you can set a separate volume level for each track and leave it there. You can also equalize—modify different frequencies—Person A's voice without affecting Person B.

YOUR LAST STEP: DIVORCE THE EDITOR

Just as the director going into editing must divorce himself from everything except what works in the editing, so you as the editor must divorce yourself from your edited work in order to judge it properly.

The ideal is to put the edited program on the shelf, walk away, and come back a month later to look at it. You usually can't do that. The alternative is to try to blank your mind and look at the program as if you never saw it before. Judge everything by one standard—does it deliver my message to my viewers? Will they react to this the way I want them to? Throw out or change anything that doesn't meet the standard.

If possible, show the program to viewers similar to your target viewers. Listen to their opinions. Don't be quick to discard any suggestion; even the stupidest remark can tell you something about how your program is working.

SOME FINAL WORDS

Making moving pictures is a subjective art. There are no absolute rights and wrongs. But there *are* some things that usually work—like the things I've explained to you in this book.

If you want to stray from the basics, fine. Just be sure you understand what you're doing and why; otherwise you lose control of your work and confuse your viewers. Until you're really sure of yourself, shoot a basic sequence for protection before going all out artsy-craftsy. You'll be glad you did.

Learn to welcome criticism of your work. And learn to criticize yourself. It's the only way to progress. Every criticism, no matter how ridiculous it may seem, can tell you something about your work.

Don't bask in your successes—analyze them and find out why they worked, so you can repeat them. Use the same process to evaluate and learn from your failures. Professionalism is based on the ability to repeat your successes, and avoid repeating your failures.

I hope my book has helped you, and I wish you happy filmmaking!

EXERCISES

By Chuck Delaney

The Bare Bones Camera Course covers all the composition techniques, types of shots and sequences, camera moves, and lighting strategies that a student of film and video needs to know to create compelling work. However, before you embark on making your masterpiece (or even your first production), a wise first step is to practice what you've learned so you start to feel comfortable putting your new knowledge to use.

If you're reading this book as part of a course you're taking, you may have homework and assignments that have been prepared by your teacher. But if you don't, or if you're reading this book as a self-study project, you can use these exercises to improve your skills before you undertake your first full-fledged production.

To complete these exercises, you can use any device that records video. If you have other equipment such as a tripod or lights, please use what you have. Because recording good sound usually requires use of a microphone, there are no exercises that require recording sound, but feel free to do so if you have the equipment.

To build a basic sequence, you'll need to use some kind of editing program so that you can splice your shots together and view them in a sequence. If you're using a smart phone or tablet to record your video, you can find an application that will allow you to do this either for free or for a few dollars. If you're using a digital camera, you'll need to acquire basic editing software that is compatible with your equipment and your computer.

For some of the exercises, you'll need one or two "actors" to work with you. Ask family, friends, or acquaint-ances to help you out. There's no need to involve yourself with wardrobe, hair, and makeup, but if you feel like making the effort to get involved with those elements, you'll find the experience that much more valuable. It may also help your actors relax and put on a better performance in front of the camera.

Like any kind of exercise, the more you put into these, the more you'll get out of them.

After you complete the exercises, you can evaluate them in two ways—by watching them yourself and analyzing what you could do to improve on them, or by showing them to interested family or friends, explaining what you did and why, and asking for their comments.

EXERCISE 1: COMPOSITION

Record a short (3 to 7 seconds) clip of an outdoor scene with one principal subject. First, place the subject in the exact center of the frame. Then, reframe the scene by moving your camera or changing your position to use the rule of thirds (Chapter 2) to place the principal subject in one of the key positions shown. Record a short clip.

Find a second subject that's either closer to the camera or further away than the first subject. Record two clips, one with the subject centered and the other using a different one of the four placement points of the rule of thirds.

EXERCISE 2: BALANCE

Review the section on balance (Chapter 2) and then record two short clips of two different subjects.

First, pick a subject that doesn't move and record a clip with the subject centered in the frame and then adjust the frame to provide proper balance. This can be a person looking out of the frame or an object that requires balance.

Second, select a moving subject, such as a car, that will require you to pan (Chapter 5) to keep the subject in the same portion of the frame. Record the first clip with the moving subject in the center of the frame and the second clip placing the subject in the frame in a way that will give balance to the shot. Because panning with a moving subject takes some practice, you may want to do this several times. Remember to move from an uncomfortable position to a comfortable position.

EXERCISE 3: BALANCE - COLORS

Review the section on balancing colors (Chapter 2). Use one of your actors as the subject and place your subject against backgrounds of different colors, both neutral (white, gray, and black) and bright colors. Record short clips of the different combinations and then review to see which ones provide a sense of balance that places emphasis on your subject rather than the background.

Balance is to some degree a subjective thing. The more combinations you try, the more you'll learn. Since you're going to enlist the help of one of your volunteer actors, this exercise will work much better if you spend a few days looking for locations and making notes on the locations and backgrounds you want to use so that you can take your actor directly to them rather than wandering around looking for backgrounds with your actor in tow.

Hint: Color balance will also be affected by the color of the clothing your actor is wearing. If you want to learn the most about this type of balance, have your actor bring two different shirts or sweaters, one a neutral color such as gray, and the other a bright loud color such as yellow, red, or blue.

Finally, these concepts of balance can also be broken. For example, a background that calls attention to itself can be used as a way to camouflage your subject for a few seconds in a shot until sound or movement calls attention to your subject. Feel free to experiment with breaking the rules.

EXERCISE 4: ANGLES

As you read in Chapter 2, film and video images have just two dimensions. The third dimension—depth—can only be implied. One of the most important ways to accomplish this is to select an angle that gives the illusion of depth to your subject.

First, record two clips of two different objects. In the first clip, use a camera position that views the subject directly and doesn't give a sense of depth. In the second clip, use a camera position that adds a sense of depth to your subject.

Second, you should record one or more clips using one of your actors. The first should be made while holding the camera at eye level. Then, record clips of the same subject from an extremely low (worm's eye view) angle, and a very high (bird's eye view).

EXERCISE 5: FRAMES

Framing is a very useful way to guide the viewer's eye into the scene and to give emphasis to your subject. Either using an actor or looking for other subjects, spend thirty to sixty minutes walking around your neighborhood finding existing framing elements. After you identify a usable frame, record two clips of your subject, one without the frame as part of the scene, and a second placing the frame in the scene.

Try to locate three different framing opportunities within the allotted time. This isn't easy so you'll have to look closely to see possibilities. You can only use a conspirator to hold a prop frame (see illustration TK, currently page 36) for one of the three examples that you record.

As with Exercise 3, if you use an actor, it may be considerate on your part to scout locations before you involve the actor. Many filmmakers keep a camera or smartphone with them at all times to make still photographs of possible locations for reference and possible future use.

EXERCISE 6: LEADING LINES

These can be hard to spot when you first start looking for them. Review the examples in Chapter 2. For this exercise, record three medium or wide shots that use leading lines to steer the viewer's eye to your intended subject. Remember that this will often require careful selection of your camera position and angle, or possibly moving things within the frame. You do not need to bother recording examples of the situations shown in the chapter that are "not very good." Concentrate on seeing the possibilities. Railroad tracks and fences are always a good place to start in your search for leading lines.

EXERCISE 7: BACKGROUNDS—BOTH INTERESTING AND DISTRACTING

Backgrounds can provide different functions in the images you record.

The first skill to master is learning to select backgrounds that don't distract your viewer from the principal subject in the frame.

First, review the examples in Chapter 2 and then record short clips in medium and wide shots that capture your subject against bland backgrounds.

Second, find ways to keep the viewer's attention on your subject using techniques to separate your subject from a busy background. If your camera permits, try using shallow depth of field to throw the background out of focus. You can also experiment with using different angles to separate your subject from the background.

Third, framing a medium shot, find ways to record your subject while moving your subject or changing your camera angle to hide a distracting background element behind your subject. For this exercise, record your subject first with the distracting element in the frame, and then apply the correction to remove the distracting element.

Finally, let's do a little research to see how effectively these rules can be broken. One of the best examples can be seen in the portraits painted by Vincent Van Gogh. Use the Internet or a take a trip to the library to look at Van Gogh's self-portraits as well as the portraits of La Berceuse and Postman Joseph Roulin. Van Gogh painted each of these

subjects many times. Many of the portraits intentionally place the subject in front of very busy backgrounds. In the self-portraits these backgrounds convey a sense of the agitated state of mind that sometimes overtook the painter.

Using one of your actors, find an extremely busy background and see what kind of medium-shot portraits you can create that breaks the rules but works.

EXERCISE 8: BASIC SHOTS

Select an outdoor location with a subject that interests you. Review the description of the basic shots in Chapter 3. The subject could be an object, or one or both of your actors. Record a series of the basic shots of your subject in the same location.

- Wide (Establishing)
- Medium
- Close-up

Try several different versions for each. Keep an eye out for the best backgrounds that work with your subjects and don't distract from the appearance of the scene.

EXERCISE 9: BASIC SEQUENCE

This is where you are going to start to put everything together. Review the illustrations and explanations in Chapter 3. Then, using your two actors, record the different shots to create a basic sequence. In addition to the basic shots that you made in Exercise 8, you can make some new ones as well. Also, make sure to record a few cutaways. At this point, you should work with static shots. Camera moves can be introduced later after you have mastered creating a basic sequence using static shots. Even though the sound recording options available to you may be primitive, have the subjects engage in a bit of conversation. If you're working outdoors, try to avoid a windy day, which can garble the sound.

Remember to vary the shots by changing both image size and camera angle. Pay particular attention to the 45 degree angle positions as illustrated [TK reference illustration currently on page 48 of BB].

Editing: Once you've recorded several takes of each of your basic sequence shots, as well as some cutaways, it's time to edit them together to create the actual sequence. Don't be surprised if this is a bit rough at first and some of the edits make the sequence look a bit awkward. If editing were that easy, everyone would be an editor. After your first attempt to assemble a sequence, you may want to make retakes of some of your shots. If that's the case, review the information in Chapter 3 regarding cutting on the action

and clean entrance—clean exit to make sure the clips you record give you the best options in the editing process.

If you're using a location to record your basic sequence that you also used for earlier exercises, you may have some cutaway options from those earlier clips.

In addition, while there isn't a specific exercise related to the problems that are created for the viewer if the camera position crosses the line, you should make the effort to record several medium shots that could be placed in the basic sequence that do cross the line so you can see for yourself how that situation does confuse the viewer. Cut a basic sequence with a shot that crosses the line so you can get a sense of how it works with moving images.

Since you're now looking at the shots you've recorded through the eye of an editor, apply the lessons learned in the editing process to the retakes. Re-read Chapter 10 as you go.

Chances are that you'll encounter a jump cut or two, but that's all part of the learning process. While your first efforts editing together a basic sequence may be a bit rough, don't let this bother you. Instead, look at how far you've already come.

Reviewing this exercise with family, friends, or your actors is especially important so you can explain to them what you were trying to do. You'll find that other pairs of eyes often offer helpful suggestions.

EXERCISE 10: CAMERA MOVES

Review Chapter 5. It's time to unleash your camera. While the various different camera moves (and combinations of moves) can add a great deal to your production, pay heed to the cautionary note in that chapter that too much movement can get in the way of telling your story and become a distraction.

Remember that camera moves have several purposes. One is to add motion to the scene in a way that enhances the viewer's interest. Another is to reveal portions of the scene after a shot has begun. Another is to take the viewer from one location to another within a single shot. All of these can be accomplished by using either zooming in or out, panning from left to right or vice versa, and tilting the camera to raise or lower the view in the frame.

As discussed in Chapter 5, two different types of moves can be used in the same shot, although this takes a lot of practice and can create challenges in the editing process.

For this exercise, you should use your experience that you've gained in all the previous exercises. First, record some basic moves. If your camera has a zoom function, you can practice zooming in on a subject. Find another subject and zoom out to reveal more of the scene. Try using different pan and tilt moves to control what the viewer sees.

If your actors are available, try re-shooting parts of your basic sequence with a move included. For example, you could start with a medium shot and then zoom out to a wide angle shot to establish the scene rather than starting at wide angle.

EXERCISE 11: MAKE A MONTAGE

You can create very effective montages that can help tell a story within your production. For this exercise, you can set out to create a new montage by making very short (one or two second) clips of different subjects. Try to establish a theme that makes sense within the production. If, for example, the story involves a character visiting Las Vegas (or your hometown) a montage of signs that identify the location will be very effective.

Another montage could establish a particular place—a park, a zoo, or a waterfall. You may be able to create a montage from short bits of the various clips you created for earlier exercises.

EXERCISE 12: LIGHTING PRACTICE

Outdoor Lighting

First, select an outdoor location that you can visit at several different times of day without having to make a lengthy journey to get there.

Record wide and medium shots of the location you've selected under various lighting conditions. Mark the spot where you positioned yourself in some way so that when you return you can record the same two shots from the same position:

- Early or late in the day on a sunny day that will show long shadows
- Mid-day on a sunny day with the sun overhead
- The same scene mid-day on a cloudy day
- The same scene at twilight
- The same scene in the rain or snow

Study how the appearance of that location changes in each of these different lighting conditions.

Second, using one of your actors as a subject and the second actor as an assistant, you're going to work with a reflector. To start, you need to create a simple reflector using either cardboard covered with aluminum foil, or purchase a piece of white poster board from an office supply store. A reflector that's about two feet by three feet is large enough for close-up and medium shots. A white reflector

will cast a softer light and a board covered with aluminum foil will cast a brighter light.

Experiment with medium and close-up shots taken in sunshine using the reflector to fill in the shadows on your subject's face. Record a clip without the reflector and one with the reflector. You will need to direct your assistant to position the reflector in a way that affects the shadows.

Using a reflector can be extremely helpful when the sun is behind your subject. Without a reflector to fill in the shadowed area that covers the entire face, the subject will appear too dark relative to the rest of the scene.

Indoor Lighting

If you have lighting equipment, try bounce lighting to provide a softer illumination. Also, when recording images indoors, it's possible to make very effective use of window light. While this could include sunlight streaming in from a window with southern exposure, the soft light of a window that does not have direct sunlight streaming in is often more effective and provides good illumination for close-up and medium shots. You can use a reflector to fill in shadows on the portion of the subject that isn't facing the window.

With these lighting exercises, the goal is for you to start to see the wide range of possibilities that exist in different kinds of lighting, both outdoors and indoors. As you progress in your storytelling endeavors, you may want to consider investing in some lighting equipment, although a great deal can be accomplished using sunlight outdoors and available light indoors.

ABOUT THE AUTHOR

Tom Schroeppel worked in film and video for more than thirty years as a freelance writer, director, cameraman, and editor. He also trained news crews at television stations in Latin America and the Caribbean.

INDEX

Action, cutting on the, Angles, camera, Aperture, lens, ASA, Axis, of action, Background light, Backgrounds, distracting, Backlight, Balance, colors,; masses, ; white, Barn doors, Bounce light, Broad light, Camera,; movie,; still, television, CCD, charge coupled device, Close-up, Colors, balance, Color temperature,; film,; television, Composition, Cutaway, Depth of field, Dichroic filter,; DIN, Direction, screen, El, Exposure Index,

Entrance, clean, Exit, clean, Exposure,; film,; television, Eye, human, Eyepiece, focusing, F/stops, Fill light,, Film, Filters, color,; dichroic, Focal length, Focus, Frames, within the frame, ISO, Key light, Lens, camera,; normal,; telephoto, wide angle,; zoom, Lens, human eye, Light, color of, See color temperature Light meters, Lighting,; background light,; backlight,

THE BARE BONES CAMERA COURSE

basic Reflector, setup,; bounce Sequence, basic,; lighting,; planning/shooting,; broad light,; shooting out of sequence, exterior lighting,; Sunlight, fill light,; Script, shooting, focusing quartz,; Shot, establishing,; interior lighting,; medium,; neutral, key light,; point-of-view,; sidelight,; wide, softlight, Slates, Line, axis of action,; Softlight, crossing the line, Storyboard, Lines, leading, Temperature, color,; Looks, leading, film,; television, Meters, light, Thirds, rule of, Montages, Tilts, Moves, camera, Tripod, Pans, T/stops, Pincushioning, White balance, Pixels, Zoom, lens,; camera Quartz, focusing, light, movement,

Fair Havens Church of Christ

Shattered and broken 261.832 M134s

1348

McDill, S. Rutherford
OVERTON MEMORIAL LIBRARY

57316

- ——. Your Inner Conflicts: How to Solve Them. New York: Simon & Schuster, 1974.
- Sandvig, Karen J. Growing Out of an Alcoholic Family. Ventura, California: Regal Books, 1990.
- Walker, Lenore E. *The Battered Woman*. New York: Harper & Row Publishers, Inc., 1979.

Fair Havens
Church of Christ
P.O. Box 1008
Hernersville, NC 27285-1008

Shelter Aid

1-800-333-SAFE (7233)

Shelter Services for Women

Under S in the white pages of your telephone directory.

Survivor's Network

18653 Ventura Blvd., #143

Tarzana, CA 91356

United Way—Crisis Line/Information and Referral

Under U in the white pages of your telephone directory.

How to Find a Counselor

In the yellow pages of your telephone directory look for the following categories:

Crisis Intervention Service

Marriage, Family & Child Counselors

Mental Health Services

Physicians & Surgeons, MD-Psychiatry

Psychologists

Women's Organizations & Services

Books About Abuse, Alcoholism, Self-esteem

Berne, Eric. Games People Play. New York: Ballantine Books, Inc., 1978.

Forward, Susan. Man Who Hate Women and the Women Who Love Them. New York: Bantam Books, Inc., 1987.

Johnson, Carolyn. *Understanding Alcoholism*. Grand Rapids, Michigan: Zondervan Publishing House, 1990.

Missildine, W. Hugh. Your Inner Child of the Past. New York: Simon & Schuster, 1963.

Agencies That Offer Help

Batterers Anonymous

c/o Coalition for Prevention of Abuse of Women and Children

P.O. Box 29

Redlands, CA 92373

Center for Women Policy Studies

2000 P St. N.W., Suite 508

Washington, DC 20036

202-872-1770

Information about services and programs for battered children, battered women, and men who batter.

Family Service Agency, Inc.

Under F in the white pages of your telephone directory.

National Domestic Violence Hot Line

1-800-333-SAFE (7233)

National Coalition Against Domestic Violence

1500 Massachusetts Ave. N.W., Suite 35

Washington, DC 20036

Information about programs for men who batter. Statewide coalitions are in most states. Contact your state capital.

A THIRD E

Appendix

Chapter 7 Therapy: How Can Professional Counseling Help?

- David Augsburger, Caring Enough to Forgive/Caring Enough Not to Forgive (Ventura, California: Regal Books, 1981), p. 26.
- 2. Ibid., pp. 56, 58.

Chapter 8 Children: The Innocent Victims

- Dayan Edwards, M.A., Breaking the Cycle: Assessment and Treatment of Child Abuse and Neglect (Los Angeles: Cambridge Graduate School of Psychology, 1986), p. 42.
- 2. Ibid., p. 44.
- 3. Maria Roy, Children in the Crossfire (Deerfield Beach, Florida: Health Communications, Inc., 1988), pp. 193-196.

Chapter 9 Recoupling: What It Takes to Start Over

 Adapted from John Powell, S. J., Why Am I Afraid to Tell You Who I Am? (Allen, Texas: Tabor Publishing, 1969), pp. 54–62.

Chapter 2 Male and Female: Equal but Different

Dr. Kevin Leman, Sex Begins in the Kitchen (Ventura, California: Regal Books, 1981), pp. 145, 146.

Chapter 4 The Abused: Why Me?

- Adapted from Lenore E. Walker, The Battered Woman (New York: Harper & Row Publishers, Inc., 1979), p. 31.
- 2. Ibid., pp. 35, 36.

Chapter 5 The Church: Haven for the Abused or Harbor for the Abuser?

- Phyllis and James Alsdurf, "Wife Abuse and Scripture," Theology, News and Notes, October 1989, p. 14.
- S. Scott Bartchy, "Issues of Power and a Theology of the Family" (Paper presented at the Consultation on Marriage and Family, Fuller Theologial Seminary, November 1984), section 6.
- Kenneth W. Petersen, "You Can Help a Battered Wife," Christianity Today, November 25, 1983, p. 24.

Notes

The Control of the season of t

lier, we do not believe God ever intended any wife to suffer the indignities of physical and emotional abuse from her husband. Perhaps God was not the one who put you together with an abuser. wrongs. "It always protects, always trusts, always hopes, always perseveres" (1 Corinthians 13:7).

As Connie and Chuck stand up and get ready to leave, Dr. Stephens reminds them, "Be sure to talk together openly and gently. Don't let problems or gripes fester inside of you. Ephesians 4:26 says not to let 'the sun go down while you are still angry.' In other words, don't go to sleep until you reaffirm your love for each other."

First Corinthians 12 talks about the spiritual gifts God has given all of His children. At the end of the chapter the Apostle Paul says, "But eagerly desire the greater gifts. And now I will show you the most excellent way" (verse 31). In the Greek, the translation of this last sentence means much more than "most excellent way"; it means, "Let me show you an even higher way, a journey over a high mountain pass."

Then Paul goes into chapter 13, the Love Chapter. God wants you to experience everything this chapter talks about. You deserve it. You are the "righteousness of God" because of Christ (2 Corinthians 5:21). God can lead you over the "high mountain pass" if you take the first steps toward your own recovery. The strong winds of this high pass may seem scary, but they will not destroy you if you trust God, lean on your friends, and allow professionals to help you in your progress.

Seek all the avenues of help and support that are available to you. Call a counseling hot line, a women's shelter, or a mental health agency. In the Appendix, you will find some sources that will help you further. As we said ear-

of authority but of source and reciprocity. To impose a hierarchical pattern on a Christ-based marriage is to distort the intent and beauty of the marriage picture and render worthless those passages that talk about equality in the body of Christ."

A Balanced Marriage

Dr. Stephens is right. In the Beatitudes, Christ said that a person who is blessed (happy) is one who is poor in spirit, meek, merciful, pure in heart, a peacemaker, and one who hungers and thirsts for righteousness (Matthew 5:3–9). A marriage where the husband is spiritually weak and in constant need of power, authority, and the security of being dominant does not have the qualities God calls "blessed." It is impossible to be both first and last, greatest and least, master and servant. In a balanced marriage there is no top dog; a balanced marriage consists of two people who make equally valuable contributions that stem from the unique abilities and talents God has given to each of them.

In his final greeting to the church at Corinth, the Apostle Paul said to "aim for perfection, listen to my appeal, be of one mind, live in peace. And the God of love and peace will be with you" (2 Corinthians 13:11).

Chuck and Connie still have several years of weaning away from therapy and rebuilding their lives together ahead of them. But they truly love each other, and true love is not self-seeking. Neither does it keep record of blaming, accusing, or bringing up the unhappiness of the past."

Look to the Interests of the Other

Dr. Stephens takes out his Bible. Connie feels that this time someone pulling a Bible on her is going to be of real help. Dr. Stephens thumbs through the pages and stops at a passage as he says, "Remember to do all the things the Lord said to do to create the abundant life He promised, 'having the same love, being one in spirit and purpose. Do nothing out of selfish ambition or vain conceit, but in humility consider [the other] better than [yourself]. . . . Look not only to your own interests, but also to the interests of [the other].' That's from Paul's letter to the Philippians, chapter 2."

Dr. Stephens looks up from the Bible and turns to Chuck. "Chuck," he says, "Christ modeled headship. Never did He use force or coercion or abuse to accomplish His aim within the body of believers. Rather, Christ was tender, loving, patient, kind, and protective."

Terrorism, arm-twisting or breaking, aggression, violence, and intimidation are alien to everything Christ stands for, and those qualities should be alien to His believers and their intimate partners.

The therapist turns to another passage: "There is neither Jew nor Greek, slave nor free, male nor female, for you are all one in Christ Jesus' is the way the Apostle Paul explains our role in Christ in Galatians 3:28. Chuck, the relationship between the head and the body is not one

"Remember, also, that even though you are transparent with each other, you both need an element of privacy, a place in your relationship that belongs exclusively to you where the other will not trespass."

No Guarantees

Dr. Stephens goes on explaining to Chuck and Connie that even though they have been through intense therapy and both feel they are ready to resume their life as a married couple, they have no guarantees that everything is going to be smooth sailing. "Chuck, you've undergone a partial transformation. A new person and pattern are emerging; parts of the old are being extinguished. At this stage, however, there can be no guarantees, because expecting or hoping for a 'guarantee' may throw you back into your old childish way of expecting magic. To expect guarantees means you are still thinking like a junior-high kid. There are no guarantees in this life except those we make ourselves.

"This 'no guarantee' process is central to your therapy. You, Chuck, have closely examined the way you felt about Connie—in fact, all women—and hopefully have come to an in-depth understanding as to how you used power and control to your advantage. After all this time, you should have moved beyond that stage in life. Now it's time for you and Connie to get to know each other's new personality to reestablish true intimacy.

"You should both be willing to carry more than onehalf of the load of your relationship without complaining, will each have to create new patterns of behaving, restructure new mind-sets, secure new ways of thinking. Any element of your old way of behaving, Chuck, could trigger flashbacks in Connie and undo many months of work."

At this stage of their therapy, Chuck is going to have his patience challenged, something that never happened when he and Connie lived together before. Dr. Stephens suggests that at the beginning of the comingtogether process Chuck and Connie wait to get back together physically and also hold back from resuming sexual relations. They are to treat each other as if they were just beginning to date. They will feel out the new subtleties of their relationship and get to know each other all over again.

"Intimacy is much like a romantic, close, slow dance" Dr. Stephens continues, "where the two of you melt into each other without unhealthy enmeshment or fusion. It does not mean that either one of you will lose your identity or personhood. The intimate relationship calls for a healthy independence—that quality of being self-sufficient and interdependent, where you realize that no one is an island.

"Being intimate means that each of you will be spontaneous and creative. You will bring a freshness and newness to every day of your lives. You will grow and develop both individually and as a couple. You will move beyond the things that happened in the past, seek contentedness in the present, and look forward to a great future. You must learn to trust each other absolutely and to be absolutely trustworthy.

Coming Together Again

As the long counseling process draws to a close—nearly two years after it started—Connie and Chuck meet in Dr. Stephens' office. He tells them, "Connie, Chuck, you have been through a lot these past months. You have both had to move away from your old familiar life-style and tear down a relationship that was not healthy. You are now ready to start work on a new intimacy, one you never thought possible."

True Intimacy

"Intimacy means more than we usually think of when we hear the word. It means that two people are very open with each other. It means warmth, caring, positive regard for each other, empathy, and support for each other. It means you drop your defenses and become transparent. You become involved in each other's life."

He goes on to describe how, at first, both Connie and Chuck will want to react in their old ways toward each other. Connie nods her head because she is worried that moving back with Chuck will make him think she is again taking personal responsibility for making their marriage work. Chuck looks a little smug because he thinks that maybe he will be fully restored to his former status. But this cannot happen. They both need to be slowly exposed to each other's new self. Dr. Stephens explains: "This coming-together phase must be a gradual, delicate movement. Each day will bring new challenges but also new surprises and joys. You

is not. Interacting on this level requires a very secure, trusting, open, worry-free relationship. We engage in this level of communication when we have no worries about the reaction of the other person.1 "John got fired from work yesterday. Maybe he wasn't the most trustworthy employee, but he was a good worker when he was there. I don't want to worry you, but I'm concerned this may be the beginning of a general cutback. I sure don't need to be out of work now with all the expenses we have." While the preceding example is one-sidedcommunication does not happen unless at least two people engage in it-it shows the various levels, and you can imagine the responses to each of the levels. Communication is a learned skill. If you were never taught or encouraged to converse on a deeper level when you were growing up, it will take some time and effort to learn to do it easily.

Good communication skills should be practiced with other people, maybe in a support group, while the husband and wife are still separated. After their separation, and after the husband has had a chance to learn how to handle anger and reprogram his mind-set, the wife has had time to heal, and the two of them have been working separately on good communication skills, the process of recoupling husband and wife can begin. Since the amount of damage has been great, and the amount of healing that was needed was also great, the recoupling process is best accomplished patiently and gradually. Initially, old conditioned physical and emotional reflexes are going to spring back into action, and it takes awhile to extinguish them and implant new ones.

least effective, the first of these is the *cliche level*. This is the most superficial of all, the kind of communication we engage in when we meet someone on the street, whether a stranger or an acquaintance, and comment, "Hi! How are you? Nice day, isn't it?" Sometimes in a marriage the cliche level can even be applied to "I love you."

The second level is also quite superficial. It is the *facts level*—facts about other people, not about ourselves. This is the news level of communication. A husband may say, "John got fired from work yesterday," without giving any more information or any indication how this may affect him.

The third level has a little more substance to it. At this level, we reveal *ideas and judgments* about the facts. We expose a little more of who we are and what we are about. This is the beginning level of interacting with another person and showing our value system: "John got fired from work yesterday. But I guess he deserved it. He really flaked out a lot."

The fourth level carries this idea a little further in that it involves revealing *feelings and emotions* about the facts. "John got fired from work yesterday. I guess he deserved it, but it has me a little worried. Even though he flaked out some, he really was a good worker. I'll miss him."

The deepest level of communication, the fifth level, is the complete *emotional* and personal truthfulness in communication, when we truly reveal how we feel, what our values are, what is important to us, and what father abuse his mother. Maybe he comes from a culture that believes the proper way to rule a home is through intimidation or terror. In this case, it is important that the man be taught there are other, more healthy ways of dealing with anger, frustration, and aggression.

Chuck chose to intimidate and throw temper tantrums as a way of exerting control. He will need to prove to his family, beyond a doubt, that he has progressed way beyond the stage where he stopped maturing. He has to show and prove that he has learned to monitor, regulate, and control his emotions in an adult way.

Developing these skills takes a great deal of time and effort—and a lot of guidance from people who know how it has to be done. Once the abuser recognizes that he does not have these skills, a counselor can begin the process of helping him achieve them, practice them, and perfect them. Then, and only then, will the husband be ready to move into the kind of relationship where he and his wife can stand psychologically naked before each other, ready for the intimacy of a loving marriage relationship, and where the two of them can practice what the Bible means when it talks about headship. One of these learned skills is to communicate properly and lovingly.

Learning to Communicate

According to John Powell, human communication can be broken down into five levels. Beginning with the

Recoupling: What It Takes to Start Over

Chuck will have a monumental task when he begins to convince Connie that he is no longer frightening or dangerous. Connie may feel she has forgiven Chuck and moved beyond her fear of him, but the testing period will still be ahead of them. She may need to tell Chuck, "I think I have forgiven you, but I have not yet forgotten what you did to me and our children. Until I can see you in a different light, I can't blindly agree that a miracle has taken place." Connie needs to see that the cure is reliable and valid; she needs to see it in operation. Not only does Chuck have to work at his own recovery but he also has to work at restoring trust, faith, love, and tenderness to his wife and family. This is not an easy task, and it is his responsibility.

Most men who are batterers come from a background of being battered themselves, or the child watched his myself. Some of them are short-term and some will take awhile to reach. But I have started. 6. I have begun to seek outside interests for myself that do not necessarily include my marriage, chil-TF dren, and career. 7. I now know that I am basically good. T F 8. I have found some supportive and loving friends T and relatives. 9. I can now feel that I may choose how I think, feel, and react. 10. I do not have to stay in an abusive situation. There are ways I can change my life.

If you answered False to even one of these statements, perhaps you should go back and read key chapters of this book, or talk to people who can encourage you to seek the higher way that God has prepared for you.

You alone are responsible for the choices you make in life.

In chapter 9, we will see the positive side of overcoming an abusive relationship. However, therapists say it takes a great deal of work on the part of the abuser. He will not want to change his way of living because it brings him too much pleasure. Not every couple will find the positive results discussed in the next chapter.

Before reading chapter 9, do the following exercise, "How to Know When You Are on Your Way to Recovery." It could be an indicator that you are on your way to improved emotional health. Perhaps you have decided to begin the long process of therapy that will help you and your children overcome the years of abuse you have suffered. If so, you should be aware that there are no easy answers. Listen to your therapist. Do not try to take shortcuts.

Answer the following statements by circling T (True) or F (False).

- 1. I feel I can now take some steps that will help me toward taking control of my life.

 T F
- 2. I am beginning to feel physically and emotionally stronger because I choose to improve my situation.

 T F
- 3. I have much more hope in the future. T F
- 4. I am at peace and have discovered a new faith in God.

 T F
 - 5. I am in the process of setting some goals for

for the way your parents behave. Believe in yourself and your own abilities. You have to build your own place in the world.

Stand on your own two feet. You can do this very well if you do not weaken your chance by using drugs or alcohol. These substances do not erase the problems, they just make them go away for a while. They will still be there when you come down. Drugs and alcohol cannot cure the fear, pain, and hurt you feel because of what goes on in your home.

Look for other people to be friends with and to guide you. Other people can help you believe in yourself, and soon you will be able to trust them and confide in them. It is important to tell someone you can trust about your problems at home—maybe a school counselor or the parent of one of your friends, the pastor of your church, or a favorite teacher.

Study hard and work up to your potential. It is almost impossible to study at home if you never know when a fight will start. Does your school have a study room? Can you go to the library? Find a place to study and get good grades. That is another way to show that you like the person you are becoming.

Avoid getting into fights at school or with your brothers or sisters. You may have a bad temper and feel like fighting with your best friends, your brothers or sisters, or other kids. You may shout and throw things around or slam doors and say bad words. You have been taught to do these things, but you don't have to continue doing them. You can learn to control your own temper.

not help themselves. They are so caught up in the vicious cycle that they lack the initiative and will to reach out.... By law you cannot be prosecuted for acting in good faith. You are disturbed by the fighting and screaming. You worry about the little girl in the apartment down the hall. You lose sleep over the little boy in the house on the corner.... Be a friend. Contact local service agencies listed in your phone book.³

If you are a neighbor or a teacher who has contact with children in abusive homes (or if you are the abused wife and can find the courage to do so), you can help children in an abusive home by telling them the following things:

When your parents fight, leave the room or wherever the fighting is going on. Go to a neighbor's house as quickly and quietly as possible. If they are fighting at night and it wakes you up, either stay quietly in your room or move to a room where there is a telephone. If you need to call an ambulance or the police, you can make the call without notice.

Don't blame yourself for your parents' fights. Your mother and father are responsible for their own actions and choices in life. Their problems have nothing to do with you.

Make friends and get involved in school activities. Feeling good about yourself comes from inside you. If you feel ashamed and embarrassed, it is because you feel guilty. But you did nothing; you are not responsible

earthly father discounted and humiliated them, and they fear that God might in the same way reject them.

This is a long way from Christ's description of a God who longs to shepherd, nurture, protect, heal, comfort, love, and give us abundant lives. Rather than judging or condemning children who act out their fears and distress in antisocial or unacceptable behavior, the church needs to respond to them the way He did.

There are ways to head off longtime or permanent damage to these little ones. We can show them the real God by shepherding, nurturing, protecting, healing, comforting, loving, and sharing our abundance with them.

If we know of children who live in homes where there is physical, sexual, and/or psychological abuse, we should not become accomplices to the violence. We need to openly and honestly confront the wrongdoing (if not the wrongdoer). The first way most of us respond when we know or suspect that abuse is going on in the lives of people we know is to deny or avoid the situation by either keeping silent or maintaining a posture that everything is fine. It is human nature to recoil from situations such as these. However, we must overcome this tendency so that these little ones can be rescued from their terrifying environments.

Church leaders, friends, and extended family members need to get involved in the lives of these offended children by opening their doors and their hearts to the little victims. Maria Roy says that everyone has

a moral responsibility to save a victim's life (child or adult). The abused child and family oftentimes can-

(Regal Books) and *Understanding Alcoholism* by Carolyn Johnson (Zondervan Publishing House).

All Is Not Lost

These descriptions sound as if children from homes where they observe their mother being abused have no chance for a normal adulthood. This is not entirely true, but like the wife recovering from continual abuse, the cure for ricochet abuse will take awhile. "I think children who are forced to watch one parent abuse the other learn to lay aside their natural personalities for survival's sake," Sheri relates. She is now married to a man who is very patient with the hangover effects from her own life. However, when she was sixteen she got pregnant so that she would have an excuse to leave home. That marriage ended in divorce when her little girl was born. When she married her present husband, he adopted her daughter and began the work of rebuilding Sheri's confidence and security. She says that "if these child victims are loved, accepted, and nurtured as adults they can still find their natural selves. But it can be a very long and painful process."

Because Sheri and her siblings are fairly typical of adults who come from homes where Dad has assumed the role of God, in their eyes the real God can be very difficult to approach. They want nothing to do with a father figure who represents authority. Their impressions of Father-God fill them with terror and disgust. After all, their abuser but he also has to deal with the craziness of his background spent in the home of alcoholics.

Alcoholic families play hundreds of very devious games that are geared to excuse drinking and irresponsibility. Children in such families have to sort through their feelings about the world in general. They have to work hard to conquer insecurity, anxiety, fearfulness, dependency, and feelings of distrust, suspiciousness, and lack of safety.

Children of alcoholics sometimes take one of two paths in life: hyperresponsibility, which makes them very boring, dull, and overadult, or high irresponsibility, which indicates too much childlikeness. The hyperresponsible person does not look like much of a problem. He/she seems mature and normal. The problem is that this person compulsively takes not only his own responsibility but also heaps on his shoulders everyone else's responsibilities so that ultimately he breaks under the load. This causes him to feel depressed, inadequate, resentful toward all those he feels responsible for, angry at others close to him who do not want to help shoulder the load, then guilty for being angry, and finally ashamed for not being able to do it all.

On the other hand, the adult child of alcoholics who takes the path of high irresponsibility never grows up. He is the man who may move into adult abusive relationships. If you would like to know more about this subject of adult children of alcoholics, there are many good books written on the subject. Two recent releases are *Growing Out of an Alcoholic Family* by Karen Sandvig

won't commit herself to any relationship, career, or situation for more than a few days at a time. "Cass says that life is one long series of unpredictable moments," Sheri says, "and she won't hope in any future that may not arrive. Cass is scared silly to join a club that meets at regular times, date anyone who might expect her to make plans a month in advance, or accept invitations more than a week ahead."

Cass learned that life can be full of nasty surprises and inconsistencies. Her way of dealing with this is to keep commitments at arm's length. "Cass pretends to be carefree, but there's a large part of her, like the rest of us, that's still a kid at home, not daring to look ahead for fear of what tonight or tomorrow might bring."

Sheri sums up how she and her brothers and sisters face life now that they are grown up. "I believe the overall problem with all five of us kids is that we grew up feeling a need to pretend. None of us finds worth in who we are. We all hide behind or within some sort of pretense out of a strong childhood need to abdicate our right to be human. We all learned that who we are is not good enough, and we have no assurance that someone like our father won't come along and make us suffer because we aren't acceptable in his or her eyes."

Adult Child of Alcoholic Parent(s)

When a male abuser comes from an alcoholic family, he not only has to deal with the problem of being an vinced that everything will be all right if she has enough money, expensive furniture, and stylish clothes. If she can surround herself with enough 'things,' she'll be happy. She maxes out every charge card she can get approval for. She spends hours on her personal appearance and basically pretends to be whomever she wants to be at the moment. She's practically driven her husband into bankruptcy and lives behind a veneer of false security that may very well split open someday to reveal a little girl whose reality was so painful she created a fantasy world to live in."

Darin, eight years younger than Sheri, has chosen to live a "safe" life. He married his high school sweetheart, took a conservative job, and now has two children, a dog, and a cat. He goes bowling on Wednesday nights and generally does whatever he thinks makes people happy. His is a regular "Ozzie and Harriet" life-style. What's the matter with that? Sheri explains: "Darin finds that his life is dull and unfulfilling and he gets very weary of always doing the 'right' thing. He wants to let down a little and do something that brings him more personal pleasure than his current job. But he's so far into his stiff life plan that he doesn't know what that would be. He has no idea who he really is because he has hidden behind what he thought was 'normal' for so long that his real self is beyond reach."

Cass, the baby of the family, appears to be the least plagued by growing up in an abusive home. She seems to function well day-to-day. However, her problems show up when it comes to making commitments and plans. She tight for money or feel pressured by the disapproval of others, I battle tremendous anxiety. I just want to hide away from the world in my own home and keep myself safe from anybody who, like my father, could hurt me or my loved ones. I have a deep and stubborn fear that my very survival depends on others, and if they choose to cut me off from life itself, they very likely have the power to do so. It's difficult to convince my adult mind that everyone is not abusive like my father."

Sheri's brother Paul responds in a different way as an adult. He has adopted an extremely "macho" facade. Sheri explains: "He acts as if nothing bothers him that has anything to do with feelings or emotions. Once he broke down with me, though. He told me he deliberately chose to encase himself in this tough exterior because he had always felt so helpless when Dad battered Mom. So he decided that his only defense was not to expose his real self at all. Paul felt so inferior because he couldn't make Dad stop hitting Mom or yelling at us that he crawled into an emotional cocoon. On the outside he acts unapproachable and tough, but inside he's just a powerless little boy who couldn't prevent his mother from getting beaten." Some adults like Paul also become abusers because they know no other way to deal with the conflicting emotions of concern for another and fear for their own safety.

Her sister Melissa grew up to live in a dream world. Sheri says that Melissa "checked out of reality into fantasy. She's kind of a stereotypical 'dizzy blonde' who flits through life on the gossamer of her dreams. She's con-

- 3. Show signs of malnutrition and lack of supervision.
- 4. Have poor hygiene—torn and dirty clothes.1

Signs of emotional maltreatment include:

- 1. Speech disorders.
- 2. Retarded physical development.
- 3. A failure-to-survive syndrome.2

Many such children attempt suicide.

Hangover Results of Domestic Abuse

Living in a home where terror is the pervading emotion causes permanent scars on the souls and spirits of children that last well into their adult years; in fact, the scars never totally fade. Sheri said that the whole family waited in fear as her father got home from work. They could tell by the way he shut the car door, or turned the doorknob as he entered the house, if it was going to be a bad night for them, but especially for her mother.

"It's a living hell to be so concerned about and connected to another person that every day of your life is filled with terror and every night is disturbed by edgy sleep and haunting nightmares! And I never seemed to get over that anxiety. Now that I'm grown, the anxiety and worry seem to have grown with me. When I'm overtired, overworked, or overstressed, or I'm a little

ing of always being caught up in excessive anxiety and worry to violent, aggressive criminal activity. In between these "extremes" are problems of teenage pregnancy, drug and alcohol abuse, juvenile delinquency, running away, and permanent injuries children receive when they are hit by a piece of furniture their fathers aimed at their mothers, or when they try to intervene to stop the battering and become the new target of the violence. Often when a child is injured under these circumstances, the father will turn his shock and anger back on his wife: "Now see what you've done. It's all your fault. You've caused your kid to get hurt."

Along with these direct effects on children from the abuse inflicted upon their mother comes the problem of physical neglect. Many mothers who are regularly abused become so emotionally tied up with their own problems that they neglect the care of their children, particularly young children. Examples of this type of neglect include abandonment, lack of supervision, nutritional neglect, medical/dental neglect, inappropriate or insufficient clothing, hygiene neglect, lack of proper shelter, and educational neglect.

The study *Breaking the Cycle: Assessment and Treat*ment of Child Abuse and Neglect describes a child who suffers from physical neglect. The child may:

- 1. Be constantly hungry.
- 2. Have unattended physical problems such as untreated wounds or lack of dental care.

door onto the concrete drive. He barked at her, 'Get out and stay out until you can be a decent wife and mother!'

Even after twenty years, Sheri experiences the emotion of the moment. Her eyes mist over with tears as she feels the old emotions: hatred for her father, compassion for her mother, and sorrow for all the kids. She explains that she believes her father was the worst kind of abuser because he believed he was justified in "chastising" everybody when things were not going the way he felt they should.

The Offended Little Ones

Christ once called a little child to Him and taught a lesson about the kingdom of heaven. Then He warned His hearers about offending these little ones: "See that you do not look down on one of these little ones. For I tell you that their angels in heaven always see the face of my Father in heaven" (Matthew 18:10). What greater harm can you do to a little child than to subject it to continual terror so that he or she grows up to grow away from God?

Being part of the drama or being observers to the drama, watching their father play out systematic violence against their mother, causes all kinds of problems in children during their growing-up years. The least of these problems may be chronic bed-wetting, the greatest, violent behavior toward other children. When they reach adulthood, their problems may range from a feel-

thing, except for little Cass. She was whimpering like a frightened little animal.

"For a minute or two it looked as if Dad had forgotten Mom, but then something crossed his mind and he spun around to her. 'If you'd do what I tell you to, things would be all right around here! But no, you have to go against everything I say and screw it all up! Look at these kids! Not one of them has the sense God gave 'em! All Sheri thinks about is boys. Paul's out in nevernever land half the time, and the young ones don't know how to do a thing for themselves or help out around here!'

"We all knew that the longer he went on, the worse Mom would get it. That's the way Dad worked—the bigger the frenzy he let himself get into, the harder he'd punch Mom. I remember sneaking glances at the younger kids, who were white with fear, holding their breath. Dad began by attacking Mom verbally about her person. 'I can't believe you! You're lazy and fat and you don't do anything worth keeping you for! I don't know why I put up with you!' Then he let go—"

Sheri stops for a minute and rubs her hand across her pale face. Then she starts again with a quivering voice, "Then my dad made a fist and smashed it into Mom's cheek so hard she spun around and fell to the floor. Dad just looked down at her and bellowed, 'Get up! Get up! I want you out of this house!' Mom lay on the floor, curled up like a baby. Dad reached down and grabbed her arm and pulled her to her feet. Then he pushed her through the living room and slammed her out the front

many lights on in the house. He gave us all a sermon on how wasteful and ungrateful we were. This grew into his ranting and raving about how hard he worked and how dedicated he was to keeping a roof over our heads, clothes on our backs, and food in our stomachs. He made sure we knew that if it weren't for him, we couldn't survive. We were just a bunch of extremely unappreciative brats. The implication was that Dad didn't have to take care of us, and if we were too 'bad' he might stop.

"On this particular night, as often happened, my mother stood by and listened to my dad, hoping to head off a more serious confrontation. It didn't work. Dad eventually turned on her, demanding to know why she didn't give him more support. She quietly responded, 'Yes, kids, your father is right—we need to be more careful about wasting things like electricity.' For some unknown reason, this really made Dad mad. He demanded to know how she dared patronize him! From this point on, in any situation in our family—whether the issue was lights or how to build a doghouse—my mother couldn't win. The lid was off my dad's emotions, and no one in the house could stop what usually followed."

Sheri's face still reflects the terror and anguish she remembers from those days. "Dad would raise his hand and shout at Mom, 'Maybe you want one of these, huh? Do you?' Mom would cower and whisper, 'No.'

"I can still see Dad shaking his head, hollering, 'I don't know about you people. If it weren't for me, you'd all go to hell in a hand basket.' All the kids were huddled together against the wall, too scared to move or say any-

8 Children: The Innocent Victims

Whether directly inflicted or hit by ricochet, child victims of domestic violence invariably bear scars that last many years, maybe a lifetime, if they do not work through the pain of the experience.

Sheri, now thirty-six and the oldest of five children, clearly recalls how watching her father abuse her mother affected her and the other kids in the family.

"When I was sixteen, my father had a large financial setback. The frequency and intensity of his abuse of my mother escalated dramatically afterward. He'd come home from his business tired and irritable. Any little thing could set him off on an angry rampage." At the time, Sheri's brother Paul was fourteen, Melissa was eleven, Darin was eight, and Cass was six.

"For example," Sheri remembers, "I remember one evening when Dad got home and thought there were too Tentro en la companya de la companya del companya del companya de la companya de

An abused wife should be cautioned against doing her own therapy or entering into any discussion with her husband that might involve negotiating how to get back together. A professional therapist should be part of the coming-together-again process.

In the next chapter, we will look at the innocent victims of domestic abuse—the children—and how years of watching their parents battle can permanently affect them if they are not given effective therapy.

must make changes before he can be restored to his family, then Chuck will begin the process of change.

What to Do When the Abuser Refuses to Get Help

More times than we wish to acknowledge, a husband refuses to go into therapy. Should a wife just forget the whole thing and go back to him anyway? Of course not! Nothing has changed. Her husband may so resent the attempts to get him to change his power position that he becomes more abusive than ever.

When an abuser refuses to go into therapy, his wife generally has few alternatives but to extend the separation indefinitely until her husband finds motivation to reconcile and rebuild the relationship or end it completely. Clinically speaking, external motivation is always a less desirable form than internal motivation. By indefinitely extending the separation, the wife raises the pain level in her husband to a point where he chooses to do something about the dysfunctional relationship. What he will choose is impossible to predict beforehand. He may feel that his wife and family are not worth the effort and seek to end their marriage. Or he may decide that his marriage is worth saving and will work hard to change.

If he decides to preserve the relationship, he will still be challenged with his underlying narcissism and selfishness. These need to be addressed in lengthy individual as well as marital therapy. Of course, the separation must be continued during this time. else's? Am I convinced that my opponent's action or attitude is bad for our relationship? How important is this issue? What is at stake? Am I overreacting? What have I just done? What am I about to do? What do I really want?

If you choose not to deal with the other person, other ways of dealing with anger include running, swimming, biking, conducting an imaginary dialogue with self and "you," banging on an old pillow, drawing, or writing out your feelings.

4. If you choose to express your anger at the other person, you need to do the following:

Deal with your feelings first by making "I" statements, not "you" statements: "I felt hurt when you ____ (and I am defending myself with anger)." Deal with the issue next.

Be sure both of you know the real issue: "When you do _____, I feel you don't care; I need to know you care. If you did _____, I'd know you cared."

Involve the other person in following these steps. 5. Be prepared for the possibility that the issue will not be resolved at this time. Expressing feelings and needs in an assertive way can be satisfying in itself.

Chuck is still in the process of learning to work through his anger. If Connie forgives him too quickly, without keeping him responsible to make the necessary changes, Chuck will not work at taking responsibility for his actions. When life becomes so unpleasant that he knows he again." A "clean bill of health" means that Chuck has learned to control and manage his anger properly. Chuck has to go through a prescribed procedure in order to begin to see why he deals with his anger by using violence. Dr. Stephens leads him through a series of steps that he will follow each time he feels angry.

1. Acknowledge that you feel angry. It is a legitimate feeling.

2. Try to define what is making you angry. Could it be a secondary emotion behind fear, threat, hurt, or something else?

3. Decide how you want to act about this anger. Do you want to interact with yourself only or with the other person? If you wish to deal only with yourself, consider the following:

a. Do you want to dump on someone else? If this is your decision, you had better be prepared for the consequences. The other person may withdraw. Will that satisfy you?

b. Do you want to win? Winning may increase feelings of resentment in the other person so that he/she feels cornered and may counterattack viciously.

c. Do you want to resolve it? You may have to deal with your feelings first before you are able to tackle the issue.

If you decide you want to increase understanding or intimacy with the other person, then you need to ask yourself: Is this my fight or someone into a situation that is still physically dangerous but now she also is further away from help because she trusted the one who gave her bad advice. To blindly forgive an unchanged abuser is to deny the deep problems surrounding wife battery. The husband will often display an overnight—and short-lived—change in behavior to show his wife she has every reason to believe him. Perhaps he will not lose his temper for a week or two. This does not mean he has genuinely changed, only that he is trying a new approach—suppression—to avoid confronting the severity of the problem.

Also, for a husband to blithely say, "You forgave me, now let's not talk about it anymore," again puts the entire burden of responsibility on the wife to keep the peace so that abuse never occurs again.

True forgiveness is much more complicated than blind forgiveness. Biblical forgiveness, the kind that is permanent, is always preceded by the offender's repentance. Repentance requires that we examine our actions and the motivations behind them; after examining them and realizing that they are improper we then renounce them, turn from that way of acting, and proceed down an entirely different path.

When true heart change has occurred, we are ready for confession—openly professing the wrong, acknowledging responsibility for the wrong, then following through with the changed way of living and acting.

Under Dr. Stephens' guidance, Connie tells Chuck, "I can't and don't forgive you, not yet. When you have finished therapy and are given a clean bill of health, then ask me

Asking for forgiveness is a heavy request. In so doing, you are asking that person to completely forget whatever you have lone to him or her. This is what the Bible says God does for us: "He is faithful and just and will forgive [aphieemi] us our sins and purify us from all unrighteousness" (1 John 1:9).

The problem is that there are conditions to this forgiveness. In 1 John 1:9 the conditions are to repent change the way you act or think, and confess—publicly speak forth this change of heart.

In his book Caring Enough to Forgive/Caring Enough Not to Forgive, David Augsburger gives five conditions in which we are not to forgive. Two of them apply here. One of these is when forgiveness is "one way." He says:

Many acts of invasion, injustice and injury are inflicted on innocent parties. In such situations, forgiveness may rightly be discussed as a one-person process, although even here the forgiveness is a partial, incomplete process which seldom concludes in real reconciliation and the recovery of relationships.¹

Augsburger also advises against forgiveness when it denies anger: "Unowned anger contaminates love, unrecognized resentment blocks the free expression of acceptance and affection. What is offered instead is angry love."²

When an abused wife listens to a well-meaning pastor or other church leader who tells her she must forgive her husband and return home, not only is she thrust back I did it" as you make your way toward your goal. Connie felt that way the day she enrolled in a beginner's oil painting class at the local adult school.

Forgive, the Christ Way

At one point in their separation, Chuck calls Connie and scolds her because she has not forgiven him for his past offenses as Christ commanded His followers to do.

"Connie," Chuck whines, "Christ said we were to forgive 'seventy times seven.' Can't you forgive me just this once so we can be a family again?"

After the initial flood of guilt Connie is so used to assuming, she gets hold of herself and thinks of the years of abuse she has experienced from Chuck. Then she figures that his forgiveness quota is probably exhausted.

What did Christ mean when He told us to forgive as God has forgiven us?

The passage Chuck quoted is Matthew 18:22 (kJV). The Greek word translated "forgive" in this verse, as well as most other passages having to do with forgiveness, is aphieemi. The word means "to send away, walk away from, leave behind, forsake." The same Greek word is used in Mark 10:28 when Peter says to Christ, "We have left [aphieemi] everything to follow you!" and in Luke 10:30, which describes how the robbers beat the man on the road to Jericho, then "went away, leaving [aphieemi] him half dead."

about reaching your goal. Carefully explain on paper what you want; don't use vague generalities or poorly defined ideas. Connie was a pretty good artist when she was in school. She had always wanted to take art courses to improve her skill, but Chuck ridiculed the idea until she gave up on it. So one of the items in her list was, "Take a course in oil painting."

About #2: Item by item, think about what you are doing now that could help you toward reaching your goal. When Connie was alone, she would often sketch a vase of flowers or another still-life scene that impressed her. Of course, when Chuck was around she hid her work or threw it away.

About #3: Decide what is working against you and stop it. This is where you may have to call on your friends to encourage you. Connie began to ask her friends for their opinions about her art work. They were very encouraging, but most of the time she thought they were just being nice.

About #4: When you feel you are about to slip, or have slipped, get your friends or your therapist to help you. Don't be ashamed to need the support and encouragement of others. It's okay to lean on others temporarily. Relying upon crutches while your broken leg knits is not a sign of weakness but of wisdom.

Finally, compliment yourself and give yourself praise when you have succeeded at changing certain things. Feel good about your growth. It's okay to feel that glow and button-popping pride when you achieve a major accomplishment. It's okay to bask in the warmth of, "Wow! suddenly, while injury was being inflicted, or gradually, as abuse continued. Since abuse takes place over a period of years, it is extremely difficult to reverse the survival defense systems abused women automatically put in action during times of being battered. The qualities that make an open, honest, intimate relationship possible are gradually destroyed. Warmth, openness, sensitivity, supportiveness, love, and vulnerability all yield to emotional separation, hurt, anger, defensiveness, callousness, resentment, and bitterness.

Change Self-defeating Behaviors

Part of Dr. Stephens' work with Connie included helping her to see that she showed self-defeating behaviors not only in her behavior toward Chuck's abuse but also toward other areas of her life. He had her take the following test so she could be aware of some of these behaviors. This is a good test for you to take as well.

- 1. What do I want to accomplish in my life?
- 2. What am I currently doing that will lead me closer to this goal?
- 3. What must I stop doing; what habits keep me from accomplishing my goal?
- 4. How much can my caring friends help me, and when do I need to get professional intervention?

About #1: By clearly defining what you want to accomplish, you will begin to get a picture of what you can do

fire or hit by shrapnel of the violence, or indirectly, as they witness the conflict and battery. It is difficult to overestimate the degree of injury to children as they stand by, terror-stricken, while one of the two most significant adults in their lives tears viciously at the other.

Children in such dysfunctional situations develop an ambivalence toward intimacy that mixes feelings of wanting to be close to others with those of being scared to death of that closeness. A young boy will learn a twisted concept of strength, of what it means to be the male in an intimate relationship. A little girl will grow up fearful, having intense needs to pacify the male or at least calm the stormy waters—as her mother models such a responsibility—while being scared to death of conflict. They both learn that male-female relationships are exploitive, nonsupportive, noncaring, and conflict-saturated.

Damage done to children from abusive homes can be more extensive than that inflicted upon the wife. Children do not have a defense system already in place as adults do. It takes a long while for a child to develop the skill to defend himself/herself physically and psychologically against the kind of damage done by domestic violence.

Chuck's greatest challenge will be to change the way Connie feels about him. During her marriage to Chuck, Connie was exposed to both physical violence and psychological abuse. In order to defend herself against Chuck's abuse, she has had to shut down those parts of her that were being injured: her self-esteem, emotions, love, and concern for her husband. She did this either tions on a very deep level, because they operate below the threshold of his awareness, and this is something he does not want to do. Why should he give up a position that feels good? Relinquishing power would mean, to his way of thinking, losing status and position.

Dismantle, Examine, Restore

At this point in the counseling process, Connie and Chuck move into the second phase: Dismantle, Examine, Restore. For Connie, this second phase is a time of healing and decompression.

For Chuck, dismantling means the tearing down of oneself, one's belief system (not religious ideals but those unexamined beliefs that keep us from conforming to the image of Christ in our everyday living), and dismantling the dysfunctional aspects of one's reactions to reality. The dismantling of one's personhood is an agonizing process; it cannot be accomplished in less than six months. Chuck will need to get to the place where he recognizes that his marriage is worth saving. He needs to see Connie not as an object to possess but as a person who is cherished and loved as Christ loved the church.

When Chuck is able to examine his power assumptions and becomes willing to challenge the way he thinks and acts out these assumptions, he will be into this second phase of the counseling process. He has to work in several areas where he has caused injury: in the children; in Connie; in himself. His children are victims of domestic abuse either directly, when they are caught in the cross

Remember how we talked about Chuck's mind-set? He needs to challenge his power assumptions about his marriage before he will be able to begin the road to recovery. Tell Chuck to continue with counseling, that you won't go home until he completes all the therapy. That's the only way we can be sure it's safe for you to move back home."

In this first phase of Separate, Disentangle, Detach, disentangling is similar to demolishing a building that has deteriorated beyond repair. It needs to be broken down, swept up, and hauled away. Such a process takes time. Connie needs to be de-stressed. She needs to recover from trauma and open wounds. Tender places have to toughen up to withstand reality again. Perhaps issues in her own family history will have to be dealt with.

Chuck, on the other hand, needs this disengagement to reveal his dysfunctional behavior. He has spent a great many years creating this power-based relationship, and tearing it away produces trauma for him as he sees that power shift from himself exclusively to a power-balanced structure. Since he has everything to lose and nothing to gain, in his eyes at least, he will resist as hard as he can. That is why, when Chuck gets Connie's message that they have to continue with the counseling schedule, he moves into the fourth wave: denial again.

Chuck tells his friends, "See! It's her fault. What do you do with a wife who won't submit?" Chuck still has a long way to go before he recognizes what a healthy family relationship is. He has acted on a mind-set that took decades to form. He needs to challenge his power assump-

may excuse the way he treats his wife as the way "my old man treated my old lady—with firmness—and they got along fine." Many abusers do not know anything other than what they were taught in their own homes.

When Chuck finds out that there is strong theological proof his arguments are wrong, he goes to see Reverend Johnson. Reverend Johnson shows him the same passages he had shown Connie about love, forgiveness, and conforming to the image of Christ. He prays with Chuck and gets him to say that he now sees the light. He is healed of his abusive behavior.

This incident helps Chuck move toward the typical third reaction: *shallow repentance*, or pseudorepentance. He calls a prearranged location and asks that Connie call him back. When she does, he tells her he is a changed man. "Connie, you're right. I didn't know I was being such a rat. From now on, though, things are going to be different. You and the kids come on home. We're gonna be a real Christian family."

Connie cries when she hangs up the phone. It sounds so wonderful. She really does love Chuck and misses him terribly. She wants to set things right so badly that she is very close to doing something terribly wrong. But she has an uncomfortable feeling that it was too easy. Dr. Stephens had told her it would not be a quick cure. She calls him and tells him the situation.

"Connie, this is the most difficult phase to deal with in your relationship with Chuck," Dr. Stephens explains. "It's like putting a Band-Aid on a compound fracture. Chuck is still the power-based adolescent he always was. she feels she has someone on her side, she has begun to see more clearly how terrible her family situation is. She can see how her children are being affected by Chuck's violence. Mustering all her courage, she and the children move out of their home and in with the friend of a friend, someone Chuck does not know, who wants to help. Chuck has to be thoroughly convinced that Connie will no longer tolerate abuse.

When Connie and the kids move out, all their friends know that things are not going well in Chuck and Connie's marriage.

Chuck's first reaction is *denial*. He tells his best friend, "Connie's just going through some sort of phase. She magnifies every little spat we have." He marshals every piece of evidence he can to show that he could not possibly be an abuser. However, his friend has sometimes seen bruises on Connie that look suspicious. He suggests maybe it would be a good idea to follow through with counseling.

After a couple of visits to Dr. Stephens' office, Chuck begins to realize he cannot get out of the accusations easily, so he takes another tack. He begins to *justify* his actions. At lunch break at work, or when he goes to men's Bible studies, he turns to Scriptures that talk about the man being the head of the house, and how a woman should submit and, like his children, obey him in all things. These arguments always involve taking verses out of context to support the abuser's right to treat his wife as he chooses.

If the abuser does not have a religious background, he

place where she could again deny the gravity of her situation and convince herself it really is not as bad as she thought it was. This will probably happen even if she moves away from Chuck for a while.

Chuck, for his part, has spent years convincing Connie that she is to blame for his anger and their problems. He is always the innocent party. He can deny any responsibility. Therefore, he is going to resist separation and therapy. After all, he does not believe he is the one who needs to change.

Even if Chuck promises never to touch Connie again, separation is vital. He has been unsuccessful at creating a loving relationship on his own, and no amount of promises to be good from now on, without a lot of deep change, will make a positive difference in their relationship. He needs to work hard toward the privilege of regaining what he has lost. He must undergo the discomfort of losing his wife and children so that he can do some deep, honest, no-holds-barred soul-searching to come to terms with those things that have made him unable to control his anger.

Connie needs to move out of the place of pain and Chuck needs to move into it.

Dr. Stephens knows how hard it is for an abused woman—especially a Christian woman—to face the idea of separation. "If you don't separate soon, I'm afraid you may suffer serious injury; I know the longer this abuse goes on, the greater your children will be affected emotionally," he adds.

Dr. Stephens' statement frightens Connie. Now that

Separate, Disentangle, Detach

Attacking the problem of wife battery means attacking the structure of the relationship in depth and from within, not just treating the symptoms. To do this effectively, it is vital that the wife separate herself from her abusive husband before treatment begins. But separation is hard. We mentioned in an earlier chapter some reasons abused women find it so difficult to leave their husbands; it is just as hard to separate when therapy begins. Her first reaction is to want to return to the old familiar, comfortable setting she was accustomed to. Also, a Christian woman will easily fall prey to the trap of protecting her husband because she is taught to respect, honor, and obey him, whatever the cost.

Without separating from her husband, she will be unable to see clearly that he is the one who needs to change. Separation makes objectivity possible. Also, a geographical separation is essential for the family's physical safety.

The psychological complexity of the problem of abuse requires that when therapy begins the abusive husband not be where he can easily continue to control and manipulate his wife. He needs to be removed from the environment that allowed his destructive behavior.

"I would suggest that you separate from Chuck until some changes occur," Dr. Stephens says. He watches Connie's face when he makes that statement. He is pretty sure she will resist this suggestion. But separation is vital. If she stays with Chuck, Connie will get to the God's healing power to undo all the damage that has been done. None of these areas should be excluded.

It is important that an abusive husband be directly confronted with what he has been doing. He needs to get involved in his own therapy as well as in family therapy. He will have to do a very thorough job of soul-searching. He needs to get to the point where he can own up to his full responsibility in the relationship, where he no longer blames or projects his own responsibility onto another. He has to look at his history of significant relationships, beginning with his relationship with his parents, to identify dysfunctional patterns. He will need help in managing his anger and in understanding why he feels the need to strike out.

Each type of abuser we spoke about earlier in the book will need a different kind of counseling approach. No generic approach can be successful with all types of men. Therapy has to be tailor-made to each person, and the therapist has to be thoroughly equipped to deal with the unique problems dysfunctional men bring with them into the office.

Counselors recognize three phases a couple in this kind of counseling undergoes. Each phase takes from four to six months. The phases are (1) separating, disentangling, and detaching (so that wounds can heal); (2) dismantling, examining, and restoring (personal patterns of behavior); and (3) coming together again. In this chapter we will talk about the first two phases. Then it is necessary to discuss a very difficult subject: forgiveness. Chapter 9 will cover the third phase in the counseling process: coming together again.

loss. This revamping of his mind-set is what Chuck has to do before he will be able to function without abusing his family.

The Process of Beginning Counseling

Connie realizes that this process of starting over—for herself as well as Chuck—is more than she can handle without some professional help. She looks around until she finds a therapist who is sensitive to what the Bible has to say about marriage and also knows that every person—man and woman—is equal in the sight of God and deserves to be treated like a child of God. Dr. Stephens listens to what Connie says—and believes her! It is not the first time he has heard a story like hers.

"Will Chuck come to see me?" Dr. Stephens asks Connie.

"I don't know. He knows I talked to my pastor about our home situation and it made him uncomfortable, but it didn't change anything," Connie replies.

"It's more complicated than that, Connie. Recovering from an abusive life-style takes a lot of time and effort—especially on the part of the husband—and a lot of loving care for the children in such a home. You have all suffered so long that there are deep wounds which will need lengthy healing," Dr. Stephens explains.

One of the earliest results of domestic violence is the complete and almost irreversible erosion of trust, respect, and love. I say "almost" irreversible because it will take a great deal of counseling, work, prayer, and surrender to

The mind-set from which the male abuser operates needs to be restructured entirely so that his power base is changed to a servant base. Herein lies the problem. He must willingly give up the very power he has staked his life on. This is no small task. It is an arduous, difficult, time-consuming process. It involves rather lengthy psychotherapy, a time that is fraught with frustration and setback. He has to be led to rewrite his life script. To do that means he has to step outside of all his relationships, including his marriage and family life, so that he can see how his actions dictate and then reinforce the script he lives by. He has to replay his life story just to see how his script came to be the way it is; then he must painstakingly rewrite it, bit by bit, until it becomes one of healthy relating instead of power-based relating.

One of the hallmarks of healthy functioning is the "democratic character structure." This refers to the idea that a healthy individual is one who feels he neither has to be one-up or one-down. He feels equal with other people. He can be either a team leader or a team member, depending on the requirements of the situation. He does not have to dictate in every situation. He can focus on the job and work to get it done, regardless of power or rank implications.

Contrary to the democratic character structure is the fixated authoritarian adolescent who has to control most situations he is involved in. He calculates ways of securing or displaying power. Fortunately, most men mature into a stage where power is less crucial. They are able to give up the accoutrements of power without experiencing

one day to turn around and start all over fresh, just flip to a new page and begin to live a normal, loving, trusting life together.

The process of changing mind-sets and creating new patterns of behavior will take almost as long as it did to establish their present way of treating each other. This time around, they do not have the advantage of coming into their relationship not knowing each other's mind-set as they did when they first met. Rather, they are already too familiar with each other, and that overfamiliarity can work against the development of a new marriage dynamic.

Revamping the Male Mind-set

How do you go about changing a mind-set? The superior-male mind-set is one of the reasons men become abusers. The male concept of power is very adolescent. He collects power and he displays it. He won't share it or distribute it. He does not use it to support someone else or seek responsibility. He uses it to establish rank, power, position, and status.

A man who continues in this mind-set as he grows older may soon become mean spirited and vicious. Once he has moved into a position he has acquired by power, he must continue power-playing to keep from losing it to the next power-player who comes along. Having once established this power niche does not mean he gets to keep it without continuing the same methods he used to get there in the first place.

Therapy: How Can Professional Counseling Help?

Even though he was a sincere, concerned, and loving minister, Reverend Johnson was not the one to help Connie with her problem of an abusive home life.

Unlike Connie, most victims of abuse do not seek therapy on their own. Usually they are referred to a counselor by their doctor, pastor, a woman's shelter, or someone else who has experienced abuse. However, Connie knows she has to have help. If she had looked for help when Chuck first began to abuse her, their relationship would have been very healable. But after a certain length of time, recovery is much more difficult. It involves more than the healing of bruises or broken bones. It involves undoing familiar patterns that have developed over the years together. She and Chuck will not be able to decide

Application of the Company of the Co

- ____26. You are able to think for yourself and make your own decisions.
- 27. You put your best efforts into what you do and get satisfaction out of doing it.

How did you do? Pick out one that was a strong No and decide what you can begin to do to renew your mind about that one item. Or, if you are not ready for a strong one, choose an easy one, like number 25. Set a realistic goal to begin working on renewing your mind about that strong No.

In the next chapter we will see how therapy can help you find peace in your life.

to make things different. Take our mental health, for example. The Apostle Paul, in writing to the church at Rome, said, "Do not conform any longer to the pattern of this world, but be transformed by the renewing of your mind. Then you will be able to test and approve what God's will is—his good, pleasing and perfect will" (Romans 12:2). If Paul encouraged us to renew our minds, it must be possible. What are some indications of a healthy mind?

The National Mental Health Association published a list of attributes a person with good mental health has. There is a place beside each of these for you to indicate Y for Yes or N for No. First, honestly test yourself, then go back and see how you think your spouse would rate him/herself.

	1.	You feel comfortable about yourself.
	2.	You are not bowled over by your own emotions—fear, anger, love, jealousy, guilt,
	3.	or worry. You can take life's disappointments in stride.
in the	4.	You have a tolerant, easygoing attitude to- ward yourself as well as others; you can
		laugh at yourself.
	5.	You neither underestimate nor overestimate your abilities.
<u>Laure</u>	6.	You can accept your own shortcomings.
		You have a healthy self-respect.

look like? What does it take to create such a phenomenon?

The people we have been describing probably seldom saw close up a healthy marriage modeled for them as they grew up, so neither husband nor wife has any idea of what one looks like.

Kahlil Gibran, in *The Prophet*, speaks of two oaks standing near each other—not so near that the shadow of one stunts the growth of the other, but near enough so that their roots intertwine and become like one system. Their relationship is one of unique creativity because each life creates, grows, evolves, and develops individually, forming a relationship that is also creative and growing and evolving and developing.

Sounds great! you say. On paper! But exactly what does that beautiful picture mean in real day-to-day living? We've already discovered that a marriage is made up of two people who have something profound in common: male and female are both made in the image of God. After that, we are very different. We have also discovered that few of us are privileged to come from perfectly functional homes where both mother and father had a healthy, wholesome outlook on life in general. We create our own individual mind-sets from those people and events that surround and influence us. Some of us get stuck in our maturing process at a bend in the road and do not progress any further.

All kinds of roadblocks, hindrances, and discouragements stand in the way of a healthy relationship with another person. But that does not mean it is useless to try

promises. He has successfully made *his* recovery *her* responsibility. Not only that, he has neatly and successfully shifted all of his responsibility onto God to make things happen. He makes God an errand boy who will satisfy his childish demands. When he now sins by assaulting his wife, he can say that "the devil made him do it" and call on God to again forgive him and restore him to full fellowship (and kingship).

All of the New Testament letters exhort believers to act responsibly and practice discipline. Some fellowships teach their members to seek miracles and instant solutions rather than patiently work through the trials of everyday life. Claiming the miracle cure without following what the Bible teaches about the maturing and self-discipline process is irresponsible and not a legitimate route for the abuser. He must claim personal responsibility for his problem and seek a deep and permanent change. True change takes time and work and in these kinds of situations requires the help of a skilled change agent.

The abused woman needs to be wary of sudden miraculous changes in her abusive husband. She should not settle for a lie and a shortcut in lieu of genuine change. In the next chapter we will see how counseling with a skilled change agent can help you in an abusive situation.

Analyzing a Healthy Relationship

What does a happy, compatible, functional, satisfying, long-lasting, mutually rewarding, "oneness" marriage

A charming love letter accompanying a dozen long-stemmed roses and a fabulous display of tears gives her enough evidence that a supernatural event has taken place. She has fallen prey to the belief that all she has to do to get a miracle is "name it and claim it" with enough faith to see it come about. Sarah tells her story: "Jim says he will never hit me again. He says his behavior for the past four and half years was caused by his not letting God work in his life. He says that he and Pastor Rick prayed that he would not be angry anymore, and I have to follow through and not doubt God's work in his life."

Sarah knows if she does not accept this instant-miracle solution, some of her friends will accuse her of having "weak faith." Also, she fears that if it is a miracle and she turns her back on God, she will be denying His power. Then her church will see her husband as the victim. Jim will look like a godly hero who has overcome great trials and emerged the victor. He may even stand up before their church and give a testimony as to how he was once an abuser but now he has changed, thanks be to God. Time will tell. Of course, there are miracles associated with being born again as Christ described. But the Apostle Paul reminded his readers that new birth frees us from the bondage of having to sin; it does not take away our free will to continue in sin.

The abuser, by proclaiming his "decision," may create a comfortable escape from the uncomfortable reality that he needs to begin the long process of working through his problems. Meanwhile, his wife, the victim, is left to wonder if this is just another one of her husband's empty said he did not know it was wrong to beat his wife until he was separated from her and put in jail with other offenders. That was the first time anyone had ever challenged his right to abuse his wife. But his separation was accompanied by the next step.

Step #6: Get individual and family therapy. During a sabbatical, the husband can consider how his mind-set has contributed to his abusive behavior. He can learn to reprogram, if he has someone to guide him. Reprogramming will help a man to know himself deeply enough to see how he reacts in situations that give rise to frustration, pressure, and finally, explosive abuse. Then he can bring about some kind of self-control.

Children also need to be in therapy. By the time domestic violence reaches the point where you take flight, your children have been influenced in incalculable negative ways by the abuse. They need to be told that intimidation and violence are not what marriage is all about.

Step #7: Avoid the quick-fix miracle. The abused woman sometimes faces a problem that is unique to a Christian setting: her husband tells her that a miracle has occurred. He has seen the error of his ways, and he is healed. He will never again abuse her in any way. He has suddenly changed from a toad to a prince.

To back up her husband's revelation, the church tells her that "yes . . . miracles happen if you have enough faith." Here again, she discovers that the burden of responsibility for the problem is back on her shoulders because it is up to her to accept God's "miracle" and place herself back in her home setting, even though she fears the change was too quick.

it. The healthier a man is, the more he will be able to reconcile himself to the importance of a sabbatical.*

A separation will provide a time for an abusive husband to search out the causes of, and take responsibility for, the disordered pattern of his life. Recoupling after separation, when the husband has had a chance to reexamine and reprogram his mind-set and the wife has had a chance to heal, has to be done gradually. The damage to their relationship has been great, and healing will take time and much patience.

At first, after they reunite, old habits will spring on their own back into action, and the couple will find themselves drifting back into old familiar ways. It will take a while to extinguish old responses and patterns of behavior and implant new ones. The wife should be resolved to not move back into the old relationship. Her husband, on the other hand, is eager for rapid and full restoration of his kingly status.

Separation from wife and children could help your husband recognize that the way he is treating you is not acceptable. The young man in the TV series on wife abuse

*The Apostle Paul, in speaking to the Corinthians, said that a "husband should fulfill his marital duty to his wife [sexually], and likewise the wife to her husband." He went on to say that if they separated "by mutual consent . . . for a time," they should "devote [themselves] to prayer" (1 Corinthians 7:3, 5). This is the kind of sabbatical a husband and wife should consider when they are caught up in an abusive relationship. Spiritual retreat is a time when a man and woman can seek Christ's mind and spirit, which is the purpose of this kind of separation. It is important to see that an abusive relationship is antagonistic and offensive to what God ordained in marriage.

resume living with her abusive husband; it can also give her time to heal from physical or emotional wounds.

Contrary to popular belief, separation does not have to lead to divorce. A sabbatical by mutual consent—or out of necessity to protect wife and children—can be a time to reflect upon and examine the nature of the marital relationship. In today's world, pressures on father, mother, and children are very great, so great that tensions build and become more than a couple can bear. Just consider for a minute the many demands that are placed on your family. Even children are encouraged to participate in more and more activities. For these families, a time of separation with perhaps a guided and deliberate consideration of their situation and the events in their lives that brought about the deterioration of the relationship could mean a new beginning.

Such a process is very similar to decompression. Pressures build in individuals and within families. It is important to pull away periodically and spend some time alone, examining one's heart and soul and thinking through one's priorities.

Most abusive men resist the idea of separation because it means the king is removed from his court. To such a man, it is the same as losing his power base. This leaves him without a kingdom to rule.

Separation can be painful to all involved. However, it may be necessary for both the abused family and the male abuser. However, the more urgent it is that the abuser be apart from his family, the more he will resist can analyze what abuse is, how it began, and how you have become a captured part of the pattern. You should first approach abuse with this thought: I did not want to be abused. I did not consciously or unconsciously do anything to bring about abuse. His anger is not something I caused. It is something that is amiss in him; he has not learned how to deal with anger. Until you can accept that fact, you will not be able to go further toward stopping abuse.

It will do no good to make a list of things to avoid doing that you have been punished for before, because your husband will make his own list of new things to abuse you for. The triggers are all within him, and he is the one responsible for controlling them. It is his problem, his fury, his rage. When you realize that you are not at fault, your husband is, then you will run into another barrier: your man cannot acknowledge that he is the problem. For a long time he has gotten away with blaming you—and other people—for his problems. Until now you have agreed with him, thus helping perpetuate the cycle. Now he has to face the fact that he alone is responsible for his inability to handle his anger.

So you pack a few belongings and go with your children to a women's shelter for domestic violence. Sometimes you can go to your parents' home or to the home of a friend, but that is the first place an angry husband will look.

The Christian community usually scorns a separation from a relationship. However, such a separation can give an abused wife time to consider her fate if she is to else about a problem is a way to begin to see it in proper perspective, especially as you watch the upset in the face of the person to whom you are telling your story. You can begin to see that your abusive situation is not a normal or acceptable one.

Step #3: You must go, along with your confidant if need be, and make a police report regarding the physical violence. This step is the most difficult for many reasons, but it is necessary because you and your family need to be protected from further violence as you take additional steps to change your situation. Also, in the event that you or your children are again assaulted by your husband, a police report can help bring legal action against him.

Naturally, this is hard because no one wants to expose to humiliation someone she has loved. But as long as the abuse is kept quiet, the abuser is free to continue battering.

Step #4: Call the pastor of your church—if he has not yet been told about your situation—and make an appointment to talk to him. Take with you the person you confided in under Step 2. Explain the situation to the pastor. Do not be open to any denial of the situation or treatment of it as unimportant or possibly even triggered by you. The pastor may indicate that if you were more obedient or submissive or spiritual, your husband would not have cause to strike out. Blaming the victim is very easy to do, especially by pastors who have bought into the superiormale mind-set.

Step #5: Separate yourself from the abuse so that you

ever, may be both emotionally able and trained to handle confidences of this type.

Maybe your family would respond favorably, if it is not also an abusive family. What about your best friend, the one you grew up with?

If you have any money—and sometimes even if you don't—you can appeal to women's advocates and support groups. Many larger cities have shelters where you can go and talk to people who can help you find your way out of this difficult situation.

If the first person you approach does not respond in a favorable way, try someone else. Suffering in silence is a hard habit to break. Standing up, speaking up, and being heard and seen is sometimes difficult for the battered woman to do, but it is something you must do if you are ever to break out of the cycle.

Exposing a wound to air helps heal it. Exposing an abusive husband to the world sometimes brings about the help you need to get out of your possibly deadly situation. It might also help bring your husband to the place where he realizes he needs help. However, external pressure by itself is not enough to bring about real change. Such help is generally short-lived and superficial, mostly cosmetic to make the man look better. Deep change is needed before the relationship can be healed, and deep change rarely comes from external motivation. But calling attention to the problem may bring the abusive husband to the place where he gets the help he needs to change his abusive pattern.

If nothing else happens, speaking aloud to someone

have to make some concrete changes before that happens. Below is a step-by-step procedure for you to follow. Consider all the positive things that can be yours if you no longer live under an abusive situation, then begin to do something to help yourself.

Step #1: Understand that abuse is wrong. Every woman deserves to be treated kindly and gently. Because abuse is wrong, an abused woman must learn to say, "Stop, I won't tolerate this. I won't take it anymore." Obviously, this is not going to stop the abuse, but it is the first step. This is hard to do because as a little girl you may not have been taught that it is okay to be assertive in a relationship, that it is okay to disagree. You may have been told all your life that peace comes about by shutting up and submitting.

Step #2: Find someone to talk to about what is going on. A woman who is battered tends to keep silent about it, especially if she believes it is her fault. She feels tremendously alone because she cannot think of anyone to talk to who would believe what is taking place in her life and could help her sort through the problems. She knows that people think her husband is as kind and loving at home as he is in other places. Many male batterers look like Prince Charming on the surface, and when people hear that home is anything but ideal they harbor doubts about the information.

The first person most battered women talk to about their problems is their pastor, and as we have already said, often the pastor is not equipped to handle such information. Some pastors or other church leaders, how-

10. I can't cope with my problems.	F
으로 가게 하면 어린 경험을 맞지 않아? 나는 사이트 아이트를 잃어야 하면 하면 하는데 하는데 하는데 하는데 하면 하는데	F
12. If people really knew me, they wouldn't like	se
그러지 어릴 생생님이 그리는 아ુ프라의 방사 구름에 있다고 하면 이번에 가려면 하면 어떻게 되었다. 그 사람들은 사람들은 사람들은 사람들이 살아 살아 살아 살아 살아 살아 들어 없는 것이다. 그렇게 살아	F
13. I get embarrassed and blush easily.	\mathbf{F}
14. If I hadn't been so stupid, I wouldn't be in th	ıe
	F
15. I often call myself stupid or other names. T	\mathbf{F}
그는 가장에 없어 있었다면서 아이를 가는 사람이 있는 것이 없는데 하다고 있다면 되는 사람들이 하는데 하는데 이 사람들이 되었다는 사람이 되었다면 되었다면 모든 그렇게 되었다.	\mathbf{F}
17. A person's value is based on his accomplish	h-
4위에 있었습니다. [2] 그렇게 모두다시면 하나에서서를 하게 보는 모르는 하나 하나 사이들이 되어 있는데, 하는 사람이에 들어가는 모르게 되었다면 모르는 이번 가는 모르는 이번 제품을 했다. 제공	F
18. Losing is worse that dying because you have	to
	\mathbf{F}
19. I wish I had enough energy to do regular exe	r-
cise. T	F
20. I always eat food that's not really good for m	e.
T	F

How did you do? If you put a T after more than three or four of these statements, you may have a problem with self-esteem. If you responded T to more than six or seven, you should work toward a more positive belief about yourself.

Take Steps to Help Yourself

One of the most difficult conclusions an abused wife has to reach is that no one can help her until she takes the first step. Improving your self-esteem level is a good place to begin, but that will not stop the abuse. You will learn to say no to the child's demands to do things for him and tell him to do for himself. But to say no to the adult "child" will probably provoke him to abuse the person who says no or whom he feels he can blame for his predicament. Both of these types of men go into marriage with a highly unrealistic set of expectations as to what marriage is and what it can do for them. The male with too-high self-esteem wants to be adored, worshiped, and served. The male with too-low self-esteem wants to be rescued, lifted, encouraged, cheered up, buoyed up, pampered, and babied. No marriage partner can meet all that is expected from either of these men.

Take a minute to evaluate your own self-esteem. In the following test, respond to each statement by circling T (True) or F (False). Don't take too long to think about the statement; just give your first response.

1.	I hate looking in mirrors.	Т	F				
	What I show the world is not who I real	ly a	m.				
		T	F				
3.	People don't like me.	T	F				
4.	I never talk about my successes.	T	F				
5.	5. Life is hard enough without taking extra risks.						
		T	F				
6.	I am physically unattractive.	T	F				
7.	People will take advantage of me if I let	the	m.				
		T	F				
8.	I've done a lot of things I regret.	T	F				
9.	I am angry most of the time.	T	F				

thwarted and angry. His wife feels as if she is being leaned on.*

The other theory which has equal amounts of supporting evidence is that the male abuser has too low a selfesteem. Over is the key word for this male. He tends to overcompensate for feelings of inadequacy; he overcompetes; he overproves himself. The tragedy is that he can never be self-satisfied, he can never rest or let past successes influence his present sense of self-worth. He is on a treadmill of proving, proving, proving. Naturally, he experiences anger and depression. This person always feels empty. No matter what is fed into his "well of needs," it is always empty as far as he is concerned. Since the well is bottomless, his needs are never fulfilled because they are not appropriate adult needs but are infantile in character.

At some point in the life of a child, a parent has to

*Years ago I [Brik] was demonstrating a variation on this point in a church. To illustrate, I called a big, strapping friend and his wife to come up front to participate in an object lesson. I had the wife, a rather petite lady, lean on her big hunk of a husband as I went on with my presentation. After a few minutes, it became apparent that this hulk of a man was beginning to tremble and perspire with the nottoo-heavy but constant weight of his wife on him. Before long, his wife began to complain because of the stress she was under to do the leaning.

I let them continue in that position for a while without acknowledging their discomfort. Pretty soon, the husband could not support his wife anymore, so they adjusted their positions. At that point, I talked to them about how fatiguing it was for him to be leaned on so persistently and for her to do the leaning. The point was made, much to the delight of the audience and more to the amazement of this couple who were for the moment personifying the male leaned-on

pillar of strength and the male-dependent wife.

Figure 3 Escaping the Cycle of Low Self-esteem

Feelings of healthy reality-based self-confidence and self-esteem established	Feelings of Inferiority
Solid self-concept—healthy accep- tance of mixed bag of "Good ats" and "Not so good ats"	Temporary setting aside of feelings of inferiority
Realistic self-concept built on combi- nation of "Good ats" and "not so good ats"	Objective—not subjective—reality- based self-appraisal: Who am I; what am I; what are my skills, competencies, aptitudes, talents
Self-concept building and enlarging on occasional defeats but mostly wins	Objective reality-based self-concept begins to form
Some setbacks—smaller, less pain- fully felt—but mostly growth	Realistic plan of attack to be established
More successes—some defeats	Creation of small sure-win risk/task
Further enlarged plan of attack	Small successes—small gains—start of accumulation
World enlarges further	Add on to plan of attack
Self-concept building on some defeats but mostly wins	Creation of larger sure-win risk/tasks
Small setbacks but mostly successes	Larger successes—larger gains
Some successes—some defeats	World enlarges in proportion to gains made

is to let these toxic messages get diluted and finally washed away by messages that say you are a very worth-while person in the eyes of people who care deeply about you.

Do not listen to other people who may try to tell you that you are overreacting. Well-meaning church members who do not understand or cannot relate to what you are going through often see nothing wrong with a relationship between a superior male and an inferior female. Fortunately, less and less of that kind of thinking is prevalent within the church community.

Figure 3, Escaping the Cycle of Low Self-esteem, shows the progress an abused wife can make toward getting out of what appeared to be an inescapable situation.

Consider the Abusive Husband's Self-esteem

There are two prevailing theories about the abuser's self-esteem. Some evidence suggests that an abuser has a sociopathically high self-esteem, which allows him to feel as though he is entitled to whatever he wants merely for the wanting. When he does not get something he wants, or things do not go the way he wants them to, he gets angry, then pushy, sour, and abusive. This anger comes from external frustration and internal expectations. This male has been indulged to the point where he is spoiled. He will throw temper tantrums when he is denied anything he feels he has a right to. When reality does not meet his need, which is usually the case, he feels

please her husband enough and their marriage will fail. Often, this woman has the same idea about her relationship with God: she must work hard to please God or He won't like her either or help her when she calls on Him. She does not understand the concept of unconditional love: she is loved not because of what she does but because of who she is.

Following are a few things you can do to help improve your self-esteem:

Develop a circle of friends who care deeply for you and on whom you can rely.

Share your concerns with them and lean upon their strength. At first, you will have to become very dependent upon their strength; it is not a sign of weakness to have to lean on a network of proven, reliable friends from time to time. You will not be completely dependent on them forever.

Listen to their input. If they want to help, let them help. Let them reach out to you and carry your weight for a while.

Spend time with families who have good, healthy family relationships. Watch what happens as they interact with one another. Let the good feelings from these healthy friendships percolate down to the core of your being, where they can begin to make you feel good about yourself. More often than not, your self-esteem has been undermined by messages from your husband that undercut your self-worth. You have to get these messages out of your system, just as you would rid your body of poison that has had a toxic affect on you. The best way to do this

low self-esteem. What is self-esteem? It is the level of respect you hold toward yourself, ranging from very low to very high.

Generally speaking, a woman with poor self-esteem stays in an abusive relationship because her self-concept does not encourage her to look for anything better. Individuals with low self-esteem generally also have low self-confidence that restricts them to only those activities they know they can succeed in. These people avoid failure. Their motto tends to be, "Avoid failure, aim low," or "Take no risks." An abused woman would rather try to make the best of a very painful situation than leave it for something that is unknown and therefore scary. Often she is in a familiar situation because she was also abused by her father, mother, or both.

An abused woman who does try to improve her situation by behaving the way she thinks her husband wants her to finds herself in a no-win situation, because the more she tries to change the situation the more her husband works at tearing her down so he can stay in control. The harder she tries, the worse the abuse becomes.

In some marriages, this scenario is a little different. A husband will let his abused wife work as hard as she can to keep things the way he wants them. The harder she works at it, the better the relationship is between them, and he has not had to contribute a thing toward it. The quality of their relationship is totally in the hands of the wife. She does all the work while he gets all the benefits. She may go on like this for decades, never realizing she is abused. She lives in fear that she will not be able to

Solutions: How Much Can You Do to Help Yourself?

What can you do to stop your husband from abusing you? Family members and friends who are aware of your predicament often feel confused, angry, frustrated, and frightened at what you are going through. If you have confided in your pastor or doctor and have not been given any real help, read on and see how you can either help yourself or find help for you and your family.

We cannot cover all possibilities, but we will offer some practical steps you can take to begin to better your situation.

Work on Your Level of Self-esteem

Lenore Walker, author of *The Battered Woman*, found that both the abused wife and her abusive husband have

eminant perfect after any at being the second of the secon

AND THE PROPERTY OF THE PROPER

9. It is easier for me to cope with other people's problems than to confront my own.

T F

10. When I see or hear about happy couples, I get twinges of self-pity or envy.

T F

If you answered True to one or more of the statements, you need to take charge of your life. Accept the fact that life holds a variety of disappointments for all of us, but we do not have to buckle in defeat. We can change most unpleasant circumstances if we work at it.

Be aware of your pattern of self-defeating thoughts and emotions and take steps to change your own mind-set. Buy or check out of the library some books on improving your self-esteem and begin to practice what the authors suggest. Find a way to get professional help. Begin to keep a daily journal of your reactions to what is going on in your life so that you can monitor your progress toward change for the better.

separate the individual selves. When God said that the two shall become one flesh (Genesis 2:24). He did not mean one disappears into the other, lives for the other, takes responsibility for the other, stands in for the other in such a way that it takes away from the other. Whether we are single or married, God sees us as individuals, each equally important, with unique talents and gifts. A husband and wife should come together without the disappearance of one. It is a partnership, not a fusion, or much worse, a disappearance.

In the next chapters we will look at other ways an abused wife can either help herself or be helped by others. But first do the following exercise, "Where Are You Now?"

Answer T (True) or F (False) to the following statemen

nts.	ig sta	Le-
1. I keep hoping a miracle will happen t	hat w	vill
improve our home life.		F
2. I feel as though God has somehow assign	gned :	me
to a life of long-suffering.	V 750 -22	F
3. I think most men are basically little	boys	in
grown-up suits.	T	F
4. I feel ill, depressed, or fatigued some pa	irt of	ev-
ery day.	T	F
5. I am much more pessimistic than I was	s whe	n I
was younger.	T	F
6. I am constantly on edge and easily star	rtled.	
	T	F
7. I sometimes go to bed during the day.	T	F
8. I bury myself in work to keep busy.	T	F

What Is Co-Dependency?

To the above suggestions from Kenneth Petersen we would add one more: Become familiar with the meaning of the word co-dependency. Co-dependency involves the unhealthy fusing of two lives to the detriment of both partners. One partner is more responsible, more accessible, more dependable, more reliable, more mature than the other but does not necessarily know it. Such a person—the co-dependent—nobly submerges his or her life into the other's without any inkling as to the injury being done to both of them. Without knowing it, he/she gets taken for a long, painful, and destructive ride. Imbalance is the byword for the relationship, with the co-dependent on the downside of the tilt.

The two partners fuse and lose their boundaries. One starts doing for the other what the other should be able to do for him/herself. The co-dependent is one and one-half a person; the other is barely a half.

These two people entangle themselves in each other's life to the unfair advantage of one and the sad disadvantage of the other. Wear and tear builds in the codependent until he/she is ready to break. The carried partner wonders what the carrying partner's problem is and registers wide-eyed surprise that anything is wrong at all.

The most important aspect of co-dependency involves confusion over boundaries, identity, and proper responsibilities. The co-dependent lacks a sense of where his/ her being stops and the other's begins and is unable to Emphasize that she is responsible for stopping the abuse. The counselor must help her overcome her "learned helplessness," the feeling that she cannot do anything to alleviate her situation. There are things she can do! She can turn to women's advocates to help her; she can get help from law enforcement agencies; she can leave home; she can get counseling for herself and for her husband, if he is willing. Above all, she should tell other people—family, the family physician, neighbors, her best friends—what is happening in her home. Often, airing a bad situation puts a different light on the woman's ability to begin to help herself.

Encourage her to see a doctor if she has been physically abused. Many abusers will punch where bruises and cuts won't show or will inflict internal injuries that could lead to death. Women and children are often killed before anyone knows they are being abused.

Remind the abused wife that God loves her and sees her as His special creation. God does not want us to suffer. He is concerned about our well-being, but He will not circumvent our free will. If a woman "chooses" to stay in a bad situation, God will seldom intervene.

Help her find a support community. Inform those who are mature in the Lord, and who may have training in such areas, that there is a woman in trouble in their church. If the woman is concerned about others knowing her plight, it may take awhile to convince her that nothing can be done until she is willing to accept the help of others.³

If your church and your pastor will not respond to your hurt in these ways, it's time to find another church.

What to Expect From Your Church Leader

What kind of help should a battered woman look for from her church? Kenneth W. Petersen, in an article in *Christianity Today*, agreed that many church leaders do not know how to deal with wife abuse. They are not prepared, not informed about God's view of women and men, or are so embarrassed by the situation they cannot see a solution clearly. Petersen gives some general suggestions that were culled from those who counsel abused women.

Believe that she has been abused. A pastor or other church leader should put aside any preconceived ideas about wife abuse and listen to the woman bringing a complaint. He/she should not take the stance that she probably "deserved" whatever punishment she got. Remember, she is already carrying around a lot of guilt and does not need more piled on her.

Pray with her. Prayer is effective and has psychological value. Perhaps this is the first time anyone has ever prayed with and for her in this problem. The counselor should guide her prayer life and assure her that he/she will continue to pray about her situation.

Determine the frequency and severity of the abuse. If she and/or her children are in a life-threatening situation, the woman needs to be protected and encouraged to leave the home. There are shelters throughout the country that harbor abused women and children if there is nowhere else for them to go.

Next, fearlessly and straightforwardly, the church must—without mincing words—let the one doing the injuring know he is not acting in a loving, responsible, or biblical manner. Paul suggests that the church should "put out of your fellowship" a member who is sinning. "Hand this man over to Satan, so that the sinful nature may be destroyed and his spirit saved on the day of the Lord" because "don't you know that a little yeast works through the whole batch of dough? Get rid of the old yeast that you may be a new batch without yeast" (1 Corinthians 5:2, 5–7). It takes more than love or prayer to conquer evil. Evil tends to resist efforts to change or contain it. The proper response to evil is to flee from or destroy it.

Third, the church needs to see that those who have undergone prolonged violence—the wife and children of the abuser-receive the professional help they need to begin a healing process. When the abusive man recognizes he is indeed at fault, he also will have to be restored to wholeness. This is not easy because the person who reacts to his world in such irresponsible ways shows he does not have an adult character structure. Without total healing, that person will refuse to accept responsibility for his actions and will instead blame the circumstances that brought about the action, which compounds the problem. The child-adult or adolescent-adult finds excuses for such behavior in everyone and everything else but where the problem belongs: within himself. "I had to hit her because she . . . so don't blame me."

We have already established that violence of any kind is wrong and should never be accepted. Physical or psychological assault, throwing tantrums, and breaking things are not acceptable modes of adult behavior. No person should be a victim of physical, mental, or emotional abuse. If it is wrong, it is contrary to Christ's perfect law of love. To ignore the situation is to refuse to love. Before he gave his well-known love chapter, Paul said about the church body, "God has combined the members of the body . . . so that there should be no division in the body, but that its parts should have equal concern for each other. If one part suffers, every part suffers with it" (1 Corinthians 12:24-26). If the whole body suffers because one member is trapped in an abusive relationship, then the whole body should respond to the injury of that one member. To ignore the situation is to put the whole body at risk.

The church should react by first making an effort to correct the situation. It is not enough to tell the injured member to "be warm, be full, be on your way." If the wife and children are being physically abused, the church is obligated to find a place of shelter away from the abusive husband and father. Otherwise, turning these victims away to return to their home may mean they will be treated far worse than before because the wife looked to the church for help. She and her children need an effective support system made up of people who understand the problems involved in abusive households because they have experienced similar situations and are now in the process of recovery, or they have been trained to assist abused people.

tell them . . . " (John 20:17). Mary did as she was told and there is no indication that what she did was wrong in the eves of the disciples. Acts 9:36 talks about a disciple named Tabitha. Acts 18:24-26 speaks of Priscilla and her husband, Aquila, who were teaching apostles; Acts 21:9 is about Philip (deacon and evangelist) and his four daughters, who were prophetesses. Paul sends a personal greeting to Phoebe, a "deaconess" (not "sister," as many translations put it) in Romans 16:1. And in verse 7 of that same chapter he greets Andronicus and Junias (a female), who are "outstanding among the apostles, and they were in Christ before I was." The passage in 1 Corinthians 11, often used to indicate how women are to dress for church, actually tells how women prophets are to dress when they minister. Passages in 1 Timothy 5:2 and 2 Timothy 4 refer to women leaders.

So, whatever Paul meant in the chapters Reverend Johnson was trying so hard to convince Connie with, Paul did not mean that women are second-class citizens. Women are equal to men in the sight of God; they should be equal in the eyes of the church; they should be equal in their homes.

The Church and the Battered Wife

The church has always been a bulwark for those who are hungry, homeless, hurting, and hopeless. Do these criteria also include those women who live in constant fear and dread because they are abused by their husbands?

speaks of a woman's place in the church, but it also says something about her place in the home."

The Woman's Role in Bible History

If Connie had known Scripture a little better than she did, she could have pulled far more verses from the Bible that put women in positions of church leadership than her pastor could find that put women down. The Old Testament is filled with examples of women leaders. The name of Sarai, Abram's wife, was changed to "Sarah," meaning a female prince or tribal mother. Levite women had their place in Tabernacle services. Miriam (Exodus 15:20), Deborah (Judges 4–5), and Huldah (2 Kings 22) were prophetesses.

When Mary and Joseph took Christ to the Temple after His birth, the infant was praised by Anna, who "spoke about the child to all who were looking forward to the redemption of Jerusalem" (Luke 2:38). Anna was a prophetess who "never left the temple but worshiped night and day, fasting and praying" (Luke 2:37). Many women followed Christ and His apostles wherever they went. In fact, women were the chief financial supporters of Christ's ministry. When He was in her home, Christ commended Mary for choosing the better part, that of listening to His teachings as one of His disciples, rather than worrying about getting dinner ready as her sister, Martha, was doing.

After He arose from the dead, Christ appeared to a woman first and told her to "go . . . to my brothers and

vows used to contain the words *love*, *honor*, *and obey* for the bride. Nowhere in the Bible is a wife admonished to obey her husband. Children are told to obey their parents (Ephesians 6:1; Colossians 3:20), indicating that, in the eyes of God, a wife's position in the family is equal to that of her husband. In fact, Paul said we are all children of God "through faith in Christ Jesus. . . . There is neither . . . male nor female, for you are all one in Christ Jesus" (Galatians 3:26, 28).

As Pastor Johnson continued to read the Scripture verses to Connie that he felt would convince her she was not seeing her home situation the way the Bible would have her see it, he sensed he was losing control of the meeting. He thumbed through his Bible and stopped at another passage. "Now, Connie, I don't often bring up this verse in the New Testament because I realize how important a woman's role is in the church—especially in teaching children." He remembered that Connie taught children's Sunday school. "But Paul had some very definite ideas about a woman's place in the church. 'Let your women keep silence in the churches: for it is not permitted unto them to speak; but they are commanded to be under obedience, as also saith the law. And if they will learn any thing, let them ask their husbands at home: for it is a shame for women to speak in the church.' That's in First Corinthians 14:34 and 35, the King James Version. Related to that," Pastor Johnson continued, "is First Timothy 2:11 and 12 in the same version: 'Let the woman learn in silence with all subjection. But I suffer not a woman to teach, nor to usurp authority over the man, but to be in silence.' I know, Connie, that this

begin to treat his wife with a new sense of respect and deference, for he realized that he had been more sensitive to his "sisters in Christ" in their congregation than he had in many ways been to his wife. . . . About a year later this same friend made a further discovery while meditating on Ephesians 5. He began to feel that if he were to treat his wife as Christ treated his Church, he would have to find significant ways to "die" for her sake. So he told her and their congregation that he was going to "die" to certain role expectations for his wife that he had previously taken for granted. He planned to take responsibility for various aspects of the housework in order to free his wife to follow more of her own interests and ministries. . . . About six months later I heard him tell their congregation that he had just begun for the first time "to really understand" God's word to him in Ephesians 5. For he now saw that if he were to respond to the admonition to treat his wife as Christ treats the Church, my friend needed to go beyond "releasing" his wife from his expectations of her to also becoming her advocate by encouraging her growing senses of freedom and responsibility. It was not enough, he argued, to "get out of the way" of one's spouse. Christ wanted husbands to be cheerleaders for their wives' growth and development into persons mighty in the Lord, full of this Spirit's fruit.2

Love, Honor, and—Obey?

Still another key word, which is no longer used but is carried over from an earlier generation, is *obey*. Wedding

"I was so terrified I ran into the kitchen and cried. An hour later he came to me and showed me from the Bible how I was under his authority, and to come out from under his 'protection' was to violate Scripture. He said he loved me and wanted nothing but purity for me and to be in God's will. It was his duty as a husband to make sure I fit in God's chain of command—God first, then Ron, and then me—and that I did everything he, as head of the family, told me to do. He said that chastising me 'in love' was the most loving thing he could do."

That is not the picture Paul intended to paint when he described the husband's position as head of the wife. Paul went on to explain what he meant by headship when he described, in Ephesians 4:15, 16, Christ's position as head of the church: "We will in all things grow up into him who is the Head, that is, Christ. From him the whole body, joined and held together by every supporting ligament, grows and builds itself up in love, as each part does its work." That is the picture of family relationship: the head leads the way for the whole body as it grows and builds up in love, as each member does his and her work.

The Biblical Position of Headship

S. Scott Bartchy, in an unpublished paper entitled "Issues of Power and a Theology of the Family," in illustrating that *headship* really means "source" rather than "boss," relates how a friend approached Ephesians 5 and 6, particularly Paul's admonition for the husband to agape love his wife. This led him to the insight that his spouse was his "sister in Christ," which led him to:

This business of headship in the family is one of the most misunderstood subjects in the Bible. These two verses, along with Genesis 3:16, "Your desire will be for your husband, and he will rule over you," are the only verses that talk about this particular position of the wife in the home.

For anyone to use these verses as a basis for wife abuse is to cruelly twist the Word of God. Nowhere in the Bible is there any justification for emotional, psychological, or physical abuse of either wives or husbands. Kim told her counselor that her husband, Ron, made all the decisions for her on a daily basis. He told her what activities she could get involved in and who she could spend time with and speak to. Each night when he came home, he grilled her about her day. She had to recite everything that was said in any conversation she had with anybody. He believed it was his God-given authority to monitor her life and control her, and he would take that authority at all costs.

"I got a call from a girlfriend I hadn't seen in years," Kim told me. "Shawna invited me to her house for lunch. She even offered to pick me up since I don't have a car. I was so thrilled to get the invitation, I didn't think about the consequences. I had the most fun I've had in ages, just talking to Shawna. When Ron got home I started to tell him about my great day. Before I even finished he said, 'You did what?' and grabbed me by the shoulders and threw me against the wall. He screamed, 'Don't you ever, ever go anywhere with anyone without my permission again.'

Jesus doesn't take His wrath out on His church; why should Chuck take his wrath out on me and the kids?"

Connie had been through these arguments before—by herself and with herself. For a long time she blamed herself for Chuck's abuse. Maybe she could try harder—make sure dinner was ready on time, that the kids were quiet when their dad came home, that things went as smoothly as possible. Each time Chuck hit her she would blame herself. Now she was getting tired of it. No matter what she did, there was always a reason for him to hurt her.

A 1990 television news special showed a therapy session that wife abusers who had been arrested were required to attend. One young man explained that his wife needed counseling as much as he did. His description of how she responded to his battery indicates she was truly "submissive": "She takes the blame every time I lose my temper. If I hit her for not doing the dishes, the next time I'll hit her for not making the bed. There's no way she can win," he explained. "You go to any lengths to get what you want as far as control . . . you gotta control everything," he said.

The "Head" of the House

Another key idea the church trips over in husbandwife relationships is *headship*. First Corinthians 11:3 says, "The head of the woman is man," and Ephesians 5:23, "The husband is the head of the wife as Christ is the head of the church, his body, of which he is the Savior." Why is it that we use the word *long-suffering* to describe a woman's role much more often than a man's? The words Paul wrote to the Corinthians do not indicate that long-suffering is limited to the female gender.

Connie sat, stunned and disbelieving, with her mouth open. She remembered the times either she or one of the kids had to go to the emergency room to have injuries treated, telling the nurses on duty they had fallen down stairs or tripped over a roller skate or skateboard, in order to avoid a police investigation. She thought of the time she bundled up her kids and drove them to a women's shelter in the middle of the night to keep Chuck from killing one of them. All she could say to her pastor now was, "I've been with this man for twenty years. Isn't that pretty long-suffering?"

The Old Standby, "Submit"

"Connie, the Bible says you have to submit to your husband. Maybe you aren't submissive enough." Ah! There's another key word: *submit*. "Look here in Ephesians 5:22 [kJv]: 'Wives, submit yourselves unto your own husbands, as unto the Lord.' And in Colossians 3:18 [kJv]: 'Wives, submit yourselves unto your own husbands, as it is fit in the Lord.'"

Connie fought back tears. "What does submission have to do with Chuck not being able to start the car, so he comes in and beats me up? And what about the rest of that chapter in Ephesians? Doesn't it say that husbands should love their wives, just as Jesus loves His church?

because they are biblical. These views have been passed down through the generations, beginning as early as the Reformation period. Martin Luther said. "Women should remain at home, sit still, keep house, and bear and bring up children. . . . If a woman grows weary and, at last, dies from childbearing, it matters not. Let her die from bearing-she is there to do it." At the Council of Macon, France, the question was asked, "Are women human?" The result of the vote was 32 yes, 31 no. Women were declared human by one vote! ("God created man in his own image, in the image of God he created him; male and female he created them" [Genesis 1:27].) John Knox, a Scottish preacher, said, "Woman, in her greatest perfection, was made to serve and obey man, not rule and command him." Of course, Knox may have been influenced by the times. He suffered great persecution as a Protestant under the reign of Catholic Mary Queen of Scots.

The Long-suffering Lover

Connie was astounded at the direction her appointment with her pastor was taking. She felt as if she were living in the dark ages. She watched Reverend Johnson open his huge pulpit Bible and begin to explain to her, as he would a child, what Paul said about love in 1 Corinthians 13:4: "Love suffers long. Connie, this means that true love puts up with a lot. Perhaps you haven't been patient enough with Chuck."

together—never mind the physical, psychological, spiritual, or moral consequences—then husband, wife, and children are obeying God's admonition concerning the marriage relationship.

Phyllis and James Alsdurf, in an article in *Theology*, *News and Notes*, said:

A woman wrote to us, "I would never in my wildest nightmares have dreamed that my husband would ever abuse me, but he did. My husband is a Christian, but his rage at things is unreal. I took our two-month-old son and fled after the fourth time he struck me, but I had received counsel that it was my duty to stay and suffer for Jesus' sake."

Many so-called Christian marriages do stay together. The costs to the husband and wife include never knowing the joy of a harmonious oneness, never realizing spiritual maturity or experiencing their full potential in any area. Their children pay by never seeing a healthy husbandwife relationship, never learning how to adapt to change and hardships, or never knowing a healthy way to deal with conflict and pain. All they see is psychological or physical terror, and they grow up without guidance on how to relate to their own future spouses and children, just a world full of intense inner emotional turmoil and turbulence. Why are our churches not places where we can bring our deepest hurts and problems?

Misuse of Scripture

Many members of the church believe certain views about husband-wife relationships and man-woman roles

Ill-Prepared for the "Real" World

Connie's heart sank as she realized that Reverend Johnson was unable to accept the fact of her longtime abuse from her husband, Chuck. She watched as he fidgeted in his chair and began to mumble the usual empty platitudes people say when they are embarrassed or unprepared to deal with an unpleasant situation. "Just have faith; pray more; show more love to your husband. Maybe he's just going through a phase; let's pray him through it; try not to provoke him to anger; don't confront him; do all you can to make your home a happy place." Everything he said placed all the responsibility for her husband's anger squarely back in Connie's lap. The implication was that she must not be making their home a haven for him. She must be making him uncomfortable in his own house. Without intentional malice, the minister was being an enabler to Chuck's anger.

Many ministers today are ill-prepared for problems of domestic violence. They want to believe that such things cannot happen in a Christian home. A wife who knows her place, gives proper attention to the needs of her family, submits to her husband as the Bible says, and follows our Lord's command to love could never be abused. Yet counselors, physicians, and law enforcement officers know that domestic violence in "Christian" homes happens with disturbing frequency.

As uncomfortable to the church as the issue of abuse is the thorny issue of divorce. Many ministers are loath to use the D word, believing that if the marriage stays

The Church: Haven for the Abused or Harbor for the Abuser?

In chapter 1 we told you about Connie, who had gone to her pastor, Reverend Johnson, for counseling about her abusive home situation. Spousal abuse is not one of the things most pastors expect to encounter within their church congregation, therefore they do not take—nor are they usually offered in seminaries—the sort of educational courses that would prepare them for this very common situation. They are taught how to impart God's Word to their people, administrate a church staff, organize effective programs, etc. Then they are turned out into a world that is drawing further and further away from the ideals of love, support, and nurture Christ spoke of.

everyone's detriment. The audience gets suckered into a contrived relationship, highly dysfunctional in its nature, where two adults tear into each other in order to produce, for her, great melodramatic moments of suffering, and for him, great melodramatic moments of "Aren't I the wicked wonder?" Pity the poor children who grow up in such surroundings.

This chapter has highlighted some of the erroneous thinking patterns in the minds of abused women. Later we will see how women can restructure these thinking patterns and begin to better their situations.

First, though, in the next chapter we will discuss how the church harbors abusive men. Many women have gone to their pastors for counsel and found they had no better solution than to tell the wives to pray about it, continue to submit, and one day their husbands would notice their meekness and forbearance and things would turn around. Not so! Much has to happen before such a radical change can take place. an error in thinking because she can never meet all her husband's needs. Something will always be lacking. When she sets out to do this, she asks for criticism from her mate. Her mission should not be to follow her husband's agenda but to follow the program Christ has set before us all. He narrowed the goals down to two: Love the Lord your God with all your heart, with all your soul, and with all your mind, and love your neighbor as you love yourself (Matthew 22:37–39). This implies that you have a God-given healthy respect for yourself and think enough of yourself to become capable of showing love to others.

There are many more erroneous suppositions we could mention, but you get the idea. No woman should have to put up with abuse from her husband.

Did you recognize yourself or someone you know in this chapter? Which of the "excuses" or "thinking errors" are you trapped by?

There are a couple of other aspects to consider from the viewpoint of an abused wife. There are some women who put up with abuse because they seek the praise of others. These women need a stage upon which to play out their saintly, sacrificial, and good lives, so they perform as the critical parent to the bad boy. In this situation, the wife and husband play against and off each other's dysfunction.

Another type of abused wife needs the applause of her onlooking audience, so she becomes the melodramatic sufferer. This situation is very rare but it does exist, to we were having dinner with some old friends, the subject of relationships came up. The other husband turned to his wife and said, "We've been married twenty years. Would you marry me today, knowing what you do about me?" Without missing a beat, her reply was, "I choose to be married to you every day I live with you. The marriage contract to me is not necessarily a 'permanently binding' contract. I can leave it any day I wish. The fact that I'm with you now tells you that I choose to be." We should all be free to choose, and choosing every day to remain married is something only free agents can do.

Erroneous supposition #6: I have no identity apart from my husband. If I leave him, I'll lose everything. Your validation comes through many sources, not just one: you are validated as a child of God. You are validated as a person. You are validated as a woman. You are also validated as a wife. But you cannot identify with only one of these areas; you are much more complex than that. Even if you stay with your abusive husband without trying to do something to correct the situation, what will happen if he leaves you or dies? Then you are left with no validation. You become a nonperson. It is necessary for you to develop the other aspects of your being.

Erroneous supposition #7: Christ said we are supposed to be servants, just as He was. He met everyone's needs. Isn't that what I should be to my husband? This response is related to the "happiness" response. The idea is that if the wife follows in Christ's footsteps and becomes a servant to her husband, meeting all his needs, he will be content and won't have any reason to abuse her. This is

traditionally assign them to; rather they are done by whoever is better at doing them. There is no "woman's work" or "man's work" indicated in Scripture (except in childbirth).

Erroneous supposition #4: I promised to stick with my husband till death do us part, in sickness and in health. This part of the wedding vow is not meant to imply that a wife is to submit to a disease process without fighting it; wife batterers are sick. To lie down and die is not a solution to physical illness, yet that is exactly what many women do when they are confronted with a disease that is neither physical nor organic. Just as you would fight for life if you had an organic disease, you should fight when any life-endangering disease threatens you—including abuse by another person. Help is available. (See the Appendix at the end of this book.)

Erroneous supposition #5: My job is to make my man happy, no matter what it takes. This is an impossible task. No person can make another person happy. Happiness comes from within our own selves. We choose to be happy. Conditions surrounding us do not make us happy; they may help us to feel more in tune with the world, but they do not make us happy. If a wife sets out to make her husband happy, she will always fail. It means she must always do the "right thing." If she does one thing wrong, or leaves something undone, it will bring on an attack of unhappiness in her husband, and many abusive husbands look for things that are "not right."

The best marriages are those in which each person chooses to love, care for, and be there for the other. While Erroneous supposition #1: My husband is supposed to be head of the family. The error here is in how "headship" is interpreted. We will discuss this more fully later, but a short correction of this error is this: Man is ordained by God to play out his headship and authority by taking care of and nurturing those who are his responsibility. Headship means "responsible for," not "dictatorial lordship over," his wife.

Erroneous supposition #2: The Bible says I am to submit to my husband (Ephesians 5:22). This is true, but just one verse before this one is the exhortation to all Christians to "submit to one another out of reverence for Christ" (Ephesians 5:21). The word translated "submit" in both verses is the same Greek word. Obviously, Paul did not mean to imply that any one person should be "the boss." To submit to each other means we are to yield to one another in politeness and respect because we revere Christ. All of us are under the headship of God Himself. The husband is to first be submissive to God; when he has assumed this position, then his wife will gladly submit herself to her husband as her brother in Christ, after she too has submitted to God.

Erroneous supposition #3: My husband is supposed to assume responsibility for all the decisions in the home. All human beings—both men and women—are gifted in various ways. Each person has an area of wisdom that complements others' areas of wisdom; none of us is wise in all ways. It is therefore necessary to work out a partnership in marriage so that all bases are covered. These duties do not necessarily have to be carried out by the person we

he points the finger at her and reinforces her low selfesteem, she retreats until she feels, "I quit," and her world collapses. She now takes no risks, drops out of the game entirely, and she sees no evidence that her husband could be wrong about her inability to do anything. She has bought into the battered woman syndrome. Her selfconfidence is reduced to zero and she stays put.

Notice the inferiority cycle is a product of someone else's definition that undermines her own opinion of herself. No matter how strong a person is, no one is strong enough to be invulnerable to the continual, gradual erosion of self-esteem.

It is highly possible to regain good self-esteem or to begin to see yourself the way God sees you—as a unique, talented, spiritually gifted person whom God and others love very much. Many good books are on the market that can help you see yourself as God wants you to. One of these is *I'm O.K.*, *You're O.K.* by Thomas Harris, M.D. Another is W. Hugh Missildine's *Your Inner Child of the Past*. Don't continue to doubt yourself and your abilities. Get help.

Women's Erroneous Thinking

Whenever we counsel with women who are being abused by their husbands, we try to find out which of the foregoing reasons they use in their miserable situations. We find that many women think what they are going through is normal or even noble. This idea is reinforced by several erroneous suppositions in women's minds.

down, and assaults her physically or emotionally (or both) until she completely loses her self-confidence.

This is where the cycle begins. The first indication of a lowering self-esteem is the feeling *I can't*. Then she moves into worry, fear, anxiety, and various degrees of catastrophic thinking. This is a mind-set that leads her to feel as if there is some kind of catastrophe just around the corner which she dreads and will do anything to avoid. Then she seeks safety and security. People who are pervaded by fear, worry, and anxiety are unable to take risks. The result is that first their ambitions waver and then their expectations toward life in general diminish.

Because she has now lowered her expectations, the woman takes smaller risks and her world begins to shrink. Taking smaller risks results in lowered performance, lowered accomplishment, and reduction in the number of successes. This brings on Crisis Number 1: a lower batting average than she once had.

With a lower batting average staring her in the face, she develops a fear of tasks in general. As she shrinks from tasks, she also retreats from the world and the world shrinks even further. As she makes fewer accomplishments and realizes an even lower batting average, she enters into Crisis Number 2: the actual recognition of real evidence that she is inferior.

At this point, she has moved into a condition where she is uniquely vulnerable when her husband tells her, "See, what did I tell you?" This response from him reinforces her definition of *inferiority*. She now buys into what he has been saying all along: she cannot do anything. Once

Figure 2 Cycle of Low Self-esteem

and tries to make the best of a very bad situation. She did not seek out the situation, she does not like what is happening, but she sees no way out, no other options. It is like knocking a glass off the counter and knowing even before it shatters on the kitchen floor that you are helpless to stop it.

There are many other reasons abused wives give for staying with their husbands. As long as they choose to stay and tolerate their situations, no one can do anything to make their lives better.

The Battered Wife Syndrome

The abused wife finds herself subject to what is called the "battered wife syndrome." This syndrome results from a wife staying in an abusive relationship until her self-esteem shrinks to the point where she is relatively unable to make any moves at all toward independence.

The path to the battered wife syndrome is illustrated in Figure 2, the Cycle of Low Self-esteem. A woman comes into a relationship with a certain amount of life experience behind her. She has achieved certain skills, gained some recognition for her abilities, and learned to accept herself for what she is.

Then, without realizing what she is getting into, she marries a man who has abusive tendencies. Before long, she finds herself in a negative atmosphere as the abuser begins to systematically undercut her confidence by chipping away at her self-confidence. He insults her, puts her

or for worse, in sickness and in health, till death do us part." Their commitment keeps them in relationships long after they have stopped loving their husbands. After all, in this day when more than 50 percent of all marriages end in divorce, it's somewhat of a badge of courage to stick it out—through a very little "better" and a lot of "worse."

Another reason is that Christ says we are to forgive seventy times seven. These women do not realize that domestic violence does not fall in this category. We will talk about forgiving in another chapter, but we will comment here that an abusive husband does not respond to the admonition to return good for evil. He needs a professional care-giver to help him overcome his abusive behavior, just as he would need a physician to help him recover from a serious physical illness. An abused wife who turns the other cheek may find her jaw shattered.

As long as his wife is forgiving, loving, and patient, the abuser will find it unnecessary to grapple with the deep-seated problems that make him an abuser.

Christian women also *quote the Beatitudes:* Blessed are the meek, and blessed are those who suffer, and blessed are the peacemakers. This, of course, is another example of Scripture taken out of context or applied in places where Christ never meant it to be applied.

Another reason a woman—church-oriented or not—stays with an abusive husband is a phenomenon referred to as *learned helplessness*. A wife who suffers verbal abuse or physical battery long enough soon loses all her inner fire or spunk. She can no longer get up and walk away. As she looks fearfully around her, she sees no way to escape, so she shuts up, puts up with the punishment,

This is especially so if she is from a home that was also dysfunctional.

Her world, no matter how ugly, is not as painful and ugly as the home where she grew up. She may reason, "T've got it better than Mom did. I only get beat up three or four times a year; Mom got it three or four times a month." This view of life and marriage keeps a woman locked in a destructive relationship because her life experience has taught her that it could be worse and, possibly, this is as good as it can get, in this life anyway.

Some women hate the thought of doing things by themselves. They cannot imagine going into a restaurant without having someone with them. They would never go to a movie alone. Friends only rarely invite a single woman to a party or for a visit. And churches are often the greatest offenders. There is seldom any place for a single woman (or man, for that matter) in the church, even though only 12 percent of families live in "traditional" households where mother and father are together and mother stays home with the children. Single people feel like fifth wheels at any church function. Churches are missing their biggest field of ministry when they neglect to nurture the divorced.

Women who cannot bear the thought of doing things by themselves stay with their abusive husbands for the little companionship they do get.

Women who have been brought up in homes where the family has regularly attended church come up with their own set of reasons for staying with abusive husbands. One of these reasons is that they *vowed to do so* "for better

take them all in, so she is doomed to misery in every direction she turns.

Economics is probably the biggest reason a woman stays with an abusive husband. He is her only means of support. Perhaps she never prepared for work outside the home. She either got married right out of high school or she took courses in college that did not prepare her for the work force. Now she has two or three young children. one of which is not yet in school. The idea of leaving her home—abusive as it may be—to find an apartment where young children are allowed, then a baby-sitter who will stay with the youngest one while she looks for a job, then goes to work, is terrifying and overwhelming. She can look around her and see plenty of single mothers who are trying to support their children alone; even if the husband offers to help support them she fears for their safety when he has weekend custody. And it usually takes a lot of abuse for a woman to leave both her husband and her children.

Because making a living for herself and her children seems impossible, the woman feels overwhelmed and paralyzed. Also, she may fear worse abuse (even death) for herself and her children if her husband finds her after she leaves.

If a woman has gone from her parents' home to marriage, she may be *afraid of being alone*. She imagines it is lonely and dark and scary out there in the world. An occasional beating or verbal put-down during an otherwise tolerable marriage relationship is still better than no relationship at all to a woman who fears the unknown.

when she was nine. Beverly wondered if her dad left because there was something wrong with her. When her mom got involved with making her own new life, Beverly began to cut school. She never was a good student anyhow, and pretty soon she was so far behind she knew she could never catch up. When she was sixteen she quit school completely. She reasoned that all she ever wanted out of life was a husband and a family. Why did she need to go to school to be a homemaker? She got a job at a local café, "slingin' hash." It wasn't a bad job, and she made pretty good tips. One day a bunch of guys came in from a construction job across the street to have lunch. Tony was one of them. He was so cute. He had a dimple in his chin and his eyes sparkled when he kidded her. Beverly fell for him immediately. They were married just after she turned seventeen. Now, eight years later, she has four children, a mortgage, a ten-year-old car to run errands in, and a husband who regularly "punches her out," just to keep her where she belongs.

Whenever she gets enough of Tony's abuse, Beverly will threaten to leave him. Tony laughs and says, "You don't know how good you've got it. You'll never get anyone better than me. You're really lucky to have someone to take care of you. Without me, you'd be on the street." Beverly believes him. She goes for counseling once in a while, just to relieve the tension. "If I lose Tony, I lose everything," she tells her counselor.

Beverly stays because she no longer has any selfesteem. She believes she isn't worth much and that no other man will ever love her and her children enough to masochistic tendencies; any woman who would put up with physical and emotional violence must like the punishment. Current research has very effectively laid to rest this idea. Women who stay with their abusive mates do so for many reasons, none of which has to do with their liking or seeking out the punishment they are getting.

Along with the erroneous idea that women stay with abusive husbands because they have a psychological need to be punished is the myth that they unconsciously "seek out" (look for) relationships in which they will be abused. According to this myth, their psychological radar is out for men who will abuse them; once sensing these abusive males, they head right for them like moths to flames.

Sometimes if a woman comes from a home where her father abused her, she may not recognize that an abusive man is not normal. She may turn to him because she is familiar, and perhaps comfortable, with him. But that situation is rare. "I had no idea Barry was like this before I married him. I'm no fool!" Jenny exclaimed. "I would have broken off the relationship in a second if I'd even suspected he was so violent."

One reason women stay is fear for their safety. "He will hit me harder when he finds me, and he says he will find me." These women understandably fear for their physical safety, their very lives. He says, "If you leave, I'll come after you. You can't hide from me. I'll find you wherever you are, and when I do, I'll kill you." Minor injuries are better than death, these women reason.

Some women stay in unhappy marriages because of low self-esteem. Beverly's mom and dad were divorced

peace. But statistics prove that this is not as common as we would like to believe, even in Christian communities. Men who cannot control their anger and become abusive are more than likely products of dysfunctional families. Since they have never experienced a harmonious, functional home life, they do not know how to create one.

Those same statistics say as many as 50 percent of all married women will suffer physical or psychological battery sometime during their marriages. That is a staggering number of abused women, and many of them give up on their marriages early on. Those marriages that are happy, peaceful, fulfilling, and mature are that way because the husband and wife have both learned to experience give-and-take in their relationships.

Why Does She Stay?

After only one month of marriage, Jenny is considering calling it off. She is trying to get a handle on the situation, so she came in for counseling. But she still wavers: What will people in the church think? What will friends (parents, etc.) think? And then there are all those wedding gifts, and the new apartment with new furniture and plenty of debts. These are superficial reasons for staying in a situation that looks bad from the very beginning. But there are deeper reasons a woman will stay with a man who abuses her.

The last generation of psychologists believed that wives stayed in abusive relationships because they had

and nurture her all her life. She never suspects that the man she chooses to spend the rest of her life with could turn out to be a terrorist.

A Christian woman sees herself as a helpmate for her husband. Just as God created Eve a helpmate for Adam because he was lonely and needed someone more like himself, the wife today sees herself as the modern counterpart for her own "Adam."

We are told in our wedding vows that we become one in the eyes of the Lord. She is going to be a partner with her husband, sharing in the decision making—even little decisions will be shared. She sees herself helping her husband be all God intended him to be, with her by his side all the way. It is a very happy picture. What goes wrong?

"I grew up in a family of calm, levelheaded people," Jenny said. "We looked at things logically and rationally, and we were in control. I don't understand why I'm in this situation. I think I'm going to have to get an annulment. I hate to. You know how things are in a church: 'What God has put together, nobody had better put asunder.'

"My mom's marriage wasn't like this. Dad is a good husband, a gentleman, a good provider, and a great father. I didn't know adult men could be the way Barry is. Did I ever have an unusually good home life!"

Jenny's statement and dilemma are valid. Many homes are happy ones where husband and wife share the power, and their children grow up to be well-adjusted adults who seek to create their own homes of love, harmony, and heard about wife battery could never happen to me. I figured the women who were being abused by their husbands somehow bought into it, that they unconsciously looked for men who would dish out punishment, so they were asking for it. But that's not true, at least in my case. I don't like to be punished for anything, and I sure wouldn't look for an abusive husband. I had no idea Barry had a dark side. I honestly fell into this situation. Barry is as miserable after only one month of marriage as he was charming and seductive before. I feel like I married a Jekyll-and-Hyde character without knowing there was a Mr. Hyde."

Jenny said she was introduced to this part of Barry on their honeymoon. "And it was over something so trivial. The bellboy left some of our luggage in the lobby by mistake when we checked into our honeymoon hotel. Barry and I went downstairs to check on it; it was still there, but he flew into such a rage at the poor bellboy. I thought then, *Oh*, *oh!* Trouble here.

"It's happened several times since then. Some little thing will provoke him and he turns into this screaming maniac. All the time he's ranting and raving, I'm scared to move or speak or do anything that might make it worse. He hasn't hit me, at least not yet, and maybe he never will, but I'm terrified of his tantrums."

In the Christian community, both men and women are taught to wait for the right mate whom God has prepared for us. We believe in "happily ever after" marriages. The little princess believes that the man she will marry is going to be Prince Charming, who will protect, care for,

holism, low self-esteem, promiscuity, hyperresponsibility, sexual unresponsiveness, insecurity, and anxiety, to name a few. They generally move into another dysfunctional relationship primarily because they have never experienced healthy relationships. All they know is abnormal behavior. Therefore, when domestic violence occurs, they are not struck by the abnormality of it and so do not seek to escape it. It seems normal to give or take abuse, so they are willing to live in an abusive environment.

Children in dysfunctional families either become very adultlike or they never become adults because they are not exposed to appropriate adult behavior for a sufficient length of time. They learn to feel helpless about life because at that time in their growing up when they should have been developing coping strategies, nothing they tried ever worked, nothing they did was right; therefore, they gave up trying to cope. The best thing was to do nothing at all, which is exactly how they behave when they find themselves in another abusive relationship as adults. This "do nothing" strategy keeps them locked hopelessly in a situation that compounds the problem, intensifies the anger of the abuser, and escalates the abuse cycle.

The Mind-set of the Abused Wife

Jenny and Barry were married only a month when she made an appointment for counseling. "I can't believe I'm saying this," she said. "I can't believe my life has turned into this kind of nightmare. I thought all the things I wife is a factor in many abuse cases, but it is not the only factor. Some abuse occurs when the abuser is under the influence. In these cases, of course, the solution is to work on the chemical problem too.

The battered woman enjoys being punished. We know this is not true. Nobody enjoys being abused. A closely related myth is the idea that a woman who puts up with abuse has psychiatric problems.

The Influence of a Dysfunctional Family

Often, both the abused woman and the man who abuses her come from dysfunctional families. In a dysfunctional family the members do not interact in an honest, open, direct, healthy manner but rather react to one another in ways that are dishonest, covert, and indirect. They tend to confuse their roles: parents many times become the children and, by default, the children have to become parents. They never quite get in step with one another. This situation is very harmful and requires a lot of outside help.

Some of the most prevalent problems of severely dysfunctional families are (1) one or both parents are alcoholic; (2) children suffer physical and/or sexual abuse; (3) children are psychologically abused or neglected—another kind of abuse. There are probably other abnormalities. When children from such backgrounds attain adulthood, they do not have healthy models to follow, so they also may demonstrate patterns of dysfunction: alco-

tics. He accuses her of being a feminist, nonsubmissive, certainly not Christian, and absolutely unworthy of his affections. He walks out on their marriage. This lady is a lucky person.

Actually, these models can and do mix. Elements in each of these scenarios are found in some of the others.

How were these women set up to be abused by their husbands? Is there some kind of mold that turns out women who are willing to be abused?

Yes, we find that certain dysfunctional homes produce women who will put up with abuse, and particular environments encourage men to become abusers. Law enforcement agencies, physicians, psychologists, educators, women's advocates, and even church leaders are still in the process of finding all the reasons for domestic abuse. However, some conclusions have already been reached that have altered opinions which were formerly accepted. Here are some of those incorrect opinions:

Abuse occurs only in lower socioeconomic classes. The truth is that wife abuse is found in all walks of life, at all socioeconomic levels, and in all educational, racial, and age groups.

The abused wife is responsible for her punishment. We have already seen that this is not true. Abuse can occur regardless of how a wife acts or what she does. She may see herself as an unfit wife or mother, but actually many abused women are successful executives or employees and are sensitive and caring wives and mothers.

Abuse always occurs after excessive alcohol or drug consumption. Chemical involvement by either husband or

Finally, after a few years of trying, Mary decided it was just too much effort to try to please him. She started to fall apart. She gained weight, began to let the house go, and spent all her time lost in TV soap operas and game shows. When Mark began to physically abuse her, she really believed she had brought it all on herself. By then she had no legs to stand on, no friends to lean on, no strength to see her way out. But there is still hope for Mary.

The *true grit woman* cuts off abuse at its first sign. The first time her husband or boyfriend criticizes her she tells him to buzz off. She may react by pointing out a few of his weaknesses each time he finds a reason to criticize her. She keeps close contact with her family and friends who know her and can reinforce her self-esteem.

She works to keep the marriage on a level of equality: she does not take advantage of her husband's weaknesses; nor does she let him take advantage of hers. Finally, they may get to a standoff type of relationship, one where nobody wins, which is not an ideal marriage, but it gets them through until they have children. Then it starts all over with him criticizing their kids. This woman is married to a man who believes control is all that matters.

The *strong woman* starts out like the true grit woman when her husband begins with the criticism. She astutely, intuitively senses that something very destructive is about to get played out and wisely tells him to cut it out. After several attempts to "break her spirit," he senses that she is probably too strong to fall for his tac-

his own sense of failure, saw what was happening and offered to help her overcome her bad qualities. The next step was that Beth began to feel she could not possibly survive without his help. She tolerated his insults and constant criticism because she believed he was right and she was wrong. Beth was now a true victim of abuse. However, this does not have to be the end of the story.

The next category, the woman who is stronger but still killable, probably has a little higher self-esteem than Beth. Mary's abusive husband, Mark, started out by criticizing little things about her: wearing a dress that made her "look fat"; fixing coffee that was a little bitter; leaving the vacuum cleaner in the living room right after she used it instead of putting it away immediately. At first Mary tried to ignore his attempts to demean her, but after hearing constant criticism of everything she did—and a lot of things he imagined she did—she began to doubt her ability to be successful at anything.

Gradually, subtly, and systematically, Mark cut Mary off from any positive input she might be able to get from her family or friends. This caused her to shrivel even more. After a while she lost contact with her friends, and he used this to show her how unlovable she was: "Nobody likes you; I'm the only one who will put up with you."

Now Mary believed that Mark was the only significant person in her world, so she did whatever it took to get and keep his approval. She tried to remake herself into the woman she thought he wanted her to be. He would indicate that he was pleased—but only a little and only for a while.

did not think she was much to look at, although she was pretty and pleasant to be around, and she had no outstanding talents or other gifts that drew people to her. She was just a nice, quiet, gentle woman who felt she was pretty lucky when John wanted to marry her.

John was from a family that could be described as dysfunctional. He also had a bad self-image; his father was a sports lover and John was never good at any kind of sport, so he felt he was a failure in his father's eyes and that Dad was disappointed in him.

When John met Beth, he was flattered that she loved him even though he was not a jock. At first he thought she was the greatest girl he had ever met. After they were married, he began to discover that she was not the cheerleader type he dreamed he would win, even though he was not the school football hero.

The abuse cycle began with John undercutting Beth's already wavering self-confidence: "Why can't you be more alive when we're out with my friends? You act like you're dead!" he once complained. Beth immediately picked up on this and began to wonder if what he said was true. She went over how she acted when they were with other couples. She already knew that she was shy around people, even people she knew already. It was not her nature to be outgoing and vivacious. Soon she was discovering other bad qualities. She began to dwell on these faults.

It was not long before she started to feel nauseated when they went out because she saw herself as inferior to other women, and her already low level of self-confidence sank even lower than it was before. John, working out of they were not losing their virility and were sometimes bisexual

9. did not think their violent behaviors warranted negative consequences²

Men who would be abusers usually start early in a relationship with their pattern of abuse. How successful they are at gaining control depends on the type of woman they marry. Undoubtedly, there would be more abused wives if their husbands could get away with abusing them. Not all women will put up with it.

We have categorized women by their basic nature. Whether or not a woman can cope with an abuser depends on the type person she is. Most women fall loosely into one of these categories: (1) not so strong to begin with; (2) stronger but still killable; (3) a "true grit" persevering woman; (4) a strong woman. When a woman meets up with an abusive man, she may react in one of the following ways.

How Women Respond to Men's Abuse

The woman who is *not so strong to begin with* has a built-in set of characteristics that will cause her to submit to an abusive relationship. (We will talk about some of these characteristics later.)

This not-so-strong woman has low self-esteem and believes she has many faults. Beth was like that. She grew up believing she was less than a second-class person. She

- 3. believed in the traditional Western family and sex roles and in family unity
- 4. felt responsible for their abusive husbands' actions
- 5. acknowledged guilt but denied any terror and anger they felt
- 6. hid their situation from the world but learned to control their environment enough to lessen the violence against them
- 7. suffered severe stress reactions and had psychophysiological complaints
- 8. used sex to establish intimacy
- 9. believed that no one could help them resolve their predicaments except themselves¹

These abused women—ranging from sixteen to seventysix years of age—described characteristics they found in the men who abused them. These men:

- 1. had low self-esteem
- 2. believed all myths about abusive relationships
- were traditionalists and believed in male supremacy
- 4. blamed others for causing them to be abusive
- 5. were pathologically jealous
- 6. presented dual personalities
- 7. reacted to stress by drinking and abusing their wives
- 8. used sex aggressively to reassure themselves that

The Abused: Why Me?

Wife abuse is not a temporary setback in a relationship but the result of deep underlying problems within the abuser.

Most men are not abusers. Most are considerate, loving, giving, healthy, self-confident men who are looking for women who are also loving, giving, healthy, and self-confident. But this book is about the man who, for some reason or other, is an abuser.

For her book *The Battered Woman*, Lenore E. Walker interviewed women of "all ages, races, religions (including no religion), educational levels, cultures and socioeconomic groups" who lived in abusive homes anywhere from two months to fifty-three years. She concluded that these battered women commonly:

- 1. had low self-esteem
- 2. believed every myth they ever heard about abusive relationships

gamente de la travella de la companya de la compan La companya de la companya del companya del companya de la c

And the state of t

seems dangerously apparent that you are either (a) not taking responsibility for your own well-being and happiness or (b) you are being victimized in an abusive marriage.

Please, for your own sake and for the health of those closest to you, take the time and make the effort to help yourself begin to get whole. Call a counselor, doctor, pastor, or close friend and let them know what is *really* going on in your mind, heart, and home life.

In the next chapter, we will examine the kinds of women who become abused wives and explore some of the reasons they put up with abuse. But first do the following exercise, "Are You an Abused Wife?"

Circle T (True) or F (False) according to the way you feel now.

1. If I didn't have children, I'd leave my marriage

in a minute.	r	F
2. I secretly take pleasure when my husband	ge	ets
his comeuppance.	Г	F
. [18] (18] [18] [18] [18] [18] [18] [18] [18] [T	F
4. I feel angry at the way my life has turned	0	ut.
이 그리에서 살아 이 주어지에 안전되어 구멍하셨다면서 하는데 이 사람이 내려가 되었다면 하는데 하는데 나가 되었다. 그리고 있다.	T	F
5. I am afraid of tomorrow.	T	F
6. When my husband begins to holler, I shrin	k	in-
side because I know serious trouble may follow.		
7. I hide sensitive issues and problems from		
husband because it's easier to shoulder the pres	su	res
		F
8. I spend a lot of my free time engrossed in	m	ov-
ies, TV, novels, and daydreams.	T	F
9. I feel a kind of relief when I think how m	y]	ife

If you answered True to any of the above statements, it might be time for you to take a hard look at your life. It

10. I feel disgusted or ashamed when I watch how my husband behaves around other people. He's such

TF

could be if my husband died.

a hypocrite.

Needless to say, there are not many people who are willing to stand up and applaud the most insignificant things a person does. But the "adore me" male finds those who will, and eventually, one by one, wears them out.

The Role of Narcissism

In this discussion of various types of dysfunctional males, we see one common thread tying them all together: narcissism. A narcissist is a person who is completely preoccupied and absorbed with himself. He feels insecure when he thinks he is losing his rightful place as the center of attention, so he plays all kinds of games that are frequently unrecognized by those outside his own family who are unaware of the family dynamics.

Styles of playing out narcissism vary, the play of the game shifts endlessly, and the rules are changed according to the caprice, whim, fancy, purpose, and ends of the narcissist. (Eric Berne's *Games People Play* covers this subject very well.) The subtlety of this kind of power and control is that it does not always appear "abusive." However, the man who invests his time and energy to put, or keep, his wife "in her place" by destroying her morale and self-image is just as guilty of abuse as the man who beats his wife.

True love means being able to transcend oneself and one's self-serving concerns. This is what the Apostle Paul meant when he said that husbands were to "love their wives as their own bodies. He who loves his wife loves himself" (Ephesians 5:28).

ues. "I've let him make me that way. And I'm really getting tired of it, physically and mentally, and I resent him. He's turned our home into his private sanatorium, with his dutiful little wife standing eternally by his side, holding his hand, taking his temperature, wiping his nose, and drying his tears. Well, let me tell you! I've come to hate his tears. I don't feel any compassion or sympathy or caring for him anymore; I've even lost the ability to feel compassion or sympathy for my kids. I've turned into a hardened, uncaring crank."

The male who seems to cry out, "Notice me," does everything for attention and respect. His relationships tend to wax and wane according to the degree to which his family, friends, and co-workers notice and respect him. He never gets enough attention.

The last example of the depressed male is the fellow who needs his wife to "adore" or worship him. His self-esteem quickly plummets if he does not receive enough praise and adulation. This man's need could very well stem from either being overindulged early in life or not being indulged nearly enough. As a child, either he was spoiled by too much praise and too much coddling or he received no praise and no coddling. Either way, harm was done.

This person is like an entertainer who is driven by applause to perform. He needs to see his name in lights and hear it spoken by admirers. He plays for praise and applause and gets lost trying to please everybody so that he will continue to be praised. He winds up defeating himself because he sets goals he cannot come close to accomplishing.

me" type of depressed male. This is the man who supposedly is in pain and needs ongoing nurturing and comforting so as to be delivered from pain. But he never is. The pain seems to come from a never-ending fountain of despair. He never lacks a reason to be in pain. He always manages to feel bad about one thing or another.

The "rescue me" type of depressed male needs to be shored up by a strong female. He needs to be rescued from situations he gets himself into quite helplessly. (Robin Norwood's book, Women Who Love Too Much, describes women who are captured by this type of man.) Once he is rescued, rather than operating in a normal life-style from then on, he immediately gets into another situation from which he needs to be rescued. Without help, he would be mired forever in the "Slough of Despondency."

In a relatively short time, however, the rescuer tires of rescuing. If she happens to be a wife who believes in the sanctity of marriage, she finds herself stuck in a permanent position of rescuing her poor, helpless, hapless husband from one disaster after another.

Michelle tells how she feels about her chronically depressed husband, Blake: "He needs full-time emotional nursing. I never get a break to look after my own needs. He says he needs me so much he can't bear the thought of having me beyond arm's reach. I don't think he's capable of loving me for just me. His idea of romance is to tell me how much he needs me, how he'd die without me, and how I'm everything to him.

"He's right. I am everything to him," Michelle contin-

demonstrate great skillfulness and competency in many areas of his life, the depressed male goes into all relationships acting as if he is extraordinarily needy and fully expects his partners to lift him from his despondency. It falls to his wife to play the role of his personal cheerleader; if she fails, the depressed male sinks deeper into depression and sees to it that she is made aware of her failure.

Sandra married such a man. "When Mitch first turned to me to soothe his hurt and suffering heart, soon after we first met, I felt so wonderfully important. I'm needed, I said to myself. Somebody actually needs me!

"He cries so easily. At first I thought how nice it was to find a tenderhearted, sensitive guy who was man enough to be open and soft and vulnerable and so in touch with his feelings. It was good. Now, years later, I'm drained. I have a hard time keeping up my own spirits, and the kids need help too. Mitch is such a downer. I'm just an extension of his mother, wiping his hurts and rubbing his emotional owies.

"Of course, it's affected our kids. How could it not when he talks about killing himself because we'll all be 'better off' without him."

Sandra grinned a little impishly. "I mentally started agreeing with that idea a couple of years ago. Naturally, I would never admit that to him. If I did, the whole family would have to go through some kind of penance. It would be days before we'd get to the place where we felt we could leave him alone."

Mitch is an example of the "comfort me" or "nurture

male, however, is pathologically needy. His system of needs is beyond normal. He assesses his relationships by how well other people meet his all-encompassing, all-consuming needs.

The wife of such a male soon finds herself in a relationship that has no flexibility or variety. Her life becomes totally dedicated to following her husband's agenda. She becomes his nurse and social worker. In this way, this weak, crippled man becomes extraordinarily powerful in that he controls what his wife and, indeed, anyone else must do (because of what he alleges he can't do) who attempts to enter into a relationship with him.

The way the crippled male abuses his spouse is that he forces her to become overly strong. She has to be what her husband needs her to be in order to fit *his* shape. Alicia explains, "Now, not only have I stopped loving him, I've begun to hate myself for what I've become, for letting him make me into a person I almost despise. Somewhere along the way I lost me. And that's both scary and depressing."

The Depressed Male

The chronically depressed male expects his wife to be his cheerleader. He needs to be constantly rescued, encouraged, comforted, nurtured, coddled, respected, and adored.

This type of abusing male can be identified in one of four ways: (1) "comfort me" (or "nurture me"); (2) "rescue me"; (3) "notice me"; (4) "adore me." Even though he may

Not only is his family trapped but he also manipulates significant others: friends, colleagues at work, employers. Everybody feels sorry for him, but only for a while.

While the crippled male was growing up in his crippled home, he never experienced a healthy, functional relationship—only dependency, impairment, and dysfunction. He was never provided with the ingredients or models he needed to develop a normal, healthy identity and, ultimately, self-sufficiency. So he spends the balance of his life acting like a parasite, attaching himself to whatever host comes into his sphere who is either willing or naive enough to be attached.

The crippled male has a genius for sapping the life from everyone he touches. The irony is that the more failure he experiences, the greater is his need to reassure himself of his own self-sufficiency. He finds himself in a vicious downward spiral that propels him to ever greater efforts to establish mastery through methods that guarantee failure.

"The only time he's efficient and capable—even masterful—is when he sets out to prove how crippled he is," Alicia said. "You never saw such energy from one man, a veritable geyser of potency. Then when he's proved his point, he starts limping again. He changes from thunder and lightning to whimpy and whiney. His voice rises a full octave."

This male makes his mate feel needed. But the need is not healthy and constructive; it is destructive. Obviously, people are interdependent. If a person believes he is the be-all and end-all of his existence, he is dangerously close to being a narcissist. We need one another. The crippled "I never really got to know Henry's mom and dad until after I married into the family. I can see why he's the way he is. He's one of life's walking wounded—just like his folks. When I'm with the three of them, I find myself doing everything for them. It's as if I have to hand feed them. Then when I've done everything I can for them, they make me feel I didn't do as well or as much as I should have."

Alicia is right. Because of his own dysfunctional family, the crippled male never reaches the stage in his life when he is independent and self-sufficient. He needs constant support and assistance to do things the normal, well-developed person does easily for himself. "He operates on some kind of program that tells him he can't do a thing. I have to do it for him or it doesn't get done," Alicia explains.

The clever trick of the crippled male is that he gains power through weakness. His weakness is a manipulation by which he gets his spouse to organize her life around his inadequacies and insufficiencies. Alicia has discovered this: "You know, sometimes I get the feeling that I'm not really the one who calls the shots, even when I perform as the stronger one. He calls the shots because he controls what happens, I do virtually all his performing for him, and when the end result is not up to his standard, he complains and moans because it wasn't done right. Meanwhile, I haven't done anything I wanted to do. My life has revolved completely around his agenda."

There appears to be no end of strategies this kind of male will use to maneuver others with his helplessness. The problem with the alcoholic abuser does not lie in those around him, of course, but in himself, his physiological reaction to alcohol, and his fears. His wife and family and other victims see him as ugly-strong. Clinically, the power he displays is just the opposite of a well-regulated adult.

When his tirade is over, the alcoholic has major fences to mend in major ways. He now has two problems: the one he tried to wash away in alcohol, and the problem of those he has injured in his rage. Add to that a burden of guilt and sorrow (and possibly shame), and the alcoholic now has new pressures building because of his behavior. And so the cycle goes on and on.

The Crippled Male

The crippled male is one who looks helpless, which ironically is what generally attracts other people to him. He is the one who stands apart from a group of people, sometimes with a hang-dog expression on his face. The kind of women he attracts are those who enjoy caring for or waiting on a man—nurse or mother types. "I have to admit it. I married Henry because I felt he needed me. He seemed so helpless. I felt sorry for him. I thought maybe all he needed was a good woman who could help him get a hold on life, and then he could stand on his own two feet." Alicia and Henry have been married for seventeen years. They have three children, but Alicia says she has had to raise four, counting Henry. The three born to her have already outgrown the one she married.

issues builds up pressure; once a certain amount of pressure has been held in check and forced down below the threshold of his awareness, the alcoholic needs to ease the constant nagging pain and avoid even a twinge of it. He discovers that alcohol is a psychic anesthetic/analgesic at first, then a disinhibitor and releaser of pressure. When he drinks, the pain is numbed for a while, but eventually it swells and spills out in ugly forms. In short, he feels much better at first, then he blows.

His family and those close to the spilling out of anger all suffer. However, the power he releases is more of a pseudopower, a reactive anger-strength, very unlike true and mature character-based strength. This anger-driven strength is powerful and heady stuff to the alcoholic. He really gets caught up in it and its display. It feels good to blow off steam and, quite possibly, "blow away" those people he misidentifies as his problem. Monica explains: "I couldn't believe my ears. I was so stunned it took awhile to react. He says I'm to blame for his misery and his drinking. 'Wait a minute,' I said. 'There's no way I'm going to take responsibility for your drinking. You opened the can, you raised it to your lips, you drank it. You did it for yourself, to yourself, all by yourself. Don't dump that one on me, buddy.' Can you imagine? He blames me! He says I'm supposed to help him because I know he has a problem with alcohol. I'm supposed to ration it out and control the amount he drinks.

"I asked him, 'Do I look like your mommy?' He comes home and says he had a bad day and he deserves a little drink. There's no way I can stop him once he starts." vation by getting pushy and overtly—or covertly—angry, the marriage probably will not be safe and secure for his wife and children.

Pushiness, grouchiness, intolerance, and inflexibility are indications that your man is a micro Napoleon; he needs free license, free rein, and total independence in his relationships—the qualities young boys seek in establishing their superior male mind-set as they are growing up. But by the time these boys reach manhood they should have developed more mature behaviors.

The next groups of abusers we will look at—the Underdogs—are those men who manipulate from weakness rather than strength. These men are also emotionally abusive, which is harder to pin down and escape from.

The Alcoholic Male

Probably no one is as terrifying as the "mean drunk" abuser. He comes home loaded and begins to lay into anyone around him: wife, kids, mother-in-law, or other relatives. "When he drinks, watch out! Thunder rolls, lightning strikes, people get fried." Sharon was describing her husband. "It starts off with just 'a little wine for the stomach's sake.' Then by the third or fourth drink, we all want to head for the storm cellar."

The alcoholic male abuser is classified as an underdog rather than a top dog because he is chronically afraid and in pain. He fears confrontation and risk. He avoids them at all costs. Over a period of time, his avoidance of these say, "I love you dearly, tenderly, carefully, softly, and gently." However, the presentation ultimately gives way to an impatience, forcefulness, and control that says, "Don't cross me!"

One of the most notable of these characteristics is how he handles his anger. If little things seem to set him off, do not make excuses for him: "Well, he's tired...he had too much to drink...he didn't feel well...I pushed him too hard...no one is perfect." Rather, consider that he has never learned to handle his anger in a mature way. Chances are he stopped at adolescence in his growing-up process.

Another characteristic of a potential abuser is his inflexible and compulsive need to have things his own way. He may show this need openly, covered with prickly irritability, or he may candy-coat it in subtle manipulation so that you do not recognize it until one day you realize you never get your way. You always do things the way he wants you to.

Unfortunately, the average woman will not discover this autocratic, dictatorial man until she actually attempts to build a life with him. Then she finds that he is inflexible and intolerant. By then it is too late to do anything about it except get a divorce or seek counseling.

The primary question every woman should ask during courtship is, "How does he handle frustration and aggravation?" If she sees flexibility, tolerance, and levelheadedness, there is a good chance the two of them will develop a flexible, power-balanced relationship. If, however, he handles frustration, disappointment, and aggra-

The danger with this kind of abuser is that in the beginning he does not appear abusive. "He was so attentive at first," Greta said. "I thought it was nice to get all of his attention. He must really love me, I thought, to want to know every detail of my life. And I have to admit I thought it was pretty good not to have to balance a checkbook or worry about the big things in life—or even the little things. My capable husband was in control."

Greta found out that abuse in the form of control, whether nice or sadistic or possessive, brings psychological and emotional injury. The man who destroys his wife's God-given ability to make decisions, who robs her of her emotional independence, and who crushes her morale and self-image is just as much a calculating assassin as the one who premeditates a killing.

Characteristics of a Potential Abuser

How can one recognize a potential abuser? People do not concentrate on possible problems in someone they hope to marry; rather, a woman looks for all the good things that will make her home a happily-ever-after place to be. However, there are certain characteristics that manifest themselves during the dating process that will give a woman some indication of the kind of person her man will be after the knot is tied.

Characteristics of the dysfunctional male—which describes all wife abusers—are not always easy to spot. Such a man at first may seem very safe, secure, and dashing. He can have a sweetness and seductiveness that

comes to full bloom, the abused wife feels completely dependent upon her husband for survival. She truly becomes unable to think for herself or to make any kind of decision without first checking with her controller. Nor can she resist or challenge his smothering supervision. She becomes totally passive to his domination of her and, in some cases, his violence to her.

The controlling sadistic male type of controller finds it necessary to confirm his control publicly. He takes every opportunity to humiliate his wife around other people. "Every time company comes to the house, Matt begins to make fun of me," Greta explained. "It'll start off with a little teasing, but I know how it's going to end up. He gets a few laughs from our friends when he exaggerates something his 'dumb blonde' did, and then he really goes into humiliating me. I usually end up running to the bedroom in tears. Later, when everyone's gone, he'll ask me why I ran off. He says, 'I was just kidding. Can't you take a joke?" Or else he says he was trying to keep me from making a fool of myself in front of our guests. 'It was for your own good.'"

Actually, the controller feels insecure if he senses that he is slipping away from the center of influence. Thus, in a desperate attempt to regain control and keep his wife on a leash, he plays childish games at her expense when they are with those outside the family. His own insecurities and fixation with impressing his friends cause him to publicly humiliate his wife so that he will be elevated. This, of course, also serves to reinforce his wife's low self-esteem.

The controlling husband insists on doing all the thinking. He makes decisions about everything, even those family matters that the two of them should discuss. He subtly convinces his wife that she does not need to participate in decision making—or, even worse, she does not have the ability or right to think on her own.

The controlling possessive male type not only makes all decisions concerning the home but he also determines what his wife will do outside the home. Janie said, "Every time I go out it's like Twenty Questions. If I go to lunch with a girlfriend he has to know where we went, what we talked about, what I ate, how much it cost, when did I leave home, what time did I get back, who did I see while I was out, who saw me, who drove, how far, did I put the tab on the credit card, which one, did I buy my girlfriend's lunch! It drives me crazy. It's not worth going out. Sometimes the third degree lasts until one o'clock in the morning. By then I'm too tired to think. Then I really get into trouble because my brain goes numb and I can't keep my story straight. I begin to say things I think he wants to hear so he'll leave me alone and I can go to sleep. Then Paul thinks I'm lying."

The controlling husband is possessive. "Possessive?" Janie said. "Look up the word in the dictionary and you'll see Paul's picture. And it's getting worse. He's beginning to get more worked up about what I do. It makes me nervous. Sometimes I'm afraid he's going to hit me. He hasn't yet, but someday he may not be able to control himself." Janie is beginning to see that many controllers become wife batterers. Over time, as this kind of abuse

The Controlling Male

The controlling male is the most subtle kind of abuser. He can be so clever that his wife is not even aware she is being abused until she wakes up one day and discovers that she lives in a "gilded cage."

The controlling male comes in several different flavors. The "nice" chief executive officer type of controller at first can sound like a dream come true. He manages all the household resources. He does not want his wife to work. He wants to provide for the family, and he is a good provider. He can even provide in excess so that his wife will believe she is in a secure setting. He puts her in a kind of palace—soon to be a prison—where she stays in relative dependency. He does this because he is unable to provide for her emotionally, so he overcompensates with possessions. Kari said, "Whenever I try to tell Rob I feel a void inside and I'm unhappy, he says, 'You have no reason to be unhappy. I've provided everything you need: food on the table, the latest in clothes for you and the kids, a nice home, a Mercedes, a pool, European vacations. You should be grateful." And Kari compounds her loneliness by feeling guilty because she complains.

Often, a woman married to a controller will see her husband's extraordinary gift-giving as proof that he loves her. She reasons that because he is so benevolent, he must be thoroughly good. However, she soon begins to starve in his generosity because there is no real love behind it. If she complains, he accuses her of causing disharmony in their "happy" home.

ery six months or so and rarely sticks with one longer than that. There is always another hunt in the offing with bugles, beautiful horses, red coats, and all the pageantry of the noble class. This is *style*! "Tallyho" seems to be his motto.

This male rarely experiences deep intimate relationships in any area of life—marriage, career, life-style development, or parenting. He has built his life upon excitement and excitement alone. This can carry a person some of the distance but never the whole way. Unfortunately, most important endeavors in life take a lot of daily consistency, character, and perseverance if they are to succeed. So, Mr. Romance-and-Excitement fails in most of what he attempts. In time, failing gets old, and Mr. Romance-and-Excitement turns into a cynical, bitter, angry, desperate person, blaming his wife, his kids, the union, his boss, even his neighbor's dog for his failure.

Jody's husband, however, had not yet reached this point in their marriage. He was still flying high into every endeavor that promised romance and excitement. And Jody was getting tired of it. "It seems I've spent my whole life finishing what he has started and lost interest in, whether it's a project around the house or a committee he's volunteered to serve on. I'm still finishing his projects with never any time for my own. I don't feel I have a life of my own. It stopped when I got married." Her husband's addiction to romance and excitement is destroying their marriage.

George can be categorized as a "phase one" individual who has the ability to sustain only the entry-level excitement phase of a relationship. He begins a relationship pursuing the high chemistry of romance. Courtship holds a sense of magic and electricity. Before long, however, when the magic begins to settle down into something deeper, as it should, he goes looking for another relationship that once again will give him the intoxication of romance. If he gets as far as the marriage altar, he soon tires of the sameness of wedded "bliss" and goes looking for another way to get his "high."

Like the power-thrusting male, this fellow also stopped maturing at the adolescent stage. Where the first type of male is always on display, looking to acquire power, this male is concerned with romance and excitement. He got stuck at the stage of adolescence (between the ages of thirteen and sixteen) when puppy love and crushes help young people establish their identity and teach them intimacy. Instead of going on into a more stable, adult way of relating to others, the excitement-and-romance-seeking male became addicted to this first phase and is never able to stick with a relationship until it develops. In fact, he seems to have an aversion to going beyond the entry level or the conquest.

A woman who wants a long-term relationship with this man will lose him when the less intoxicating phases of marriage come into view. She will find him rushing away from the predictable, stable, more developed involvement and looking for the new, more interesting, dramatic, intriguing, and novel. He tends to change relationships ev-

The Excitement-and-Romance-Seeking Male

The excitement-and-romance-seeking male is essentially an addict. His personality configuration is much the same as the substance abuser. Power is not as important as romance is—the experience and euphoria of romance. He gets high (and therefore is highly dependent) on the rush of emotions that accompany romance or excitement.

Jody said, "George spends almost all his time looking for something he's never done before, a first-time experience. He can't stand the humdrum of everyday life. He says if routine is what life's all about, then forget it."

Psychologically speaking, this male is similar to the cocaine or amphetamine abuser; he lives in a speeded-up world of excitement, manic highs, psychological buoyancy, and constant upness. Consistency, levelness, and stability are not part of this person's life.

"You can't believe how many projects he's started and never finished because he got bored with them," Jody continued. "Then if they're ever going to get done, you know who has to step in and do them. After the initial sprint he poops out and I have to run the rest of the race for him. When the race is finished I'm tired, my tail is dragging. But he's already showered and dressed for the next sprint. He says I'm boring and stodgy. I think he's starting to look for someone who can bring romance and excitement back into his life."

very dependent despite his independent and rugged appearance. Since his image is more important than anything else, he expends little effort toward developing subtle inner qualities. Relating to such a man is very tiresome, especially for his wife. Their relationship starts off with a bang and then peters out after the initial excitement wears off. This means that his wife has to support the marriage from then on. Janet said, "Sometimes I feel I've got this great big bundle on my shoulders that I dare not put down, or everything in my life will fall out of it and spill all over the floor. I have to hold up both ends of a conversation. I have to be both mother and father."

The power-thrusting male may, from time to time, come up with earnest displays of affection or devotion or love, causing his long-suffering wife to hang in there just a little longer, thinking that he may be starting to mature and settle down. But these actions are just displays with little internal substance.

Because he is concerned exclusively with himself, the marriage relationship never goes beyond the opening bang for him. Before his marriage can mature to the level of commitment, promise, and integrity, the power-thrusting male stops working at it and his wife has to provide their marriage with those qualities all by herself. After a while she gets weary of carrying the whole load and generally burns out. "There's no more left in the well. I've just dried up because there's nothing coming in to replenish the supply," was how Janet described her feelings.

Although this type of male looks and acts powerful, actually he is just the opposite. People who have studied the power-thrusting male have several contradictory thoughts on the kind of person he really is. One thought is that he is basically insecure and needs to display power to reassure himself of his masculinity. If you could open up his head you might find him riddled with insecurities. He covers them over with power thrusts.

Another thought is that he is "empty." He is unable to have deep feelings because there is no depth. All he is concerned about is the acquisition and display of male beauty and power. Everything he does orbits around this concern. This condition, generally speaking, comes from the need to overcome the feeling of being a nothing. He continually needs to be reassured of his position, power, and status. He sees that everything he is involved in puts a positive light on him, like a trophy case filled with people, objects, and experiences arranged neatly so that he looks his best.

Still another theory suggests that this male is so full of himself he cannot see anything or anybody else beyond himself. Everywhere he looks he sees his own reflection—elevated and inflated. The world is his banquet table, and everything on it is for his personal choice and consumption. Every person around the table is there to serve him and cater to his every desire and fancy just as, in all likelihood, his indulging mother did.

He craves excitement; generally, he is easily bored and has to be entertained. He needs to be challenged and is obsessed with their appearance and how they look to other people. Janet went on to say that Tom spends four hours a day working out, trying to keep his Adonis-like body. He uses Grecian Formula to hide the gray in his hair. "He's starting to get bald, but neither the kids nor I would dare say anything to him about that. He'd really lay into us then."

The power-thrusting male usually attracts other men as well as women, especially men who are not powerful and who have a need to identify with powerful people. Women who find these men desirable are those who, like Janet, enjoy a strong "pillar" to lean on.

At first glance, the power-thrusting male looks like a dashing daredevil. Janet says Tom drives a TransAm, "souped up like you can't believe. He doesn't just accelerate, he lays rubber. When he goes waterskiing, he's got to slalom behind the biggest, baddest, fastest, meanest boat." The power-thrusting male does not just "play"; he has to conquer, to win big. If he loses, as soon as he finishes sulking he demands a rematch and will kill himself to win.

At work, he does everything for praise, and he expects it. He has to get all the promotions. He treats those who work under him like serfs or servants. At home, everyone has to do things his way. He has no longtime friends; people get tired of catering to his need for power.

Janet is still very pretty. She says she must stay pretty or Tom will go find someone else who is, and she has to consider her children. "I'm just a trophy. When I start getting wrinkles, he'll be gone." about where we were going or what we were going to do. It was great for me at first because I felt vulnerable and thought I needed someone to protect me and shelter me; he was someone I could lean on."

Janet had been married to Tom for fifteen years. She showed up at the office one evening just after the last appointment. She needed to talk about this "drill sergeant" she lived with. "He always has to have his way. Nobody else has anything to say about it. Just today he ruined another family celebration because he has to run everything. It's my daughter Cindy's birthday and she was invited out with her friends for the evening. 'I'm the head of this family,' her dad scolded. 'You'll all do what I say, and I say we're going to stay at home and have a nice family dinner together.' None of us wants to stay home with him. He's so overpowering he bulldozes right over us."

As a power-thrusting male, Tom's primary concern is the acquisition, display, and wielding of power. He is one of those men who got stuck in adolescence and was never able to turn competitiveness and the power drive, which are typical of adolescence, into sharing, caring, and nurturing. Janet said, "You know, he acts just like my sixteen-year-old brother, except my brother is more grown-up. Tom talks about high school and college as his 'glory days.' He still has his letterman's jacket, and he pulls out his college yearbook and high school scrapbook whenever anybody comes over. He bores our guests—and me—to death. He just never grew up."

Men like Tom look and act very powerful. They are

the time. How can he expect not to be angry? It is a hellish world. So he brings his own hell home and spreads it around, then complains because home is not a happy place to be. "We're all going to hell anyway," he says.

"He goes around spoiling for a fight, for someone to blame," says Marie. "He has no real friends except other people just like him who complain and criticize everything and everybody. What kind of friends are those? He repels good people. Even the people at church seem to avoid him. They all tried to get close to him at first, but they soon gave up when he never responded."

Marie made it very clear that she came to the office just to talk. She may never leave this man who batters her and her children every time he has a bad day. And he always seems to have bad days. She left the office determined to try harder to agree with him, dead set to reaffirm him; after all, it isn't his fault he had a bad childhood. Besides, what would people at church say if she left her husband? He is the head of the house, you know. And she's supposed to submit and the children are supposed to obey.

The Power-Thrusting Male

"Tom was so macho. The first time I saw him I thought, Now there's a real man! When he walked into the room, everybody watched him. He looked confident and strong. All the girls were after him; unfortunately, I got him. When we were dating, I thought it was nice that he took charge of every date. I didn't have to make any decisions

house when he's around. When he comes home the kids make themselves scarce. They're terrified of his angry outbursts. They really need a father to encourage them and show them love. But they won't get it from him."

In this chapter, we are going to describe the types of men who abuse their mates—some from a position of power, some from a position of weakness. Those who abuse from a position of power we call the "Top Dog Men." These are the Angry Male, Power-Thrusting Male, Excitement-and-Romance-Seeking Male, and the Controlling Male. Those who abuse through weakness are the "Underdog Men." These are the Alcoholic Male, Crippled Male, and the Depressed Male.

The Angry Male

Marie's husband, Mike, is an Angry Male. His was a dysfunctional home, and he now reacts to the harm done to him as a child by battering his wife and children. At some time in his life he suffered some form of injury to his independence or individuality and did not know how to help himself recover from it. He grew up believing that he was not an acceptable person. He was never affirmed for who he was. Now he is locked in a position of pain that produces an unending fountain of anger that continually needs to be vented. Many criminals are angry males from dysfunctional homes. Mike happens to be a criminal attorney.

As a criminal attorney, Mike blames his temper tantrums on the human "garbage" he has to be around all

The Abuser: Controlling Through Power—Controlling Through Weakness

Mike and Marie were quite active in their church. He was on the board of trustees because he was an attorney and his qualifications were valuable to the church. We suspected that Marie was a battered wife when she came to the office to make an appointment for counseling. She had a defeated look and, even though it was a very warm day, she wore pants and a long-sleeved blouse. There were no visible black-and-blue bruises; she said later that Mike was always careful not to hit her or the kids on the face, where bruises would give him away.

"Everything sets Mike off. There's never calm in the

reservation in the company of the co

The second of th

band? Does this explanation of the differences between men and women help you to understand why the two of you often misunderstand each other?

Looking at this chart makes us wonder not why we cannot get along better but how two such different beings can ever mesh into one. There is only one answer: The primary human characteristic is that both man and woman were created in the image of God. Because of this, it is possible for the treble and the bass to join together to create a harmony that brings joy, peace, abundant life, and the compatibility God intended when He declared His creation "good."

Of course, these differences should not be seen as an excuse for abuse. Abuse in any form is wrong. Further into the book we will offer ideas on revamping the mindset. We will also talk about why some men become abusers and which female characteristics allow some women to submit to abuse. Right now, though, in chapter 3 we will paint some portraits of the more common types of abusers.

lutely no evidence to support it, even research that has been conducted by male-dominated institutions and/or male researchers.) This superior-male mind-set was so much a part of our culture's thinking that to challenge it, or even drop back far enough to question its validity, seemed sacrilegious.

However, over the past few years that attitude has gradually begun to change. And it should change. The male who persists in believing that he is superior to females—and to most other men—is one who is a potential abuser. If he does not grow out of this mind-set before adulthood, the result is an adolescent man—one who grows up but never matures. That little boy on his way home from school who tries to prove his superiority gets stuck in that stage.

Fortunately, most men eventually reach the place where they outgrow aggressiveness as their primary mode and develop a gentler, kinder, and more complex character that emphasizes strength through flexibility and adaptability rather than strength by coercion. Those men who fail to mature get stuck in adolescence and need to secure power and wield it in such a way that they convince themselves and those closest to them that they are supreme. From this mind-set we get the *misogynist*—the term applied to an abuser, a woman hater.

Unfortunately, the superior-male mind-set tends to be self-reinforcing. Those who adopt it like it that way and rarely see the need to change it.

Look at Figure 1 again. In this description of male and female characteristics, can you see yourself? Your hus-

this archive of maps through life. If we encounter an experience for which we have no map, we may borrow someone else's. By the time we are old enough to think for ourselves, we have a head full of maps we have drawn from our own experiences and borrowed from others.

Seldom do we step outside our own chart rooms to ask ourselves if one of our maps could possibly be inaccurate. Generally, we are prone to question our maps only when we are lost and cannot get oriented by searching them. Everything we know about reality, every experience, fits somewhere into one of our internal maps. We tend not to like an experience that does not follow the familiar lines of our mind-set.

The "Superior Male" Mind-set

In our Western tradition, one of the most prevalent collective mind-sets has been that men were somehow superior to women. For the most part, we had pretty well accepted as fact that men were the dominant members of the species. Little girls were taught very early that they could not do certain things because they were girls; little boys were taught that they must not cry, be afraid, or be gentle because they were boys.

Certainly, there were times of bitter disagreement between the genders as to who was better at what, but for the most part, male opinion (and, sadly, much acquired female opinion) was—and in some areas still is—that the male was superior to the female. (Research, by the way, indicates that this male-superiority opinion has abso-

the stop sign, poke at each other, grab at backpacks, and generally act rowdy—anything to establish some "macho."

When they play games or go out for sports, the emphasis is on competing and winning, not on cooperation. No little boy wants to be a loser. He wants to win, to excel within his peer group—Rambo-style, in the traditional Western mind-set of the "superior male." And certainly, he is superior over girls! Thankfully, most of these boys will, in the normal course of development, reach a stage when they outgrow these aggressive attempts to prove their superiority. But some of them never grow beyond this type of power grabbing and playing. They get stuck in the juvenile mind-set and sometimes turn out to be abusers.

What do we mean by *mind-set*? A mind-set is an unseen and unbending view of the world and the things in it. A mind-set is not something we can easily recognize in ourselves. It is sort of like our own eye. We see with our eye, through the apparatus of it, yet we cannot see our own eye with our eye.

A mind-set can also be described as a "paradigm of thinking." A paradigm is a model. We pick up our models of thinking from all those influences mentioned earlier, from our own blind random experiences, and from our religious training. We draw mental maps of our world using all these sources and try to navigate through life on the basis of them. Some of the maps may be accurate; some are inaccurate. They may have nothing to do with what we are about to experience; nevertheless, we drag

Figure 1 Male and Female Characteristics

Males tend to:

Try to achieve dominance
Be superordinate, superior; try to
achieve omnipotence

Try to achieve omniscience, Godlikeness

Think in either/or categories
Think scientifically, logically in
either/or forms of logic; think in
terms of dichotomous categories,
polarities

Emphasize control
Try to control
Assign responsibility
Think divergently

Make work the center of life Look at relationships as peripheral

Be more physical/material Be action oriented

Look at love as a ritual, dutiful performance; show love through providing material needs

Be content oriented
Be conclusive, decisive, fracturable
Think in dualities

Be power dominant

Feel "I think and do, therefore I am" Be the gypsy, wanderer, adventurer

Be authoritarian

Negotiate from win-lose position Play unilaterally

Be impatient; do it now, make it happen

Deal in suddenness

Go by the book or make up new rules to suit position

Be closed; operate in a set system

Impose judgment View sex genitally

Be conscious of rank

Seek to rule

See time as tangible thing; hurry, don't waste

Use power to control or push

Females tend to:

Try to achieve consensus

Be intuitively directed in subordinate position

Play complementary role to alleged omniscience

Think in both/and identities

Know intuitively, sense; think in terms of similarities, complements

Emphasize flowing-with Try to flow with

Accept responsibility Think convergently

Make relationships the center of life

Look at work as peripheral Be more spiritual/verbal

Be analytically oriented

See love as energy shown through intangibles

Be process oriented

Be tentative, flexible, resilient Think in unities, holistically

Be egalitarian Feel "I am"

Nest, look after the home front

Be supportive

Negotiate from win-win position Think when the time is right, let it

happen Be gradual

Deal with the uniqueness of each situation; take things situation by situation, case by case

Be open; operate in flexible system

Suspend judgment

View sex with whole body

Be peer oriented Seek to serve

See time as a continuous process; flow with it

Utilize strength to endure or persevere

Men and women are different in certain important ways. Rather than viewing men and women as two equal but different forms of humankind, we tend to evaluate the differences only. Look at Figure 1. Do you see value judgments beside any of the characteristics? There is no rating indication. For example, on the male side it does not say "bad" or "right on" in front of any description! There is no badness or goodness, just differences in these characteristics.

Of course, all of these male/female tendencies do not come categorized and wrapped up inside that little new baby emerging from the womb. Most of them are acquired little by little, early in life, from "teachers," all those people who interact with us: parents, siblings, peers, baby-sitters, schoolteachers, coaches, movie and television heroes, employers, and others. As these characteristics collect, they eventually join together to form a mind-set.

Mapping a Mind-set

Every school day about 3:00 p.m., I can look out my office window and see fourth-, fifth-, and sixth-grade boys and girls walking, riding skateboards, or bicycling home from the local elementary school. If four or five boys are together, they begin to compete with one another to see who can be the most aggressive, the loudest, the best. They race their bikes down the hill and come to a skidding stop just before hitting one of the other kids, usually shouting warnings all the way down. They throw rocks at

If I were to ask a thousand men, "What is the most special physical act a man can engage in with a woman," their response would usually be, "Ha, ha, ha, that's your question? You dummy you! Everybody knows that!" The problem is, if I ask women that same question I am going to get a completely different answer. Men think that sex, sexual intercourse, is the most special physical act. But women will say the most special physical act is holding, just physical holding. "That's all I want. That's the most special physical act."

A woman emphasizes the spiritual more than the practical. She adopts an attitude that things will happen when the time is right. She operates more from a position of let-it-happen rather than make-it-happen. Women are more gradual in their actions, whereas men act suddenly.

She may flow with time, not divide it into distinct measurements.

A woman is usually less physical, less pushy, and more verbal.

Now we get to the reason for all this comparing. God created us in His image. He also created us to be different. A man is supposed to be the protector, provider, and encourager of the family. Many of these characteristics are within him to help him become the ideal husband/father figure. But at some time along the way to growing up, in some males, something goes wrong and a few of these traits become overemphasized. That is where the conflict begins.

What Is Female?

The female of our species is far different. Where the man tries to dominate, the woman works at achieving agreement. Peace and harmony, not winning, are more important. When he thinks control, she tends to flow with the situation, not oppose or stand or push against.

She is more peer oriented and not so concerned with rank and position or ruling.

A woman tries to play a complementary role to her man's alleged omnipotence and omniscience.

While he is thinking either/or, she thinks both/and. She thinks in terms of similarities and complements rather than dissimilarities and divergences.

The female is more intuitive than the male; she knows, and intuitively understands. A woman will accept responsibility rather than fight to assign responsibility. She will accommodate more to accept responsibility. She is a team player more than a team captain.

Relationships are central to her life; work is peripheral.

Love to her is a sort of spiritual and emotional energy that behaves in subtle quality-relationship ways which cannot be entirely grabbed hold of. She tends to have a whole-body view of sexuality as opposed to a genital or physical localized view. This, by the way, is the reason for many male-female sexual conflicts.

Dr. Kevin Leman, in his book Sex Begins in the Kitchen, talks about how different men and women are in the way they view sex:

The male tends to be gender conscious. His view of sexuality is very genital and localized. He shows love through providing material abundance. When he "makes love" he is physical-sensation-centered and ritualistic, playing out in terms of skillful artistic "performance."

His life positions are usually hard and fast, conclusive and decisive. If things do not go the way he wants them to go, he seldom bends or flows into the situation; rather, he remains rigid, acting as if he would rather fight than switch.

He negotiates from a win-lose position. He plays to win. He is impatient and wants to do it now, to make it happen. He acts suddenly coercively rather than gradually. He goes by his own standards of performance and, if necessary, will make up new rules along the way to suit his position. He operates within a set system of fixed options; he is rarely flexible.

He would rather assign responsibility than accept it. He tends to impose order with its rules and regulations. He likes a structured life.

He tends to impose judgment.

He sees time as a tangible reality. Don't waste it; hurry up; do it now.

Does all of this sound familiar, ladies? We can almost hear some of you saying, "Boy, is that my husband!" However, just because he has many of these strong characteristics doesn't mean he's a bad guy. It just means he is running true to form.

"What does all of this have to do with abuse?" you might ask. Read on and you will see that it gets more complicated.

male over the age of fourteen has probably said, "I'll never understand women."

If we could all understand the differences inherent in men and women, perhaps we could see why some men (and some women) resort to spouse abuse. Understanding these differences may help ward off some acts of violence.

What Is Male?

When we talk about the differences between maleness and femaleness, we have to keep using the words *tend to*, because most of the following characteristics are evident to some extent in both men and women. However, for the most part we can profile maleness in the following ways:

The "typical" male finds out early what is expected of him "as a man" and strives to be the best at whatever he sees himself as being. He wants to dominate, to be superior. He thinks "control" and works to gain knowledge that will help him control and influence his situation. He is very conscious of rank and position and wants to be the one who rules.

He likes to think he is omnipotent—all powerful, and omniscient—all knowing. He leans toward an authoritarian style in relationships.

In maleness, everything is either/or. The male tends to find significant differences and dissimilarities rather than uniformities and similarities.

Work is the center of his world; relationships are second.

Male and Female: Equal but Different

"So God created man in his own image, in the image of God he created him; male and female he created them" (Genesis 1:27).

In our "equal rights," "unisex" society, it is sometimes hard to remember that God created "male and female," two distinctly different beings with one profound thing in common: both were created "in the image of God" rather than like the other living creatures. Because male and female are different in many ways, we are bound to find a lot of characteristics in one that we do not find in the other. Therefore, particularly in a society where we expect to be equal, or "the same," we will sometimes clash.

Little girls who do not yet understand the differences think little boys are weird, "stupid," or "nuts." Grown women may describe men who do not conform to their idea of normal behavior as "thoughtless," "insensitive," and also "stupid" or "nuts." On the other hand, every

- 1. I actually asked for it this time. I shouldn't have made him mad.
- 2. He couldn't help the way he acted because he'd been drinking (or snorting coke, or using another drug).
- 3. He's nice to everyone else. I guess I just do things that upset him.
- 4. He's good to me and the kids much of the time, so I guess I can handle the times he gets mean.
- 5. He really is trying to change. He hasn't lost his temper for a month now.
- 6. He tells me he's the only man who would ever put up with me. He's probably right.
- 7. What would I do if I left him? I could never take care of the kids by myself, and I can't leave them with him.
- 8. My husband isn't as bad as my dad was. I have it a lot easier than Mom did.

These are some of the excuses we hear from women who live in abusive situations. If you have made these kinds of statements, or thought them, then this book is for you. You *can* help to create a more peaceful environment in your home and in your life.

members wounded by the emotional shrapnel of combat. Kids are often the ignored victims of husband-wife violence. But they get hit, directly or indirectly, and their pain is just as deep, perhaps deeper because of their complete defenselessness.

In preparing this material, we felt a sense of sadness because of all the wives and children we have seen and worked with who are hurt almost beyond healing—shattered and broken vessels. Those who first read these pages may be the ones who have been shattered by men whose touch withers and then destroys—those abused ones who have borne the crushing weight of love trampled upon, service taken advantage of, and sacrifice derided. Even after the abuse ends, these women need considerable time to heal. Old wounds, bone deep, need to close as disfigurement-free as possible. These kinds of wounds heal painfully and slowly, from deep inside outward. The healing cannot be hurried; it takes time.

While this work does not claim to be an exhaustive survey of all forms of domestic violence in the Christian community, hopefully, through in-depth exploration of selected situations, light will shine on some solutions to the problems.

Common Excuses for Abuse

Are you an abused wife, or do you know someone you suspect is being abused? If you feel you are being abused by your husband, do you hear yourself making any of the following statements to yourself or other people?

lence who are asking why they are being punished and are seeking a way to help themselves. In this book we will try to show that abuse is not the fault of the one being abused but that fault lies solely with the abuser. We will examine the ways in which men and women differ and try to discover that point in life when a male becomes an abuser. We will talk about why women put up with abuse and what they can do about it. And we will challenge the role the church traditionally plays in domestic abuse.

If you are an abused wife, we hope you will find in the following chapters the courage and help you need to do something about your situation. You alone must make the choice to get out of your predicament; you cannot be helped if you stand still and allow yourself to be abused. The problem of wife abuse is not easily solved, as we will show. But there are solutions, and we will describe them.

We do not believe God ever intended any wife to suffer the indignities of physical and emotional abuse from her husband. Even though we hold to the view that "what God has put together, let no man put asunder," there are times when a wife may have to realize that perhaps God was not the one who put her together with an abuser.

Each of us is given a special trust to nurture and care for those we are responsible for. When we touch those who trust us, we are enjoined to do it with protection, love, nurturance, healing, and care—not in a manner that is harsh, critical, demanding, unfeeling, injurious, punitive, or destructive.

This book will also consider the neglected, silent bystanders who are injured in the hostile cross fire: family even get out of bed: 'Lisa, if you'd put your robe on the chair by the bed, you wouldn't have to walk over to the closet to get it when you got up.' If I put my robe on the chair he probably would say, 'Lisa, this room's torn upside down. Can't you straighten up things before you go to bed?' And he keeps up this nagging criticism all day! Whenever I've had enough and call his attention to it, he denies being critical of me. I get so tired of trying to figure out ways to keep him from finding fault with me. Sometimes I feel I'd be happier—and a lot more at peace—if I left him. He makes me feel so worthless."

Abuse can be direct or indirect, intentional or permitted, pugnaciously delivered or slick. As one woman said, "I'm not sure why, but I just felt cut to ribbons."

Abuse is delivered with a fist, a club, a snarl, a smile; by neglecting to remember to say or do something; by remembering something better left in the past and using it like a bludgeon.

Abuse can be discharged at its target like a sharp-shooter's bullet, or it can be carefully and ingeniously aimed so as to ricochet before hitting home.

Abuse can be dealt out suavely, with a high and lofty attitude, or it can be down and dirty like a street brawl to the death. Abuse doesn't always show up in body bruises, but the damage to a wife's self-esteem, dignity, self-confidence, personal pride, and good nature is just as injurious—maybe more so. This book is about the man who brutalizes his wife and children in a physical way; it also speaks to the greater problem: abuse of the spirit.

We write primarily to women victims of domestic vio-

for counseling. After several weeks, the pastor discovered that the girl was being sexually abused by her father and had been since she was fifteen. Roger was her father. When Joan, Roger's wife, came for a counseling session, she revealed that she had raised three children under the stern, critical gaze of her husband and his "eyebrow." The revelation of the daughter's sexual abuse brought to light her mother's longtime emotional and physical abuse.

Joan never approached her pastor about being abused. Perhaps she was afraid it was all her fault, which is a common belief among abused wives. Perhaps she was ashamed to share this "family problem" with an outsider. But even if she had talked to the minister, he probably would not have known how to counsel her; few church leaders are equipped to deal with domestic violence and wife battery. Actually, most of them do not wish to confront the problem. Their response to a woman who is being abused by her husband is usually to tell her to "pray about it." After all, the church—like the home—is supposed to be an idyllic "haven of rest," a place of happiness, peace, and contentment. We tend, quickly and uncomfortably, to sweep aside anything that is inconsistent with this ideal before our heaven on earth is shattered.

Lisa was a victim of abuse of a different kind. She came for counseling because she was desperately looking for a way to keep her marriage together. She said that on weekends, when her husband was home all day, he would look for things to criticize her about. "He starts before we

murdered are killed by their boyfriends or husbands. Nearly 45 percent of women who are battered are pregnant.

However, abuse can also be delivered by omission: leaving things unsaid or undone that inflict physical and psychological injury. Either way it is abuse, pure and simple. Abuse can be active or passive, depending upon the cruelty or cunning of the abuser.

The story of physical and emotional spouse abuse is written in scars—on both body and mind—on untold thousands of victims. It is a story that is played out throughout our culture, in families that never miss a church service as well as those who never attend church.

Roger and his family are active in their church. Roger is an abuser who had just been asked about his early relationship with his wife. He got up, walked to the office window, and looked out for a few seconds. Then, with a lopsided grin, he turned around and said, "We'd only been married a few months when she pulled a pout and started acting like a child. So I turned her over my knee and spanked her as I would a child. And you know? She's kept in line ever since." Roger looked proud of himself. "All I have to do nowadays is lift my eyebrow, like this, and she gets that half-scared look and cows under. She doesn't say a thing, but she does what I want. I can't believe my eyebrow has that much power," Roger laughed. "But it sure keeps my wife in line."

The interview with Roger came in a roundabout way. The minister of a local church called about a twenty-twoyear-old woman in his congregation who had come to him ing before I started pounding on her. Then when I was really drunk I'd go home and either fall asleep or start on her again." In some instances, police are called to the same home two or three times during one night.

One reason law enforcement officers hesitate to respond to domestic violence calls is that, according to statistics, most policemen who are injured or killed on duty are responding to such calls. Most of the time it is the abusing husband who takes a potshot at them, but sometimes the wife inflicts injury on responding officers. Therefore, the law tends to steer clear of "family fights."

Another reason for ignoring or downplaying abuse calls is that many authority figures believe the wife must have done something to provoke her husband into beating her up, much the same as society and the justice system often view victims of rape as having some responsibility for their victimization. Law officers reason that if they get the man away from her long enough to get over his anger, the immediate problem will be solved and they can get on with their job of keeping peace in the rest of the community.

What constitutes abuse? The first thing most of us think of when we hear the word *abuse* is physical, sexual, or psychological assault on another person—abuse by commission. Every fifteen seconds in the United States a woman is beaten by her boyfriend or spouse. One out of three women is battered in her lifetime. It is the single major cause of injury to women—more frequent than auto accidents, muggings, and rapes combined. One of six American households experiences violence between husband and wife each year. One-third of women who are

own as head of the family. Women are becoming more aware that they do not have to serve as punching bags or suffer emotional diminishment, that they are equal with men in the sight of God, so they seek counseling as a way to cope with the dilemma of abuse. It is about time that some of these frightened and broken wives found their way to counselors who might be able to help them.

Until very recently, domestic violence was something that agencies and institutions, including the church, typically ignored. Domestic and child violence laws were not strictly enforced until the 1970s. Any abuse law before that time had to do with preventing cruelty to animals; laws forbidding abuse to animals were in effect and enforced before child abuse laws were! And today, in most states, wives are protected from abuse only by those laws that prohibit general assault on any person.

Even now, however, although there is legislation against spousal abuse, law enforcement agencies and peace officers tend to play down calls for help during incidences of domestic abuse, even when they are aware that the most brutal forms of physical violence have occurred in the past in a particular home and may now be occurring. During a therapy session that was required of wife abusers who had been arrested, one young husband said that "even when the cops did come to check out the call my wife or one of the neighbors made while I was beating on her, all they did was tell me to leave the house for a few hours to 'cool off.' I'd go down to the local bar and have a few drinks, even though I had already been drink-

had been occurring for years, stories of rage and terror that sent the whole family into hiding. She and her children all dreaded seeing the "head of the house" come home.

At first, Reverend Johnson was shocked that the young man he thought he knew could be guilty of such acts. Chuck was a quiet person, very pleasant to be around. The people he worked with saw him as unflappable, never excitable or disagreeable. No one would suspect him of having a temper or exhibiting violence.

As Connie continued to reveal her miserable home situation, the minister began to squirm and shuffle papers on his desk. Finally he said, "Now, Connie, don't you think you're putting too much importance on a few domestic disagreements?" Connie looked at him in amazement. He doesn't believe me! she thought. He thinks I'm making this up!

Reverend Johnson was just a few years shy of retirement. He was popular in his church and did not want to get involved in anything that might jeopardize his position there. Getting in the middle of a family squabble where he might be required to take sides could cause a lot of distress among the congregation. Also, he had graduated from seminary thirty-five years before and had never been prepared to deal with problems of this sort.

Marriage, family, and child counselors are encountering more and more incidences of wife abuse in the Christian community. Maybe something has provoked infantile anger in husbands who, when feeling threatened, turn to abuse as they desperately try to hold their

Wife Abuse: Unfair Treatment of the "Fair Sex"

Reverend Johnson looked across the desk at Connie, a teacher in the Sunday-school department. He had been glad to make this appointment, even though Connie had called just this morning and he already had a busy day, because Connie and her husband, Chuck, were active in the church education program and well liked by everyone. However, he was not prepared for what he saw or for what Connie was telling him.

Connie took off her dark glasses and showed her pastor her black eye; he had already noted her swollen lip. She told him she also had a shoulder separation and bruises on her rib cage. At first, the minister thought she had been in an auto accident. Then Connie began to relate incident after incident of unbelievable spousal abuse that

SKATTERED AND BRUKE N

The statistics on wife abuse are quite alarming. If you define *wife abuse* in purely physical terms, it seems to occur in about 10 percent of American households, although some experts put the figure as high as 50 percent. But when you add psychological abuse to it, there is little doubt that about half of all married women will at some time during their marriages be defined as battered women, either physically or psychologically.

The problem occurs in every economic and social level, and it occurs among churchgoing people as well as those who do not attend church. Usually, however, church members try to hide domestic violence from public view. But, from our experience, we know that wife abuse among Christians is much more common than most people realize.

Even in some Christian families that appear to be "picture perfect," there are deep wounds. Everybody smiles, everyone appears happy, but deep down inside, each family member is severely troubled. Even the children, as they grow up, take the psychological and physical scars into their own marriages.

For those who are going through such distress and for friends and counselors who are seeking to help, this book has been written.

S. RUTHERFORD MCDILL, JR. LINDA G. MCDILL

Introduction

In our years of clinical practice, we have always held a very high view of marriage and take quite seriously the phrase, "What God has joined together..."

However, in all honesty, we must admit that often when we hear a story of cruelty of the worst kind, the inflicting of injury almost beyond belief, scarring the body, mind, soul, and spirit, we feel that something dark and evil is operating. Something devious, almost diabolical, has made this union very unlike anything God would hold together.

Our primary task in such cases is to help the woman, perhaps for the first time in her life, develop enough strength to break out of the destructive cycle she is in and work toward something healthy.

This book provides some of the counsel we would give to assist the battered woman in her desire for healthy wholeness. en tidenen er aller Filippia Freiker i fili tide Filippia Straffe after er gifte, mog

7	Therapy: How Can Professional Counseling Help? Revamping the Male Mind-set The Process of Beginning Counseling Separate, Disentangle, Detach Dismantle, Examine, Restore Change Self-defeating Behaviors Forgive, the Christ Way What to Do When the Abuser Refuses to Get Help	133
8	Children: The Innocent Victims The Offended Little Ones Hangover Results of Domestic Abuse Adult Child of Alconolic Parent(s) All Is Not Lost	155
9	Recoupling: What It Takes to Start Over Learning to Communicate Coming Together Again True Intimacy No Guarantees Look to the Interests of the Other A Balanced Marriage	171
	Notes	183
	Appendix Agencies That Offer Help How to Find a Counselor Books About Abuse, Alcoholism, Self-esteem	187

	The Crippled Male The Depressed Male The Role of Narcissism	
4	The Abused: Why Me? How Women Respond to Men's Abuse The Influence of a Dysfunctional Family The Mind-set of the Abused Wife Why Does She Stay? The Battered Wife Syndrome Women's Erroneous Thinking	65
5	The Church: Haven for the Abused or	01
	Harbor for the Abuser? Ill-Prepared for the "Real" World	91
	Misuse of Scripture	
	The Long-suffering Lover	
	The Old Standby, "Submit"	
	The "Head" of the House	
	The Biblical Position of Headship	
	Love, Honor, and—Obey?	
	The Woman's Role in Bible History	
	The Church and the Battered Wife	
	What to Expect From Your Church Leader	
	What Is Co-Dependency?	
6	Solutions: How Much Can You Do to Help Yourself?	111
	Work on Your Level of Self-esteem	
	Consider the Abusive Husband's Self-esteem	
	Take Steps to Help Yourself	
	Analyzing a Healthy Relationship	

Contents

	Introduction	11
1	Wife Abuse: Unfair Treatment of the "Fair Sex" Common Excuses for Abuse	15
2	Male and Female: Equal but Different What Is Male? What Is Female? Mapping a Mind-set The "Superior Male" Mind-set	25
3	The Abuser: Controlling Through Power— Controlling Through Weakness The Angry Male The Power-Thrusting Male The Excitement-and-Romance-Seeking Male The Controlling Male Characteristics of a Potential Abuser The Alcoholic Male	37

there is a paper of the gall flat and the

TO Our Daughters, Erin and Lindsay

Unless otherwise identified, Scripture quotations in this publication are from the Holy Bible, New International Version. Copyright © 1973, 1978, 1984 International Bible Society. Used by permission of Zondervan Bible Publishers.

Scripture quotations identified KJV are from the King James Version of the Bible.

List of attributes reprinted with permission of the National Mental Health Association.

Material adapted from Why Am I Afraid to Tell You Who I Am? by John Powell, S.J., © 1969 Tabor Publishing, a division of DLM, Inc., Allen, TX.

All names of people whose stories are shared have been changed, as have their situations, in order that privacy may be carefully protected.

Library of Congress Cataloging-in-Publication Data

McDill, S. Rutherford.

Shattered and broken / S. Rutherford McDill, Jr., and Linda G. McDill.

p. cm.

Includes bibliographical references.

ISBN 0-8007-5382-8

1. Church work with abused women. 2. Wife abuse—Religious aspects—Christianity. 3. Abused wives—Pastoral counseling of. I. McDill, Linda G. II. Title.

BV4445.M36 1991 261.8'32—dc20

90-46455 CIP

All rights reserved. No part of this publication may be reproduced, stored in a retrieval system, or transmitted in any form or by any means—electronic, mechanical, photocopy, recording, or any other—except for brief quotations in printed reviews, without the prior permission of the publisher.

Copyright © 1991 by S. Rutherford McDill, Jr., and Linda G. McDill Published by the Fleming H. Revell Company Tarrytown, New York 10591 Printed in the United States of America

OVERTON MEMORIAL LIBRARY
HERITAGE CHRISTIAN UNIVERSITY
P.O. Box HCU
Floranco, Alabama, 35020

SHAITE SHAND BRUKEN

S. R. McDILL & LINDA McDILL

Fleming H. Revell Company Tarrytown, New York

Fair Havens
Church of Christ
P.O. Box 1008
Kernersville, NC 27285-1003

Do any of these men sound like someone you know?

 Tom is a "drill sergeant" who orders his wife, Janet, and family around and always has to have his way. He is a powerthrusting male.

Greta's husband takes every opportunity to humiliate his wife

in public. Matt is a controlling sadistic male.

 Henry acts helpless and expects his wife to do everything for him; yet he's never satisfied with the results. He is a helpless male.

• Driven by anger, *the alcoholic male* takes out his frustrations on his wife, kids, or other relatives.

These are all prototypes of husbands who abuse their wives either physically or psychologically, or both. They may appear to be "ideal husbands" when they're at church, yet at home they terrorize their wives and families. If you're married to an abuser, where can you turn for help? Or if you're a pastor called upon to counsel a victim of domestic violence, yet don't know how, what can you do? Shattered and Broken provides abused wives with the courage and straightforward advice they so urgently need. This in-depth examination of the reality of domestic violence in the Christian home also gives pastors sound psychological and biblical counsel for helping battered women and their families. An appendix at the end of the book lists resources that can assist both women and their counselors in obtaining further help.

Fair Havens Church of Christ P.O. Box 1008 Kernersville, NC 27285-1008